digital masters:
adventure photography

digital masters: adventure photography

capturing the world of outdoor sports

Michael Clark

LARK BOOKS

A Division of Sterling Publishing Co., Inc.
New York / London

Editor: Matt Paden
Book Design: Tom Metcalf
Cover Design: Thom Gaines

Library of Congress Cataloging-in-Publication Data

Clark, Michael, 1970-
 Digital masters. Adventure photography : capturing the world of outdoor sports / Michael Clark. -- 1st ed.
 p. cm.
 Includes index.
 ISBN 978-1-60059-519-6 (pb-pbk. with flaps : alk. paper)
 1. Photography of sports. 2. Action photography. 3. Outdoor photography. I. Title. II. Title: Adventure photography.
 TR821.C487 2010
 778.7'1--dc22
 2009017945

10 9 8 7 6 5 4 3 2 1

First Edition

Published by Lark Books, A Division of
Sterling Publishing Co., Inc.
387 Park Avenue South, New York, N.Y. 10016

Text © 2010, Michael Clark
Photography © 2010, Michael Clark, unless otherwise noted

Distributed in Canada by Sterling Publishing,
c/o Canadian Manda Group, 165 Dufferin Street
Toronto, Ontario, Canada M6K 3H6

Distributed in the United Kingdom by GMC Distribution Services,
Castle Place, 166 High Street, Lewes, East Sussex, England BN7 1XU

Distributed in Australia by Capricorn Link (Australia) Pty Ltd.,
P.O. Box 704, Windsor, NSW 2756 Australia

If you have questions or comments about this book, please contact:
Lark Books
67 Broadway
Asheville, NC 28801
(828) 253-0467

Manufactured in China

ISBN 13: 978-1-60059-519-6

For information about custom editions, special sales, premium and corporate purchases, please contact Sterling Special Sales Department at 800-805-5489 or specialsales@sterlingpub.com.

ACKNOWLEDGEMENTS

I wouldn't be where I am today without the help of those who have mentored me along the way. There have been numerous people, including my family, school teachers, university professors, other pro photographers and close friends, not to mention all of the incredible athletes I have worked with over the years, who have given their time and talents to help me get this far. Because I have received so much from so many, I am a firm believer in passing on that which was given to me. This book is a manifestation of that philosophy.

To my father, who let me borrow his Olympus OM-1 so many years ago and taught me if you are going to do something, you do it right. Who knew that would be the beginning of a career? To my mother, for your love and support, and my family, who has encouraged me along the way—and even modeled for me on a number of photo shoots.

I would also be remiss if I didn't thank those who have had a profound effect on my photography career. My many thanks to Marc Romanelli, who took the time to check out my work and foster me into this wild profession when I was just a pup. Nevada Wier, who through her book, Adventure Travel Photography, gave me reason to dream about being a pro photographer, and later became a close friend who encouraged me to take on this project. Joe McNally, whose knowledge and insight have helped me move my lighting skills and photography forward in leaps and bounds.

Leslie Alsheimer, who taught me much of what I know about the digital world and Photoshop. And finally, a whole slew of folks that have been there as good friends and colleagues to support me over the years: Peter Dennen, Jamey Stillings, Robert Reck, Reid Callanan, Rob Haggart, Zach Reynolds, Jose Azel, Kurt and Elaina Smith, Timy Fairfield, Brian Bielmann, and so many others. Thanks also to Corey Rich and Sabine Meyer for giving me such fantastic, in-depth interviews for this book. And to all the photo editors who edited and critiqued my work and commissioned me to shoot assignments—I wouldn't be in this profession without your input and trust.

This book would not be the same without the efforts of my editor, Matt Paden, at Lark Books. I can't thank him enough for tracking me down, asking me to write this book, and for the many long phone conversations about how we could improve it. Without his input, ideas, and ability to assist my writing, this book would not exist.

Contents

INTRODUCTION

The great American author Ernest Hemingway once wrote, "There are only three sports: bullfighting, motor racing, and mountaineering; all the rest are merely games." The gist of his statement is that these three sports were the only ones in his day where the individual was risking life and limb, while all other sports were just games because the possibility of death or dismemberment was non-existent. Today, adventure sports continue that tradition of risk and reward. Adventure athletes often put it all on the line as they grapple with their fear, ambition, and the hope of success. As an adventure photographer, you are there to document and share these spectacular moments by creating images that translate the adventure lifestyle.

Suffice it to say, adventure sports in general are risky business. In the fifteen or more years I have been rock climbing, mountaineering, kayaking, mountain biking, and trekking around the globe, I have had plenty of close encounters I was lucky to survive. But my time in the outdoors also inspires my life and creativity. Through my images and words, I hope to share my passion and relate just how phenomenal the rewards of photographing these sports can be. Adventure sports teach self-reliance, confidence, responsibility, and good judgment. Without the confidence I gained from rock climbing and mountaineering, I would have never had the wherewithal to start a career as an adventure photographer. It is precisely because of my involvement in these sports that I am able to tromp through uncharted corners of the globe, have an outlet for my creative energy, and work with world-class athletes at the height of their sport. Adventure photography allows me to explore the world in a way I never would have otherwise; when I am behind the camera, my curiosity kicks in and enriches my interactions with the people and places I visit.

Being both challenged and inspired is what adventure photography is all about. If you are reading this book, I am willing to bet that adventure is what gets you excited and you are up to the challenge of creating images that convey your passion for the outdoors. When I teach workshops, my goal is to download as much information as possible from my brain to the students. In this book, my goal is the same. I want to give you as much information as I possibly can on every aspect of photographing adventure sports, including all of the little tidbits that are not obvious. We'll discuss the photographic equipment I use and recommend, both in the equipment chapter and when we discuss each adventure sport individually. In addition to how I use that gear, I'll also describe how I approach each sport and how I carry the equipment. While the latter might seem like a small detail, how to carry and protect your gear varies greatly depending on the sport. I'll forewarn you that I am a gear head. Like many photographers, I love talking about megapixels, high ISO noise, sensor resolution, chromatic aberration and all that gobbly-gook—but in the end, cameras are just tools for capturing your vision. The suggestions I make about equipment can be considered a solid starting point for gathering your own gear; as your experience grows you'll learn what works and what doesn't work for your style of photography.

My own journey into photography first began in junior high, but it was on a trip to France in 1995 that I first thought I could make it a career. I was photographing Toni Lamprecht, a world class German climber, in Buoux, France. He was virtually unknown in the United States at the time and the images I shot of him climbing cutting edge routes were newsworthy back in the U.S. When I returned home, my first three submissions were published in *Outdoor Photographer*, *Climbing*, and *Rock and Ice* magazines. From that point on, I was hooked and worked as often and as hard as I could to make climbing photography, and later adventure photography, a full-time career. It took about three years before I was able to go full-time, and I consider myself extremely blessed to have found such a fulfilling career, and to now be able to share the knowledge I have gained over the last fifteen-plus years.

When I first started out, I would have paid almost anything for a how-to book on adventure sports photography. Over the years I learned through my own obsession, hard work, and a lot of trial and error about the important aspects of this genre like equipment, positioning, natural and artificial lighting, business practices and marketing strategies, and much more. Consider this book a compilation of my experience and hard work that can save you the time and frustration of figuring it all out on your own. My goal is that the information gathered here leads you down a path of adventurous living and inspiration in the outdoors that lasts a lifetime, and that you learn the technical skills that will help take your photography to the next level.

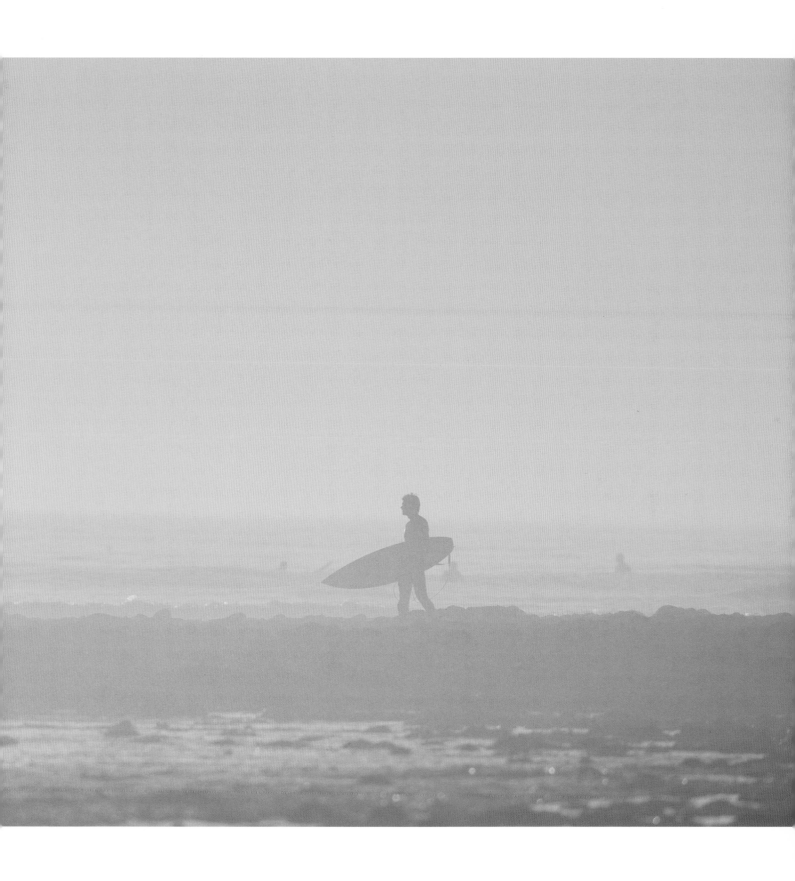

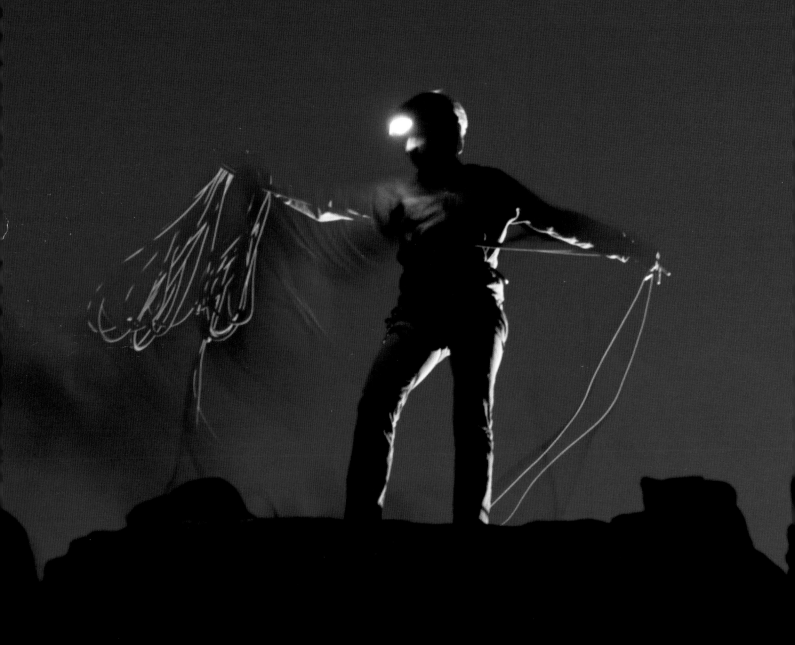

Since the dawn of photography, equipment has always been central to the craft. A photograph is the result of an inspired person using a piece of equipment to record or, better yet, create an image. And since equipment is so essential for capturing the image, we'll start some with basic equipment recommendations for adventure photography, and get more gear-specific in later chapters when we look at how to shoot individual sports.

Purchasing certain gear will not automatically make you a better photographer. Using a top-end digital single lens reflex (D-SLR) camera doesn't automatically equate to better images. A pro photographer could use a point-and-shoot and still create impressive pictures. The flipside of this argument is that there are some pieces of equipment that do give your images a different look, and those images would be impossible to capture without the right gear. A good example of this is a fisheye lens or a high-end studio strobe. So while high-end gear doesn't automatically make you a better photographer, knowing how and when to use it to the fullest advantage will undoubtedly give your photography more professional results. With this in mind, we'll start right in with the cameras.

DIGITAL SLRS

The D-SLR has become the mainstay for adventure sports photography. There are a few photographers still shooting 35mm film in the adventure realm, but even they are finally caving into the advantages of digital—and with good reason. Today's digital cameras far surpass their film counterparts on several fronts, producing photos with better resolution, lower noise, and more accurate color.

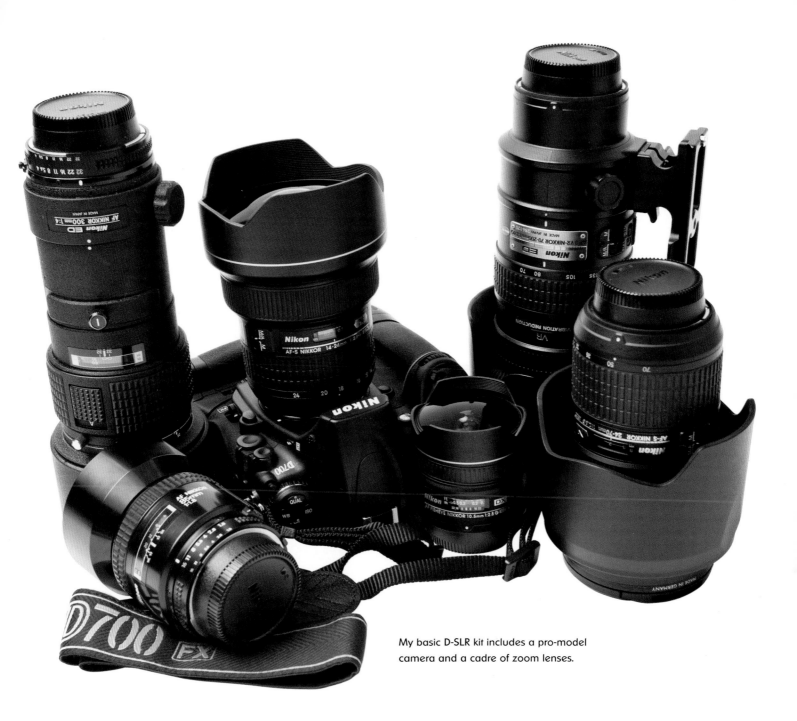

My basic D-SLR kit includes a pro-model camera and a cadre of zoom lenses.

When looking for a camera that is well suited for adventure photography, keep in mind that it is going to encounter the elements and will possibly be banged around a fair bit, so a durable camera is best. The weight of the camera is always an issue, but once you start carrying around a small cadre of lenses the weight starts to add up rather quickly anyway. Therefore, I would lean towards a heavier, more durable, and weatherproof camera rather than a lightweight (i.e. plastic) camera body.

One of the hot topics in digital photography has always been megapixels (MP). While I have found that 8MP is more than enough for most photographers, I personally prefer a camera with at least 12MP since it gives me a bit more room to crop and it also allows for better enlargements. I have done testing to see just how much better the resolution from a

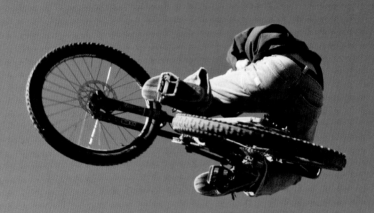

12MP D-SLR is compared to 35mm and medium format film. I found that a 12MP D-SLR blows the doors off 35mm film and is at least the equivalent of medium format film, if not a little better. Also, keep in mind that with proper processing, a sharp and well-exposed digital image can be enlarged in post-processing up to 250% with very little image degradation.

Basically, any top-end pro or semi-pro camera body is a good choice for adventure photography. I currently shoot with both Nikon Full frame and DX (also known as APS) size sensor cameras. The APS model comes in handy when shooting with telephoto lenses because of its smaller size sensor, which effectively extends the focal length of my lenses by a factor of 1.5. (See the full-frame vs. APS sidebar on page 17 for more information on the pros and cons of each sensor type.) If you want to stay up-to-date on the gear that I use and recommend, visit my website at www.michaelclarkphoto.com and check out the gear reviews in the 'Behind the Scenes' section.

Adventure sports photography requires a camera that can shoot at 5 frames per second (fps) minimum, but a framing rate of 8 fps or faster is optimum. Can you shoot sports with a slower frame rate? Sure, but in some circumstances you'll be missing a lot of images, especially with fast-moving sports like mountain biking, surfing, and kayaking.

Autofocus is also a huge factor when selecting a camera for any type of sports photography. Basically, you need the fastest autofocus you can get. And as you might expect, the cameras with the best autofocus usually have the fastest framing rates because they go hand-in-hand. Both Nikon and Canon have superb autofocus in their top-end pro or semi-pro cameras, which far exceeds the capabilities of their consumer cameras. As an example, whitewater kayaking is one of the toughest sports for autofocus because the kayakers are moving in such erratic patterns and are often blocked by water splashing about. In my experience, you need a top-end camera and pro-caliber lenses to get consistently tack-sharp images of kayaking. When it comes to action photography, having the best and fastest autofocus available is a big advantage. On the other hand, if you want to photograph rock climbers, who don't move that fast in general, autofocus speed isn't as huge of an issue.

If you add up all of the specifics for a decent adventure sports camera, you'll notice that a solid pro or semi-pro camera is a must if you really want to have flexibility out in the field. A tough 10–12MP camera with a fast framing rate of at least 5 fps and advanced autofocus isn't going to be cheap. Over the last several years, digital camera prices have dropped considerably and they will continue to do so but, as always, you get what you pay for. And in adventure photography, unlike many other genres, a faster camera sometimes does equate to better images.

Some images simply can't be captured without fast autofocus. In this picture, biker Ed Strang flew over me at about 45 mph (72 kph) while freeriding just outside Santa Fe, New Mexico. I could barely keep him in the frame so I had to trust that the autofocus would do its job and track with him.

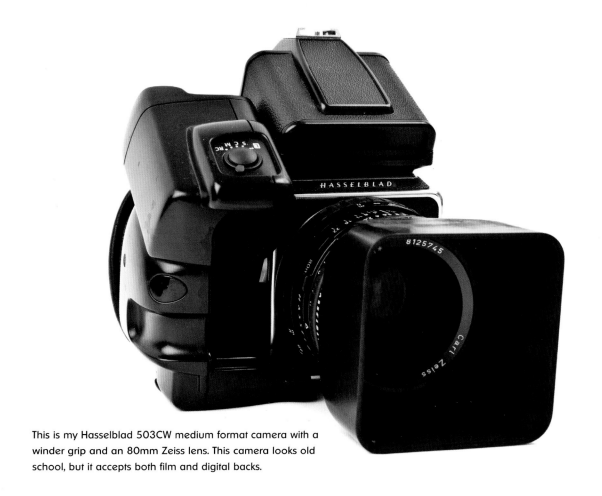

This is my Hasselblad 503CW medium format camera with a winder grip and an 80mm Zeiss lens. This camera looks old school, but it accepts both film and digital backs.

Now turning everything I just said on its head, sometimes I do shoot adventure sports with a medium format camera, which is much slower and has no autofocus. When working with medium format, I have thought through exactly the type of image I am looking for and often it is something like a figure in a landscape, a lifestyle image, or a portrait of an adventure athlete. In these instances, I'll use medium format because I want the shallow depth of field it provides (especially when shooting portraits) or because I need a higher resolution digital file. The beauty of medium format is you can shoot film or digital with the same camera. I still shoot some film with medium format when I want a specific look that is difficult to replicate with digital. When I have a high-end client that wants the higher resolution that medium format digital provides, I rent a digital back to fit my Hasselblad. In the end, it is all about choosing the right tool for the job.

Since this book is about creating better adventure images, I won't go in depth about point-and-shoot cameras. Certainly, there are some great point-and-shoots out there these days and many deliver amazing quality images, but because most lack the control or speed of a D-SLR, they are not ideal for action photography. There are certainly instances where a point-and-shoot will excel in the adventure world, such as in mountaineering where weight is paramount, or when wanting to grab snapshots while rock climbing a route. But to capture worthwhile images in this genre, making an investment in a decent D-SLR is key.

Full Frame vs. APS

There are many sensor sizes available for today's digital cameras. Canon alone has three different sensor sizes in their D-SLR range. Nikon has two. And Olympus has an even smaller sensor size (called four-thirds) that neither Nikon or Canon use. The full frame sensor versus a less-than-full frame sensor debate has been raging since Canon came out with the original "full-frame" EOS-1Ds back in 2002. A full frame sensor in a D-SLR is the same size as a piece of 35mm film (24 x 36mm). Most smaller-than-full frame sensors are considered APS size. (Nikon calls their smaller sensors the DX format.) In general, these sensors are about half the size of a full frame sensor and therefore create an effective focal length magnification factor of 1.5 or 1.6. This means that a 200mm lens on a full frame camera becomes a 300mm lens (200 x 1.5=300) when attached to an APS sensor camera.

There are advantages and disadvantages to both full frame and APS sensors. Let's take a quick look at both sensor types:

APS sensors: The obvious advantage to a smaller sensor is that your telephoto lenses have more reach than if you used them on a full frame camera. The disadvantage is your wide-angle lenses aren't so wide anymore. With a smaller sensor, you will also have more depth of field than you would with a full frame sensor. In general, images shot with APS size sensors have better edge-to-edge sharpness at any focal length than their full frame counterparts.

One of the other advantages of APS sensors is that they use a smaller slice of the image circle. This means they use the best part (the center) of a lens. So even if the lens isn't the best available, you are still using the best part of it and can get decent results.

Full frame sensors: The inverse of the lens pros and cons for APS size sensors holds true for full frame cameras. While you lose the lens magnification factor, full frame sensors are better for wide-angle photography. In terms of noise, larger photosites (or individual pixels) generally equate to less noise, so a full frame 12MP sensor will have much less noise than an APS 12MP sensor. Inversely, a full frame sensor allows for more resolution, or more megapixels, with the same amount of noise as a lower megapixel APS sensor. This means that a 24MP full frame sensor may have the same noise characteristics as a 12MP APS size chip.

Choosing a sensor: Now that you understand the advantages and disadvantages of the different sensor types, consider your needs. If you tend to shoot with more telephoto lenses and don't need super-low noise, then an APS size sensor may be the best route for you. If you need the least amount of noise at high ISOs (like ISO 6400) and tend to shoot a lot of wide-angle images, then a full frame camera is the way to go. Of course, since most of us shoot with wide-angle and telephoto lenses, it's nice to have two cameras—a full frame and an APS—and be able to choose the right tool for the job. That is why I shoot with both full frame and APS sensor cameras and use the appropriate one for each situation. In general, I keep a wide-angle lens on my full frame camera and a telephoto on my APS camera. If I were just starting out and couldn't afford both cameras, I'd choose the APS option as it would be cheaper and leave me some money to buy better lenses. And I would not purchase APS specific lenses so that in the future, if I did want to purchase a full frame camera, I wouldn't have to upgrade all of my lenses.

1. Apple MacBook Pro computer 2. Western Digital 320 GB Firewire/USB 2.0 Hard drive 3. Cord for Camera Battery Charger 4. Nikon camera battery chargers 5. Nikon EN-EL3 batteries for my full frame and APS Nikon cameras. Note that it is nice that both cameras share the same battery 6. Nikon D700 camera and MB-D10 battery grip which allows both of my cameras to shoot at 8 fps 7. Nikon D300 camera 8. Cell phone 9. Air blower for cleaning cameras, lenses, and sensor 10. Sandisk Firewire 800 card reader 11. AA Battery charger for rechargeable batteries (14) 12. Voice recorder for interviews and notes 13. Nikon D700 camera 14. Rechargeable AA batteries 15. Nikon SB-800 flash units with diffuser domes 16. Nikon EN-EL4a rechargeable battery for MB-D10 battery grip 17. Balance Smarter white balance exposure disc, which is used to set custom white balance settings 18. Walkie-Talkies 19. Cliff bar 20. Moleskine notebook 21. Headlamp 22. Nikon 10.5mm F/2.8 AF-DX lens 23. Nikon 85mm f/1.8 AFD lens 24. Minolta IV-F light and flash meter 25. Nikon 24mm f/2.8 AFD lens 26. Nikon AF-S 14-24mm f/2.8 lens 27. Nikon AF-S 24-70mm f/2.8 lens

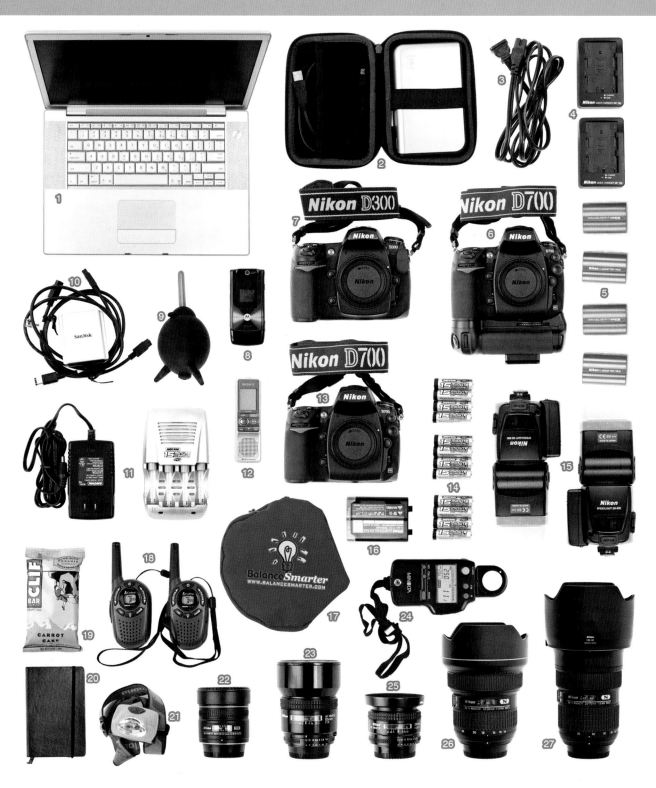

28. Visible Dust Brushes for Cleaning digital sensors 29. Connection and charging cords for Epson P-2000 30. Epson P-2000 Storage device 31. Extra batteries for Epson P-2000 32. Think Tank Memory Card wallet 33. Kirk Photo BH-1 ball head and Gitzo 1340 tripod 34. Lenspen and lens cleaning cloth 35. X-Rite ColorChecker color chart 36. Think Tank Memory Card wallet with SanDisk Extreme III and IV Compact Flash cards in 2, 4, and 8GB sizes 37. X-Rite i1 Display 2 monitor calibration device 38. Plug adapters for foreign countries and allen wrenches for removing arca-swiss tripod adapter plates 39. Bogen Monopod 40. Hasselblad 503CW medium format camera 41. Compass 42. Property and model releases 43. Batteries for Hasselblad motor drive grip 44. Pocket Wizard radio slaves for use with flash, strobes, and remote camera work 45. Nikon 300mm f/4.0 AFD lens 46. Nikon AF-S 70-200mm f/2.8 VR lens 47. Slik clamp head for mounting a camera on any cylindrical or square surface (e.g. a mountain bike) 48. Sharpie and pen for notes 49. Water bottle

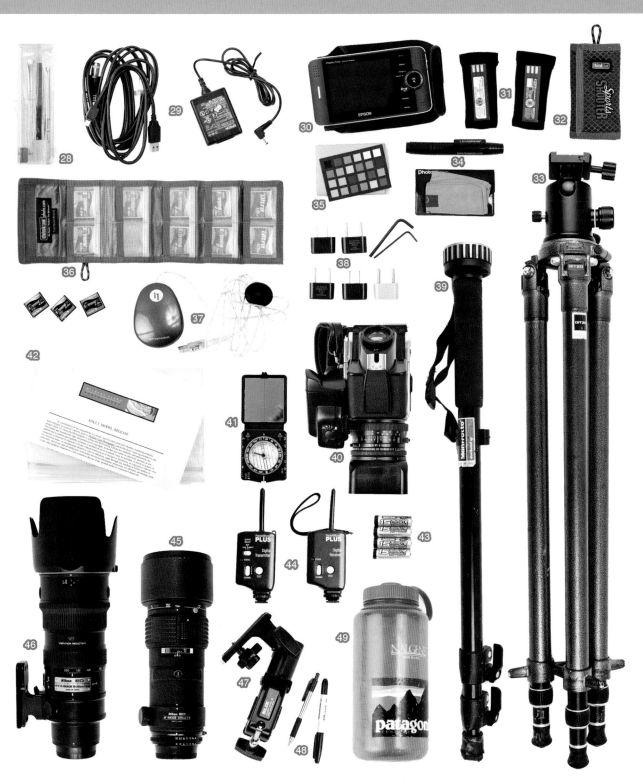

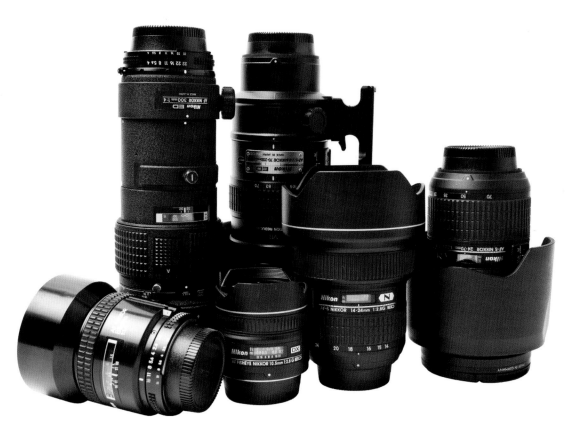

Lenses are just as important as the camera body. If you don't purchase high-quality lenses, it will unfortunately show in your images. My five main working lenses seen here are: a 10.5mm F/2.8 AF-DX Fisheye, a 85mm f/1.8 AFD, an AF-S 14-24mm f/2.8, an AF-S 24-70mm f/2.8, an AF-S 70-200mm f/2.8 VR, and a 300mm f/4.0 AFD.

LENSES

Lenses are the eyes through which your camera sees. A cheap lens is like buying a pair of $5 reading glasses at the local five and dime when you really need to go to the optometrist and get a prescription. Maybe that analogy is an overstatement, but the point is clear: lenses are every bit as important to the final image as the camera. My advice is to buy the best lenses you can afford. If you are serious about your photography or working towards becoming a professional, then it is time to plunk down that credit card and go for the good stuff.

Just as with digital cameras, there are advantages and disadvantages to certain lenses. A fast lens, meaning a lens with a large aperture of f/2.8 down to f/1.4, tends to be larger and heavier than an f/4 lens. Fixed focal length lenses tend to be smaller and lighter than comparable zoom lenses; however, they are not as versatile and these days modern top-end zoom lenses are every bit as sharp as their fixed focal length cousins. I would avoid an 18–200mm all-in-one zoom lens, as the extreme focal length range compromises the lens design. I would also avoid lenses with variable apertures like f/3.5–5.6. Instead, I recommend three zoom lenses as standard for adventure photography: a 17-35mm f/2.8 (or possibly a 14–24mm f/2.8), a 24–70mm f/2.8, and a 70–200mm f/2.8. These three lenses are my standard kit for just about any assignment. If you can't afford the f/2.8 lenses, then drop down to the f/4 equivalents. I highly recommend sticking with your camera manufacturer's lenses. There are a few good deals out there from other lens companies, but in general these lenses are not as durable or as sharp and many have lackluster autofocus performance when compared with lenses from Nikon and Canon.

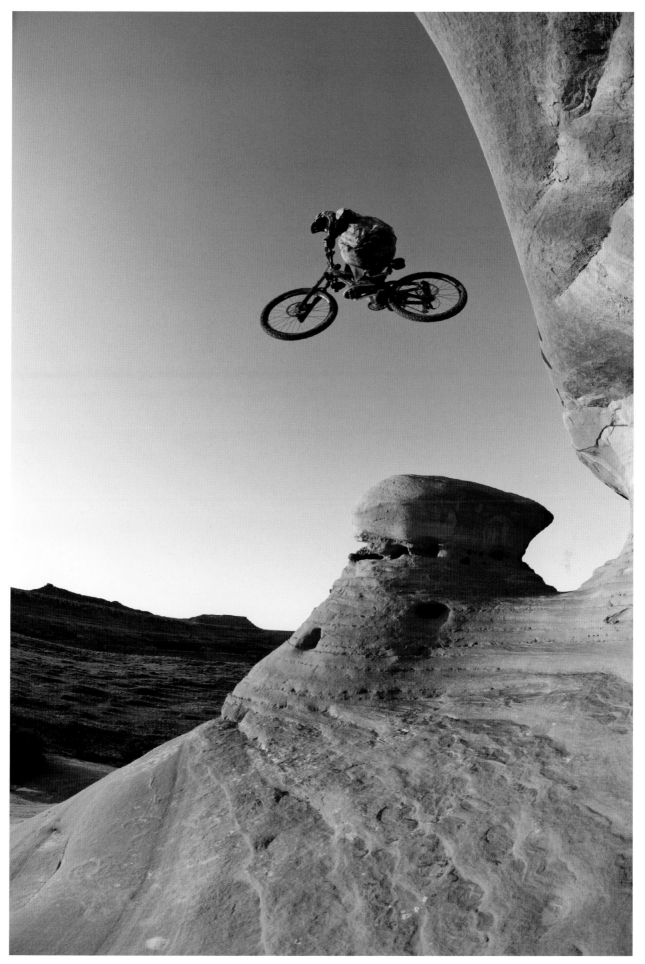

This image of Ryon Reed jumping off the Mushroom near Moab, Utah, was shot with a 10.5mm fisheye lens.

Another factor when considering lenses is how well a lens works with the autofocus of your camera. This is not to be overlooked. A sharp lens with even slightly slow auto focus will result in a lot of soft images when shooting at 8 fps. In my experience, lenses that have autofocus motors built-in to the lens are much faster than the screw-type AF lenses. Nikon's lenses with motors inside have an AF-S designation in the lens name and Canon's have a USM designation.

Beyond the basic kit, there are a handful of lenses that certainly help capture unique images. It is nice to have a super-wide fisheye lens (10.5mm for APS sensors and 15mm or 16mm for full frame), a couple of fast fixed focal length lenses, and a longer telephoto lens, depending on your subject matter. The fisheye has been my "secret weapon" lens for years, especially when it comes to skiing and mountain biking photography. A few of my favorite prime lenses are the 50mm f/1.4 and the 85mm f/1.8, which are great for low-light situations or for shallow depth of field. A 300mm f/4 is a lightweight, versatile adventure lens. If you are a surfing photographer, then you'll need both a fisheye and a 600mm. Another popular lens in the adventure genre is a 24mm or 90mm tilt shift lens. These lenses allow the photographer to manipulate the plane of focus in an image and they have recently come back into fashion. This list might seem overwhelming, but we'll get into the specific gear needed for each sport in Chapter 5.

Last but not least, a word about filters. I have filters on every one of my lenses to protect the front element. For an adventure photographer, using filters to protect lenses is paramount because cameras and lenses are constantly being banged around and subjected to snow, wind, and rain. If you want the best image quality for your high-resolution camera, you are going to have to pony up for the best filters you can find. I recommend B+W or Nikon filters, both of which are made with high-grade glass and have micro-coatings to reduce flare. All of my lenses have B+W brand UV-Haze filters on them to protect the front element. With digital, there is less of a need for filters than there used to be with film. I still carry a circular polarizing filter with me to cut reflections, but getting more saturated colors can now be done in post-production. Other useful filters are split-graduated neutral density filters for landscape photography or a straight neutral density filter to cut the light intensity so a slower shutter speed can be used. Other than these filters, everything else can pretty much be done in post-production these days, which makes life easier out in the field.

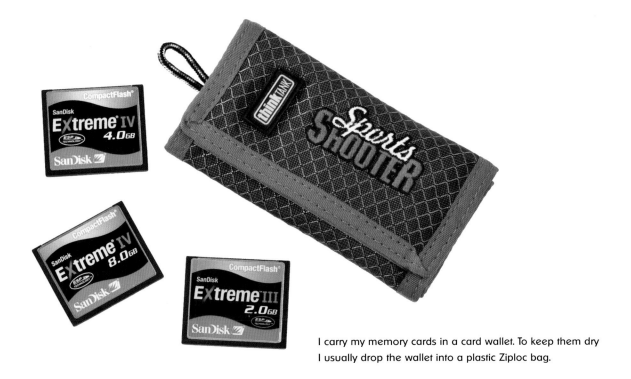

I carry my memory cards in a card wallet. To keep them dry I usually drop the wallet into a plastic Ziploc bag.

MEMORY CARDS

Memory cards are basically digital film. They store your images and act as the go-between from the camera to the computer. Not all memory cards are equal. This is another item where you want to buy the right tool for the job. As of this writing, a CompactFlash card is one of the most stable forms of storage available. It can survive the washing machine and some serious abuse and still retain information. But small things that are seemingly harmless, like deleting massive numbers of images off a card while it is still in the camera, can affect the cards more severely.

If one of your cards becomes corrupted, image data may be destroyed. Always format your memory card in the camera that it will be used in. Never erase or delete images on the card with a computer. The average PC or Apple computer uses different software that will sometimes be loaded onto the card and cause problems. Also, always turn off the camera before inserting or removing the memory card. And while shooting, it is best not to fill the card up completely as images can become corrupted. This isn't a hard and fast rule, but a good one to follow to prevent issues.

I recently spoke with a tech advisor for Lexar; he told me that it is rarely the case that all data is lost unless the actual card is lost. In most cases, 70-95% of image data can be recovered from a corrupted card and, surprisingly, even from a card that is broken. He told me a story about a photographer who accidentally smashed a card into three pieces. After sending it back to Lexar, all but three or four of the images from the card were recovered. Even in light of this good fortune, I recommend choosing the card size you need for your average job and not going any larger. For example, if you are an underwater photographer and shoot with a 12MP

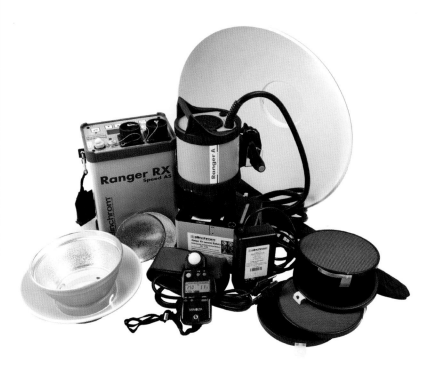

My basic lighting kit includes an Elinchrom Ranger RX battery powered setup, a light meter, and various light modifiers.

camera, a 12GB or 16GB card makes a lot of sense because you won't be able to change cards during the shoot. If you have a 6MP camera and use it only for snapshots, then 1GB cards may be all that you really need. For my work using 12 MP cameras, I use SanDisk 4GB cards because I can get approximately 200 14-bit RAW images per card. With 2GB cards I would have to change them out a little too often for my work (where I am usually hanging from a rope), and 16GB seems a little too large if I were to drop or lose a card somehow. In reality, it all comes down to personal preference.

When choosing memory cards, I recommend visiting Rob Galbraith's website at www.robgalbraith.com. He has done testing with most of the major D-SLRs to see which cards write the fastest with each camera. As this can be a huge issue, especially for sports photographers, I would recommend that you check his site and purchase a card that works well with your camera.

FLASHES

Flash photography has made some great advances alongside digital technology, particularly in the form of small, powerful accessory flash units. As a Nikon shooter, the SB800 and SB900 Speedlights are about as good as it gets. Canon has a similar accessory flash system, which is very good as well. The Speedlight technology is one of Nikon's great strengths and allows me to carry a couple of small but quite powerful flashes in the field that all work wirelessly with the pop-up flash on my cameras. In general, I find using the pop-up flash on my cameras to be very lackluster. The flash has limited power and it is way too small of a light source to create a pleasing image; besides those limitations, it is too close to the camera. Of course, accessory units are only so powerful, so when I need more "umph" I turn to battery-operated strobes like the 1100 watt/second Elinchrom Ranger RX series. These larger, battery-powered flashes are a great tool for adventure photography. In recent years there has been an explosion of new power packs that can blast up to 1200 watt/seconds of light in any location. These setups aren't exactly light since they weigh anywhere from 18- to 30-plus pounds (8 to 14 kg), and they are certainly not inexpensive, but they work extremely well for certain situations.

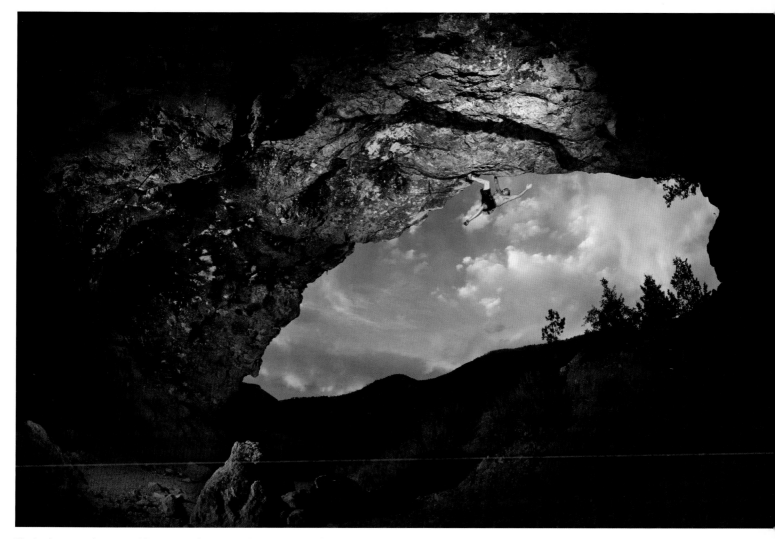

Flash photography can add an extra dimensionality to your work, as seen in this image of rock climber Timy Fairfield hanging from the lip of the Crystal Cave in New Mexico. I used two strobes and a fisheye lens at sunset, and it took about ten minutes for me and an assistant to tweak the lighting and dial everything in. Each flash head had a 30° grid spot on it to focus the light just where I wanted it.

Flash photography is now a standard in adventure images. Using artificial light creatively can take a decent photo and make it an outstanding one. The image above is an excellent example. By balancing the light inside the cave with the magic hour light hitting the clouds outside the cave, a very striking image was created. In this case, it is obvious that a strobe was used, but it does not overpower the image. The flipside to using power packs is that they slow down the entire process because they are heavy and require some setting up in addition to test firing them so you can dial in the exposure. My assistant and I lugged over two hundred pounds (91 kg) of gear up into the cave to get this shot.

Throughout this book, I'll point out how artificial light was used to make certain images and I'll describe the setup involved. Lighting is a complicated photography topic, but the good news is that with digital you get an instant preview with the push of the button so experimentation is encouraged. In Chapter 4, we will dive into the nuances of lighting, the best and most appropriate gear options available for the adventure photographer, and some lighting fundamentals.

CAMERA BAGS

A bevy of camera bags is essential for adventure photography. In my gear closet right now, I have at least a dozen different camera bags and a few assorted lens cases, all made by Lowepro. Each one serves a different purpose and works for a specific sport. Usually, the camera bag is the only thing between your camera and the elements, so take great care in choosing a good one. I prefer the Lowepro bags because they seem to be the most rugged and well designed bags on the market. Their all-weather (AW) system, which is basically a coated nylon flap that can be pulled over the entire camera bag, is a huge bonus in wet or dusty locations.

I use everything from a large backpack, like the Lowepro Vertex 300 AW, down to a chest pouch. Since my gear for assignments is usually big and heavy, the fully loaded backpack almost never gets further than the hotel room or the back of my car. I generally use it to get the gear to my location and then break down what I need for a shoot into smaller and more portable bags. I'll go

into more detail about which bags I have found to work best for each adventure sport later in the book, when I cover many sports in detail.

I also have several hard-shell waterproof Pelican cases for my lighting kits and for those times when I need extra protection for my gear, as when I am on a river trip or just want to make sure my laptop doesn't get destroyed. The Pelican cases are pretty much indestructible in my experience, but they are also a bit on the heavy side. Flying with them is costly but they do protect my gear better than anything else I've found. And when you have a $10,000 lighting kit that needs to get to Patagonia and back in one piece, an overweight baggage fee is a small price to pay.

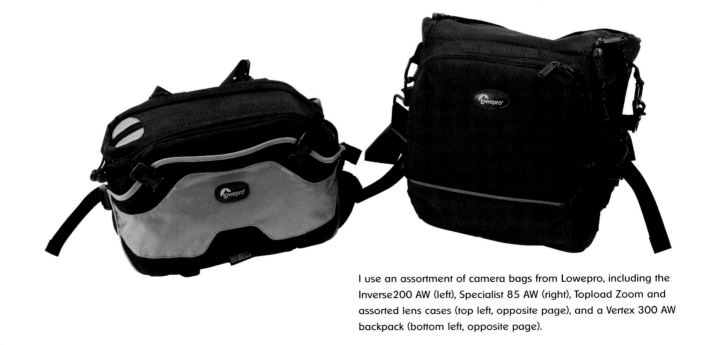

I use an assortment of camera bags from Lowepro, including the Inverse200 AW (left), Specialist 85 AW (right), Topload Zoom and assorted lens cases (top left, opposite page), and a Vertex 300 AW backpack (bottom left, opposite page).

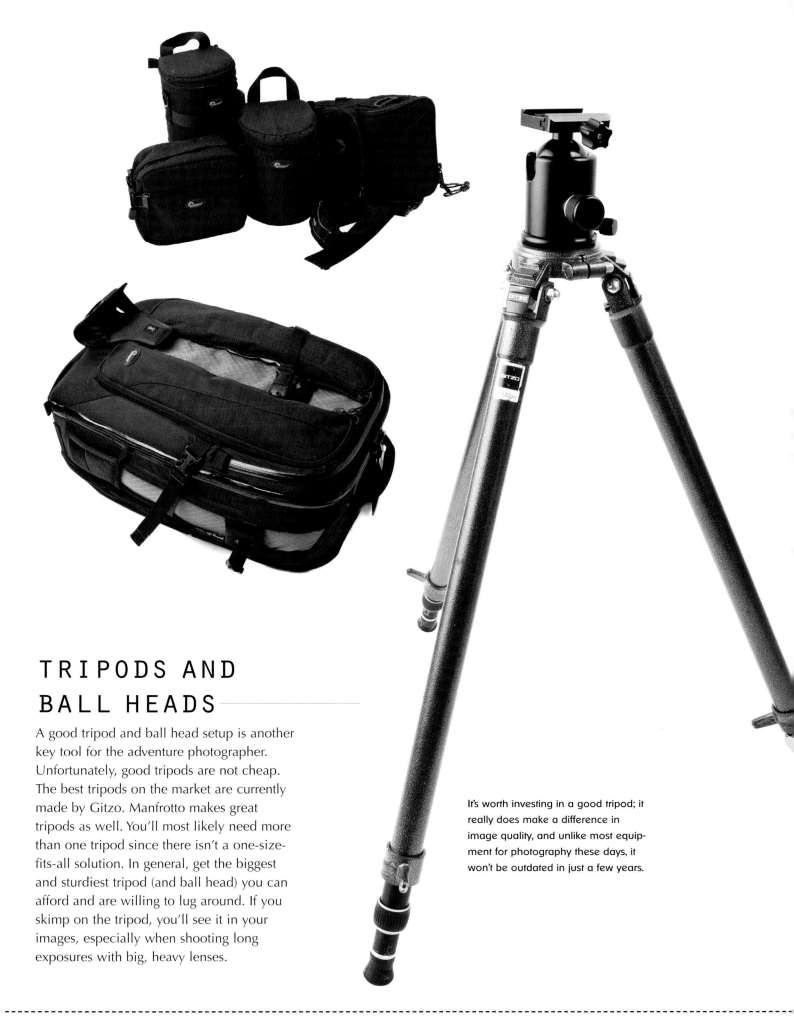

TRIPODS AND BALL HEADS

A good tripod and ball head setup is another key tool for the adventure photographer. Unfortunately, good tripods are not cheap. The best tripods on the market are currently made by Gitzo. Manfrotto makes great tripods as well. You'll most likely need more than one tripod since there isn't a one-size-fits-all solution. In general, get the biggest and sturdiest tripod (and ball head) you can afford and are willing to lug around. If you skimp on the tripod, you'll see it in your images, especially when shooting long exposures with big, heavy lenses.

It's worth investing in a good tripod; it really does make a difference in image quality, and unlike most equipment for photography these days, it won't be outdated in just a few years.

You don't necessarily need the top-end carbon fiber whisper-light rig, but if you can afford one, you might actually take it with you more often. I have two setups: one is a super-lightweight Gitzo carbon fiber rig with a custom-made lightweight BH-3 ball head from Kirk Enterprises, and the second is my old standby aluminum Gitzo 1340 with a heavy-duty Kirk BH-1 ball head. When I am shooting landscapes, portraits, or assignments close to the road and don't have to hike more than a few miles, I take the heavier tripod setup. I'll also take the heavy setup when I am shooting with really big lenses like a 200–400mm or 600mm lens. On shoots where I will be hiking far into the backcountry and know I'll need a lightweight rig, I take the carbon fiber setup. With the lighter setup, I realize that I can't put a large lens on it and expect to get tack sharp images, especially if it is windy. It does have a hook on the center column that allows me to add weight and stabilize the tripod with my camera pack, which certainly helps. In general, my lightweight setup can deal with lenses up to 200mm; anything beyond that is pushing it.

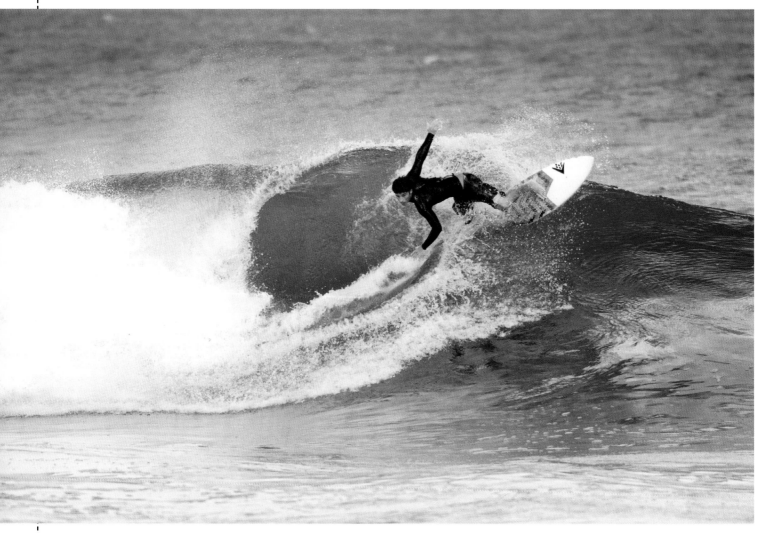

I shot this surfer at Rocky Point on Oahu with an AF-S 200-400mm f/4 Nikkor lens and my heavyweight Gitzo tripod setup.

I recommend ball heads over the standard tripod heads because they are faster and more user friendly. I would also recommend that you invest in Arca-Swiss type adapters and mounting plates. These plates lock the camera to the tripod in two easy steps by sliding the plate (which is attached to the camera) into the tripod head and locking a clamp, which secures the camera plate to the ball head. There are three brands of ball heads I recommend: Kirk Enterprises, Really Right Stuff, and Gitzo. Of these three, the Kirk and Really Right Stuff ball heads are my favorites. You pretty much can't go wrong with any of the products they make—you'll just need to figure out which one will work best for your needs. A tripod can radically improve your photography, not only by helping you make sharper images, but also because it forces you to slow down and look around. And the nice thing about a good tripod and ball head is that they will basically last forever and won't need to be replaced anytime soon.

PORTABLE STORAGE DEVICES

When it comes to storage devices, there are two common types: regular hard drives and portable storage devices made specifically for photographers. These portable hard drives have CompactFlash and Secure Digital card slots built into the hard drive so that a memory card can be inserted into the device and downloaded directly. Usually the device also has an LCD screen where you can view the images or, at the very least, the file names to make sure you've downloaded the images. The options vary greatly in price, capacity, and LCD quality.

I use an older Epson P2000 with a 40GB hard drive and a newer Hyperdrive Colorspace O with a 320 GB hard drive. The older Epson has a much nicer LCD screen than the Hyperdrive, but the battery life and hard drive capacity on the Epson can't match the Hyperdrive. Epson has some newer models that are beautiful, but the battery life still pales in comparison to the Hyperdrives and they cost almost twice as much for half the storage space. Jobo also makes a very nice storage device for photographers called the Giga Vu extreme, but as with the Epson, the battery life is limited.

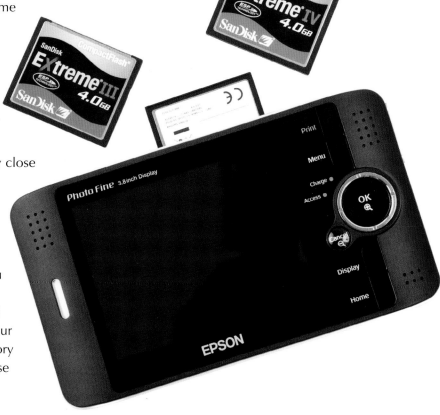

Why would you need one of these? If you stay close to home or a power source, then you can just download your images onto normal hard drives. But if you are out in the backcountry for extended periods of time without a laptop and don't have 50GB of memory cards, these devices will allow you to download your memory cards so you can keep shooting. One thing to keep in mind is that these devices are still hard drives and all hard drives fail sooner or later. So be careful trusting your images to one device and then erasing your memory cards. In general, I normally carry only one of these

devices with me in the field. Once I have filled up a CompactFlash card, I download it to my Hyperdrive. I then put the used memory card into my card wallet (facing backwards) so the images are instantly backed up in two places. I have a healthy 70GB of CompactFlash cards that can get me through a few days or even a week without having to erase any of the cards. If I know I'll be shooting more than 50GB of images, then I'll take the Epson and the Hyperdrive and back up my cards to both devices before I erase the memory cards.

COMPUTERS AND HARD DRIVES

Of course, with digital photography you'll also need a computer to deal with your images; in most cases, you'll need not only a fast desktop machine, but also a nice laptop. So just in case you were thinking digital was "free" since you can shoot as much as you want and not have to pay for film and processing, think again. For the amateur, going digital might end up being cheaper in the long run, but for the pro or advanced amateur, digital is much more expensive than film ever was due to the cost of constantly upgrading expensive equipment. C'est la vie.

I won't get too deep into the computer tech specs here. Suffice it to say that you'll need the fastest computer you can afford. If you have to skimp on anything, then let it be processor speed and spend your money on RAM. I'd recommend at the very least 2GB of RAM minimum (as of this writing), but 4GB or more is even better, especially if you use Adobe Photoshop Lightroom or Apple Aperture. With today's digital cameras, computers are working harder than ever to keep up with the large file sizes and the image editing software.

I use Apple computers and have for the last 20 years or so, even when I was a physicist, so obviously I am a bit biased. For the home office I'd recommend an all-in-one combo (like the Apple iMac) or a tower and monitor set up. I have a Mac Pro and Apple Cinema Display in my office and it is about as fast as computers get these days. For a laptop I have an Apple Macbook Pro. For my work, the laptop is not as critical as the main imaging machine in my office because I rarely, if ever, process my RAW digital images on the laptop. The reason I don't use the laptop to process images is because the monitor on the laptop can't be calibrated and profiled as accurately as my Apple Cinema Display. In general, I would not recommend using a laptop to work up your images if you care about color accuracy. On that topic, calibrating and profiling your monitor with a monitor calibration device (like a ColorMunki or X-Rite i1 Display 2) is key to everything you do with your

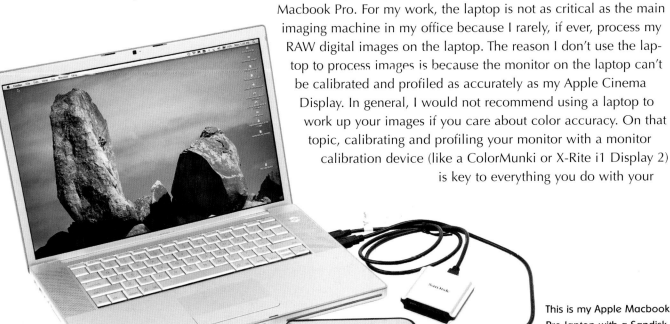

This is my Apple Macbook Pro laptop with a Sandisk Firewire card reader and Western Digital 320GB mini hard drive attached.

digital images. If you are not profiling your monitor, then you don't need to waste your time adjusting your images because you have no reference as to how you are adjusting them.

And don't forget about software. You'll need at least some basic image editing software like Adobe Photoshop Lightroom or Apple Aperture to process your image files. And more likely than not, you'll also need Adobe Photoshop to finish off the job. I vastly prefer Adobe Photoshop Lightroom to Apple's Aperture. Aperture is a great program, but I find Lightroom to be much more intuitive and powerful, especially in combination with Photoshop.

Hard drives are another huge topic in terms of storing your images. There are a bewildering array of options available, but the good news is that hard drives are getting cheaper all the time. I would highly recommend backing up your images (and all your important information) in at least three places. I have everything backed up on at least three hard drives and one of those hard drives is kept off-site just in case a natural disaster occurs at the office.

Digital cameras aren't the only expense in modern photography. You'll also need a capable computer and photo software like Adobe's Photoshop and Lightroom.

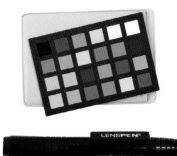

A few standard accessories (from left to right): Pocket wizard radio transceiver, Balance Smarter white balance disc, Lenspen, lens cleaning cloth, Visible Dust sensor cleaning brush and a Sandisk CompactFlash card reader.

ACCESSORIES

It is a great time to be a camera manufacturer because there are so many accessories to go along with your digital camera that your wallet will be crying "Uncle" in no time. At the very least, you'll need a handful of memory cards, something to deal with dust on your sensor, and a camera bag. Other accessories that will come in handy include a lens cleaning kit, lens hoods, remote camera triggers, multiple flashes, white balance cards (for setting a custom or preset white balance), a memory card case, and Arca-Swiss style mounting plates to attach your camera to your spiffy ball head. This list doesn't even include all of the accessories you might want or need for your computer. As one of my good friends often says, "What's the best way to make a million dollars as a photographer? Start out with two million!"

As for batteries, I normally carry at least two spares per camera on extended trips so I will not run out of power in the backcountry. Battery chargers go with me on assignments, but not into remote areas unless I have access to electricity. For assignments in foreign countries, I take several power adapters so I can charge multiple batteries at the same time.

WORKFLOW

In the digital realm, a complete workflow from start to finish is a must if you want to get the best image quality out of your digital camera. My philosophy on digital workflow is "garbage in, garbage out." What I mean by this is that a solid workflow starts in the camera. How you capture the image affects the outcome just as much as how you process the image. The reverse holds true as well; how the image is going to be processed also affects how the image needs to be captured. This might sound like a dog chasing his tail—and in some regards it is just that—but understanding the digital process is going to take some time and effort for the best results.

Since I started as a film photographer, it took me six to eight months before I felt comfortable shooting with digital, so don't underestimate the complexity of the digital process. Shooting with digital and doing it well is very complex and the minute details make a huge difference in the final image quality. Exposing for digital, managing your histograms, and processing your RAW image files takes considerably more time than just dropping the film off at the lab. I highly recommend taking the time to learn a complete workflow. Since this book does not cover digital workflow in-depth, I recommend that you check out one of the many excellent books on digital workflow, or my 124-page e-book, Adobe Photoshop Lightroom: A Professional Photographer's Workflow, which is available on my website (www.michaelclarkphoto.com) and covers my entire digital workflow, starting in the camera and covering every step to a finished image.

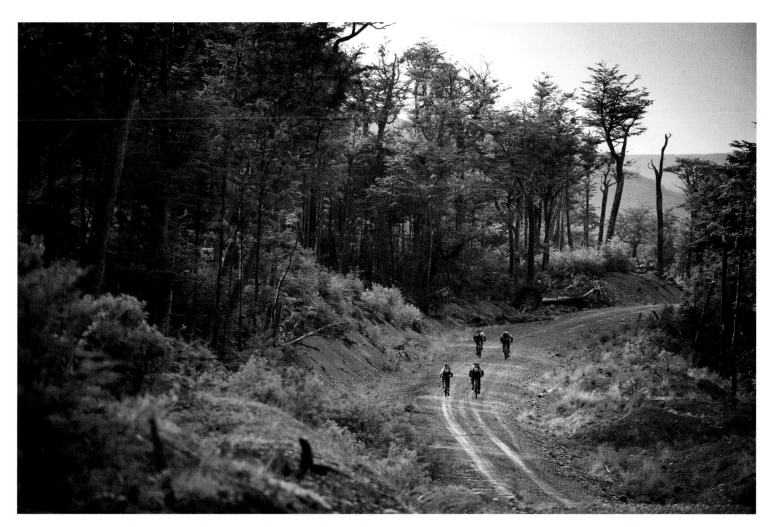

Shot from afar, this image of Team Helly Hansen-Prunesco mountain biking during the 5th stage of the 2009 Wenger Patagonian Expedition Race was converted to black and white in Adobe Lightroom.

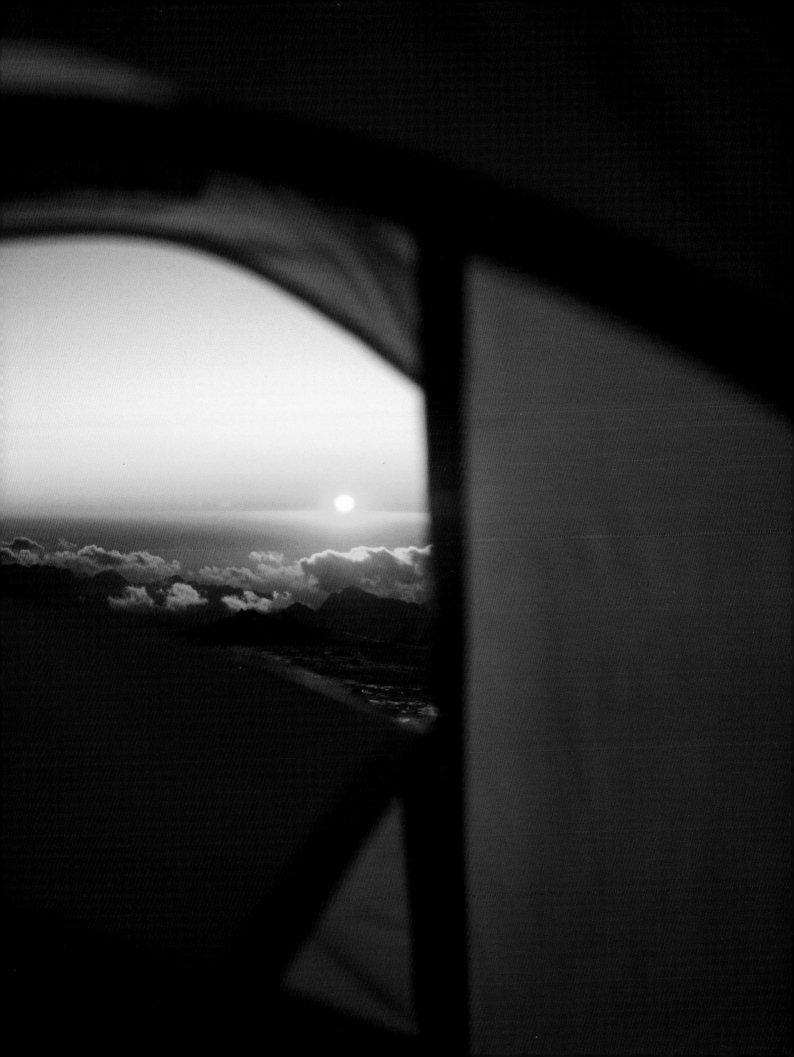

There are many times in the adventure sports photography genre when shooting images seems like the easy part. Packing and preparing for adventures and traveling, getting to the location, and often roping up to get into position can all be hard work. Add to this the need to be savvy about athletes' safety as well as your own, model and property releases, and managing risk, and it quickly becomes obvious that there's a lot more to this genre than just pushing the shutter button. Here we'll cover the outdoor equipment it's useful to own, how to prepare for local and international adventures, and important legal considerations you'll want to know before stepping out the front door.

OUTDOOR EQUIPMENT

In addition to the requisite photographic equipment, the adventure genre requires a certain amount of outdoor gear so that you can deal with the elements on location, safely get into position, and hang with the athletes. Sadly for your wallet, if you are not already a climber, surfer, kayaker, or mountain biker, this gear (depending on the sport you shoot) is quite expensive. Don't underestimate the importance of outdoor gear, as it might very well be the deciding factor in getting the shot or not; how comfortable you are in the outdoors can affect the quality of your images drastically. If your harness is cutting into your legs, you won't be able to concentrate on the images. Likewise, if you are shivering so much you can't keep your camera steady because you didn't shell out for a down jacket, your images will be worse for it.

Most folks that are interested in photographing adventure sports are probably experienced in the outdoors on some level and will have a lot of gear already. That being the case, what follows are some general recommendations for outdoor clothing and equipment. Entire books are available on outfitting and preparing yourself for the outdoors; if needed, consult one of them or take a basic guided course like those offered through Outward Bound or NOLS. Since you'll often be carrying both your photo equipment and outdoor gear, I highly recommend the "light is right" ethic. When looking for outdoor gear, buy the lightest option that you can afford which is the most appropriate for the situation.

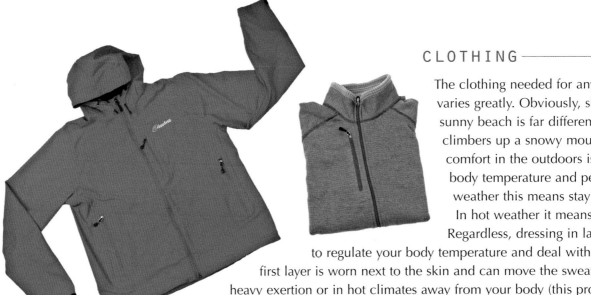

CLOTHING

The clothing needed for any outdoor endeavor varies greatly. Obviously, shooting surfers on a sunny beach is far different than following climbers up a snowy mountain. The key to comfort in the outdoors is controlling your body temperature and perspiration. In cold weather this means staying dry and warm. In hot weather it means staying cool. Regardless, dressing in layers is the best way to regulate your body temperature and deal with the elements. The first layer is worn next to the skin and can move the sweat produced during heavy exertion or in hot climates away from your body (this process is called "wicking"). Patagonia's Capeline has long been the standard for base layers, but there

are many outdoor companies making a variety of high quality base layers in a variety of weights and materials. The second layer is normally insulation, like a fleece or down jacket, and the third layer (if needed) is some kind of outer shell, like a soft shell or Gore-Tex jacket that protects you from snow, rain, and wind. Depending on the situation, one would wear only the first layer in warmer climates or when putting out a lot of effort in cold climates and additional layers would be added as needed. In cold climates, it is paramount to have an insulating layer to put on when you stop to rest, or your sweat will make you very cold. This layering technique applies for both your upper and lower body, though most people won't need as much insulation for their legs.

I highly recommend synthetic or wool fabrics for all of your outdoor clothing and avoiding cotton clothing since it absorbs water, takes forever to dry, and has no insulating properties when wet. Buy the best gear you can afford and stick with reputable brand names that have solid warranties. Patagonia in particular has one of the best warranties in the business. You'll also find that smaller niche companies often produce the best gear. If you want the best outdoor clothing on the planet, then plunk down the cash for anything made by Arc'teryx. Also, don't forget about all those little accessories like gloves, hats, sunglasses, and good socks. These items will make a big difference in your comfort.

Sometimes all it takes to get to a location is a lightweight pair of approach shoes.

FOOTWEAR

Your choice of footwear will obviously depend on which sport you are shooting. Solid shoes will help you get into location quickly, safely, and comfortably for the best images. You'll have to make judgment calls on your footwear depending on a number of factors, like location, distance of the hike, pack weight, and weather. In general, the heavier the pack you are carrying, the more supportive the shoe or boot you'll need. The flipside is that a heavier boot will be more fatiguing than a lighter one, so again keep the "light is right" mantra in mind.

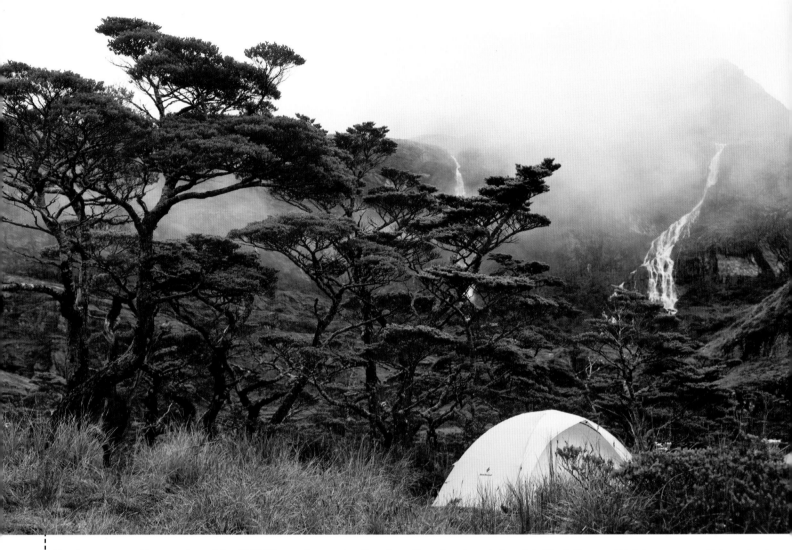

For this remote trekking section of the 2009 Wenger Patagonian Expedition Race, I took my lightweight Black Diamond Lighthouse tent, which survived non-stop rain and horrible conditions quite well.

SHELTER

Adventure photographers often find themselves camping in the backcountry, so a tent will be a key piece of outdoor gear. There are a large variety of tents out there to choose from and what you need will depend on the type of environments you'll be working in. Since most of us can't afford multiple tents, I would suggest choosing a tent for the worst conditions you expect to encounter. If you can afford a lightweight rig and a full-on mountaineering tent, then do so by all means. In my experience, three-season tents just aren't up to the job, so if you can afford only one tent, go with a four-season tent that won't let you down. In this category, look for a model with good ventilation in rainy and snowy conditions. I own a Black Diamond Fitzroy and a Black Diamond Lighthouse, both of which are lightweight, four-season single-wall tents.

If you are choosing a tent for mountaineering or winter camping, make sure you get something that is roomy, can stand up to high winds, and can deal with a heavy snow load. Finally, consider the tent color. This is a small consideration, but for expeditions where you spend a lot of time in the tent, a dark blue color isn't going to help your psyche. I prefer bright colors like yellow or green that help keep the spirits up.

BACKPACKS

Backpacks are like camera bags—no one backpack will work for every situation. Just as you have a selection of camera bags for specific adventures, you'll most likely have at least a few packs for shorter and longer adventures, depending on the outdoor sports you photograph. Again, there are a bewildering number of options when it comes to backpacks, and some adventure photographers will need an outdoor-type backpack while others won't. If you shoot surfing, BMX, or even skiing, you may only need a photo backpack, which will work better for carrying your camera gear.

As with all outdoor gear, find a pack that fits you and your needs and keep the weight in mind. I'd suggest, at the very minimum, two packs: a large daypack in the 40- to 50-liter range and a larger "expedition" pack for really big loads in the 80- to 100-liter range. For the larger pack, choose a brand that has a solid reputation and a decent suspension system so carrying the load is comfortable—Arc'teryx, Gregory, and Osprey are just a few of the top pack makers that I recommend. Seek out knowledgeable staff at a local outdoor store and have them fit you for a pack.

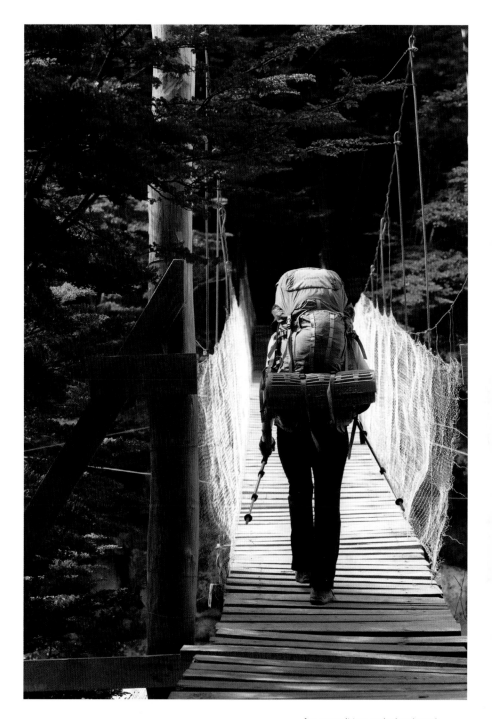

I have a few large expedition packs, one from Gregory and an older Dana Designs model, and I have often loaded them up with 800 feet (244 m) of static rope, bivy gear, and basic camera gear, resulting in a total weight of 120 pounds (54 kg). Imagine hoofing that load to the top of a big wall like El Cap in Yosemite or the Moonlight Buttress in Zion National Park and you'll start to understand just how important it is to get a solid pack with a good suspension system.

An expedition style backpack is the ticket for longer trips and getting a serious amount of photo gear to the location. A good pair of trekking poles will also help save your knees and add stability for really heavy packs.

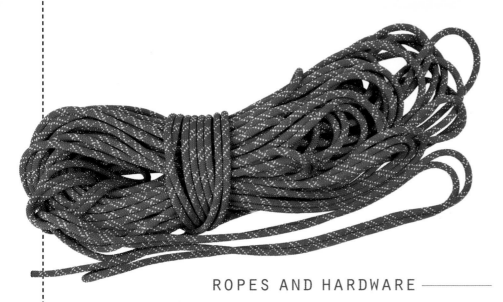

ROPES AND HARDWARE ————————

Outdoor photographers are always looking for new angles to shoot from. Finding a striking angle often leads to an incredible image. If you have the ability to shoot from 360° around your subject, this gives your images an edge over other photographers. The best way to get different angles is with ropes and climbing gear. No matter what sport you photograph, I'd highly recommend that you spend some time at the local climbing gym learning rope management and how the hardware works so you can use them to produce images from unique angles.

Here is a list of the climbing gear in my standard kit when I rope up:

Rope: For photographers, a static rope (a rope that doesn't stretch) is usually a much better choice than a dynamic climbing rope (a rope that stretches to absorb energy from falling climbers, thus softening the fall). Ropes can be used for ascending, rappelling, and traversing (see page 42). In terms of length, I prefer 60- or 70-meter ropes since the longer length gives me more options when it comes to setting up.

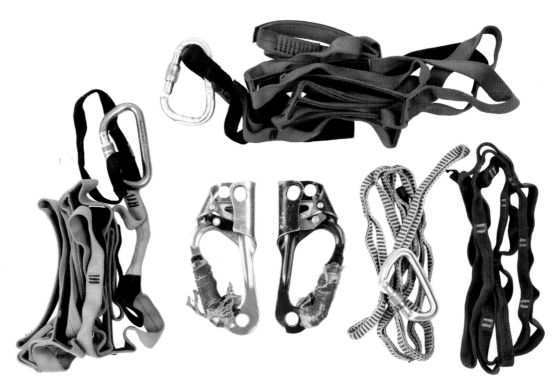

Tools of the trade: a 60-meter static rope (top) and my standard kit for ascending ropes, including ascenders, aiders, daisy chains, and a few locking carabiners.

Traditional climbing gear consists of camming devices, chocks, hexes, and other miscellaneous gear needed to build anchors and protect a fall while climbing.

A good harness: Find one that is comfortable for sitting in all day that has lots of gear loops. A few manufacturers make "big wall" harnesses, which have a thicker waist belt and wider leg loops, making them more comfortable.

Slings, webbing, and cordelettes: These help in setting up anchors and are useful for securing yourself once you do get into position, or for pulling yourself into the wall on overhanging cliffs.

Ascenders and Aiders: These are used to climb up the rope once it's set up.

Belay device: This piece of gear creates friction on the rope and is used for belaying another climber or rappelling.

Carabiners: Bring lots of them, both locking and non-locking—use an extra carabiner and sling to secure your camera just in case you happen to drop it. Clip one side of the sling to your camera strap and the other to your harness' belay loop. Always use locking carabiners on your anchors, belay device, or ascenders.

Traditional climbing gear: If I know I'll be setting up an anchor in rock and there are no pre-existing bolts, I bring along what is known as traditional climbing protection (consisting of chocks, hexes, and camming devices) to build the anchor.

Helmet: A helmet is always a good idea, but I usually only wear one when photographing longer routes or big walls.

Kneepads: One of the key items I always take with me when I work on ropes is a pair of kneepads with a hard outer surface. Knee pads are indispensable for saving your clothing and protecting your knees.

Please note that I am being fairly basic here with my descriptions of this equipment and how to use it. Learning how to use ropes and climbing gear for ascending and rappelling is not something you should learn out of a book. Seek out expert advice and be cautious.

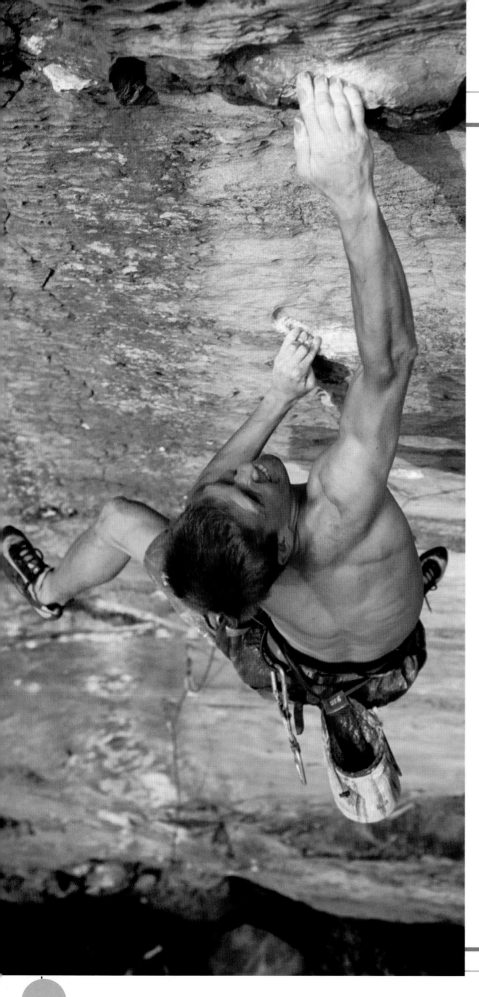

Roping Up for High-Angle Photography

A static climbing rope can put you in position for great shots of your outdoor athletes. Even if you're shooting non-climbing related sports, getting unique angles can only improve your images by giving viewers a different vantage point than what they are used to seeing. There are three basic techniques that are useful to know for rope work. Again, get professional instruction on these techniques before you jump in headfirst.

Ascending: The rope is fixed to an anchor from above and ascenders (a.k.a. jumars) and aiders are used to climb the rope. Ascenders have a camming device that clamps down on the rope and only allows them to slide one direction (up) so that someone hanging on a rope can let go of both ascenders and have their hands free—perfect for operating a camera. I use two ascenders and two aiders for my standard setup. The ascenders are clipped to my harness with slings. Aiders are webbing ladders that allow you to use your legs for upward movement and step up above your ascenders when needed, as when you get to the top of a route and need to reach the anchors. Always remember to back up your ascenders, either by using a prusik (a self-tightening knot) above the top ascender or by tying into the rope every twenty feet (6.1 m).

Rappelling: This is usually the fastest method for descending a cliff or steep terrain. The rope is fixed to a solid anchor, and a rappel device, like a Black Diamond ATC, is used to control the rate of descent via friction on the rope.

Traversing: A rope can also be used to traverse steep terrain, either as a handrail or as a Tyrolean traverse. For the latter, the rope is fixed at both ends across a gap and a pulley and ascender are used to traverse the rope. While a Tyrolean is usually extremely laborious to set up, it can be very useful for "hanging out in space" for sports like kayaking, mountain biking, and of course, rock and ice climbing. Just make sure you really need one before you go through the labor to set it up. With most Tyroleans I have ever been on, the best action was actually the person traversing the rope and not anything going on below.

What are Anchors?

In all of these descriptions of rope work, the rope is always secured by anchors. The most common types of anchors use either bolts pre-placed in the rock by climbers or traditional climbing protection using removable gear. In both cases, carabiners and slings are attached to the bolts or the traditional gear to create an equalized anchor. Sturdy trees are also a great anchor option. Don't underestimate the need for sound expert knowledge when it comes to setting up anchors—after all, they are the only thing between you and the distant ground!

UP!

CAN YOU DO THAT AGAIN?

PULL in SLACK

UP!

UNGHH!

This is one way many photographers ascend and descend a rope to shoot adventure sports. This setup uses a Petzl GriGri belay device and an ascender. One aider is clipped to the ascender so a foot can be used to help with upward movement. In this setup, the GriGri replaces the lower ascender and allows the photographer to move up or down quickly. This setup is much more strenuous than the normal one described in the text, so I don't recommended it for big walls. © Mike Clelland

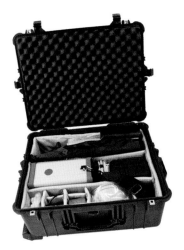

To carry the full kit while traveling, and sometimes even on location, I rely on the Lowepro Vertex 300 AW backpack. Fully loaded it weighs close to 50 pounds (23 kg).

To protect my lighting gear, I normally carry it in a Pelican 1610 rolling case. It is loaded here with the Elinchrom Ranger battery pack, two strobe heads, an extra battery, radio triggers, reflectors, and other accessories. At 65 pounds (30kg) it isn't light, but the box has really saved my gear from abuse when traveling, especially when flying.

PREPARING FOR THE ADVENTURE

Preparing yourself for adventure photography both physically and mentally is just as much a part of the recipe for success as creating the actual images. As I mentioned, getting into position is half the battle for any photographer, but this is especially true when it comes to adventure photography. Here we'll discuss a few of the not-so-obvious topics unique to this field.

PACKING

Packing your gear so that it arrives safely at your destination is one of those details that often gets overlooked. Depending on the scope of your trip—whether it is an afternoon in the backcountry or a month-long expedition— there is inevitably a significant amount of gear to transport. As you might guess, the packing strategies are different depending on the mode of travel.

If you are traveling by car, then you have quite a bit more freedom to pack heavily. I tend to take everything for those just-in-case moments where I need the white background and the strobes. Getting down to the nitty-gritty details, I tend to pack my outdoor gear in large duffels. I take a photo backpack (the LowePro Vertex 300AW) filled with my cameras, lenses, accessory flashes, and a selection of smaller LowePro camera bags so I can break my photo gear down to just the items I need on location. I also have several Rubbermaid plastic bins that are great for storing gear and other equipment. They fit nicely in the back of my Subaru, don't roll over, and are watertight in the rain. I use Pelican 1610 rolling cases to store and organize my lighting kit, which includes the strobes, batteries, pocket wizards, reflectors, cords, and many other accessories. These Pelican cases are heavy, but they are completely waterproof, dustproof, and are pretty much indestructible. I also have a Pelican 1490 case specifically for my laptop, which keeps it from getting destroyed when traveling and shooting on location. The case acts as my briefcase and can also hold portable hard drives, card readers, an iPod, extra batteries, and cables.

When traveling by air, my packing methods are a completely different story, especially now that the airlines are charging for checked bags. I highly suggest that you check your airline's baggage regulations and adjust accordingly. When I am flying to a major assignment, it is rare that I can go super light in terms of photo equipment, but if I can pare down the amount of gear I really need, life is a lot easier. Normally I take the same LowePro Vertex 300AW as one of my carry-on bags with my laptop in the padded slot on the outer lid. Depending on the airline, they might restrict the number of carry-ons allowed, but the cameras always go with me in one of my carry-on bags regardless. I use large rolling duffels to pack my outdoor gear and some of my photo gear, including smaller camera bags to break down the gear later. The tripod also goes into one of these duffels, and I pack it with a foam sleeping pad wrapped around it. I remove the ball head from the tripod before packing, and it either goes into one of my lighting cases or into the camera bag. Because a high-end tripod and ball head costs about $800, this is something I want to really pay attention to when I pack. I'll also put lightweight light stands, soft-boxes, and any other light modifiers into the duffle if I am taking the lighting kit. Softboxes and umbrellas are the go-to light modifiers when I know I have to travel by air because they pack easily. Large reflectors, like beauty dishes, are difficult to fly with so they usually end up getting shipped via Fed Ex if I really need

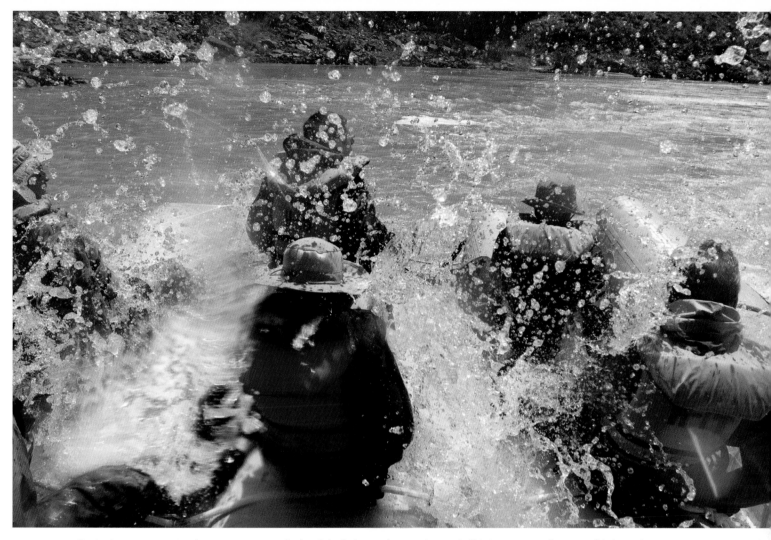

Protecting your gear is always a concern, whether it is during a shoot or in transit. This image was shot on a 14-day rafting trip down the Grand Canyon. I placed my camera and a 17-35mm lens in an Ewa-Marine waterproof housing and shot a sequence of images as we went into each rapid.

them. For the lighting kit, I use the same Pelican 1610 cases as when I travel by car. For air travel, I remove non-essential items from the cases to keep them under the weight limits. And finally, I put TSA-approved locks on the cases for security.

PROTECTING YOUR EQUIPMENT

Protecting your equipment from the elements and theft is paramount when traveling and covering an adventure. Sand, rain, and wind can damage digital equipment quite easily. When bad weather strikes, I sometimes use an extra Gore-Tex jacket to cover my camera from the rain, even though I have found that the weatherproofing seals in pro camera models do quite well—but why risk it? One

of the biggest factors in protecting your equipment comes down to the type and quality of your camera bags, which we discussed in the previous chapter (see page 26).

Dust, in my experience, is much harder to deal with than rain. In extremely dusty conditions, my cameras are usually packed away. If I have to shoot in those conditions, I'll put the camera in a lightweight clear plastic rain sleeve made by Op/Tech that fits over the camera and protects it from dust and rain. I use gaffers tape to seal the plastic sleeve on the front of the lens. These sleeves are very useful and are an inexpensive accessory to have in your camera bag. Using high-grade filters is also a good idea to protect your lenses (see page 22 for more on filters).

For underwater or water sports photography, there are a number of options for keeping your camera dry, which I discuss at length in chapter 6.

In terms of theft, my basic camera kit goes with me everywhere when I'm on a major assignment, including a hard drive with all of the images from that job. Cameras are replaceable, but usually the images are not and, in the long run, they are more valuable than the cameras themselves. In some countries, all it takes to get your gear stolen is to look the other direction for a few seconds, so vigilance is a necessity.

CUSTOMS, VISAS, AND EQUIPMENT LISTS

Dealing with visas and customs is standard fare for the world traveler, but if you are bringing large amounts of expensive camera equipment into a foreign country you might also need to bring a list of all the photo gear you have with you, the serial numbers, and the total value of that equipment. For most countries this isn't an issue, but this is just a safeguard so that the customs agents can make sure you didn't fly to Korea and buy a bunch of photo gear without having to pay the import duties. In general, I also carry a list of everything I am traveling with as a reference just in case one of my bags gets stolen. This makes it really easy when dealing with the local police and my insurance agency, which I would contact right away if anything were stolen.

TRAVELING IN FOREIGN COUNTRIES

Traveling to a foreign country is always exciting, but it can sometimes be quite exhausting as well, especially when you are lugging heavy gear around. I normally try to arrive a few days before I have to start shooting an assignment just in case any luggage is lost, and also to give me time to acclimate to the country. This, of course, isn't always possible when traveling from one assignment directly to the next, but I would recommend having at least a day to get organized before you start your adventure.

In an effort to stay healthy, I normally bring a few over-the-counter drugs with me, especially when traveling in Third World countries or when I know I'll be in remote locations. I always bring Advil, Imodium A-D (this stuff is gold when you need it), as well as water treatment pills. In some countries, staying healthy takes serious effort,

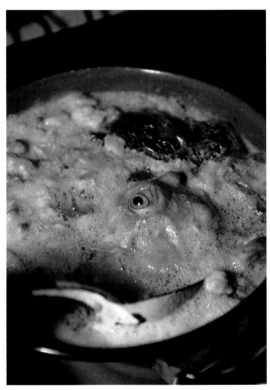

Traveling can be rough on the body and mind. At a barbeque in Potrero Chico, Mexico, we were served up goat head soup. They basically put the goat's entire head, drained of blood, into a pot of boiling water and let it boil down to this state. The eyeballs and brains were the exciting parts. Anybody know what I did with that Imodium A-D?

especially when it comes to drinking water. If you intend to travel worldwide or in the backcountry where you'll be getting water from streams, rivers, and glaciers, do yourself a favor and purchase a high-end water

filter or use a chemical water treatment solution to avoid giardia and many other water-born illnesses. I even use a water filter to treat tap water in some countries.

I suggest doing as much research as possible before you start traveling. If you have a contact in that country or can hire a "fixer" who knows the language and culture, it will help out tremendously. The more you know about the location you'll be working in, the more productive you can be with your photography.

GETTING PHYSICALLY FIT

Staying physically fit is another key aspect of adventure photography. After all, if you can't keep up with the athletes it will be difficult to photograph them. Of course, I am not saying you have to be as fit as the athletes you are working with—that is nearly impossible for most of us—but you'll need a certain level of fitness and skill to get into position and not slow down your subjects, especially since you'll often be carrying more gear than they are. I know of a few professional photographers who are elite athletes and this is a huge bonus for them; they can get into shooting positions that no one else can (or often wants to).

Part of my daily routine while working in the office is to get in an hour-long workout at least four times a week with longer workouts (usually while climbing, hiking, or cycling) on the weekends. I generally work on my cardiovascular fitness so I can keep up with athletes as we hike to the location, and so I can get into position quickly. As someone who started out as a rock climber and mountaineer, I learned that overall fitness is a basic requirement for any adventure sport, and no less so when it comes to adventure photography.

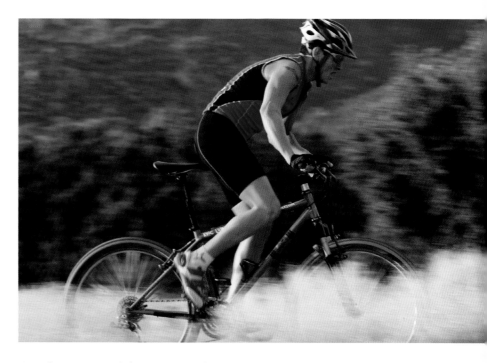

Staying in good shape is a must for serious adventure photographers. Here, Eric Lujan mountain bikes in the foothills of the Sandia Mountains near Albuquerque, New Mexico.

MANAGING RISK

One of the main concerns when photographing any adventure sport is making sure no one gets hurt in the process. Be aware that anytime you pull out a camera, people tend to get a little more courageous than they normally would be. I call it "camera courage." If you work as a professional photographer, the athletes are aware that if they do something really wild and crazy, the odds go up radically that those images will be published whether you are on assignment or not. There are a host of issues to discuss with your athletes in terms of overall safety and legal ramifications.

SAFETY AND
—COMMUNICATION

Adventure sports are dangerous and some, like BASE jumping, whitewater kayaking, and freeriding, are extremely dangerous. When I work with athletes that are going to be taking big risks, I urge them to take every precaution so they don't get hurt. As an example, when I shoot mountain bikers jumping off 40-foot (12 m) cliffs, I tell them not to do anything unless they know 110% they can do it safely. In some sports, even when every precaution is taken, the athlete may not be fully in control, as with extreme whitewater kayaking. As an adventure photographer, your goal is to get the wildest images possible, so there is a fine line between safety and allowing the athletes to just go for it. You'll have to make these calls on a case-by-case basis, but be aware that safety should always be your first concern.

How you communicate with the athletes depends on the type of shoot being done. It is important to differentiate between documenting an event or "session" and controlling the photo shoot, meaning you are directing where athletes go and what they do. In the first case, if you document the athletes doing what they would normally do, there are still some safety concerns, but as a bystander of sorts, you are not responsible for the athlete's safety or for directing their actions. They would be involved in this activity whether you were there or not. However, I would interject if I saw the "camera courage" start to influence what would otherwise be a normal outing. The camera is always a factor whether people will admit it or not. In the second case, where the photographer is working with the

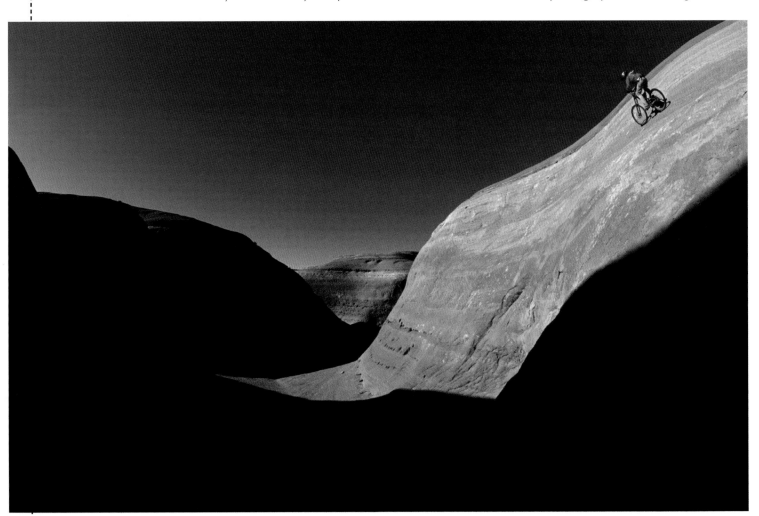

Nate McKay takes to the vertical on an 80-foot (24 m) near-vertical wall ride in Canfield Canyon at Bartlett Wash near Moab, Utah. Nate was moving upwards of 80 mph (129 kph) when he dropped into the lower bowl.

athletes to get the best pictures possible, communication before and during the shoot is central to getting the type of images you want and also allowing the athletes to perform at or close to their limits safely. By listening to the athletes, you might also be surprised at what they can do to help create images far better than what you preconceived. Often, their suggestions have resulted in images superior to the ones I had in mind.

SAFETY AND LEGALITY

Whether or not you are documenting a group of athletes or directing them during a shoot, there are legal issues to consider. If I ask athletes to do something so I can photograph them, then according to U.S. law I am liable if they get injured, especially if I have hired them to be my "models" for the day. Whether they are being paid or not, I have the athletes who'll be taking extreme risks sign a liability waiver, which basically says they agree to take responsibility for their own actions and will not sue me if they get injured. The unfortunate reality is that if someone really wanted to sue, the waiver is easy enough to get around in court. As you might guess, I try to avoid having to deal with this issue by communicating my safety concerns with athletes before a photo shoot and also by working with the best athletes I can find who can push the envelope and still retain a considerable safety margin because of their skills.

As a professional photographer, I do have excellent insurance coverage for anyone who gets injured during a photo shoot. However, the fine print limits whom this will actually cover. Basically, my coverage—and just about any coverage you can buy for this sort of business—only covers an accident, such as when an innocent bystander trips over a light stand or something to that effect. I would have to apply for worker's compensation in the state that I was shooting in for

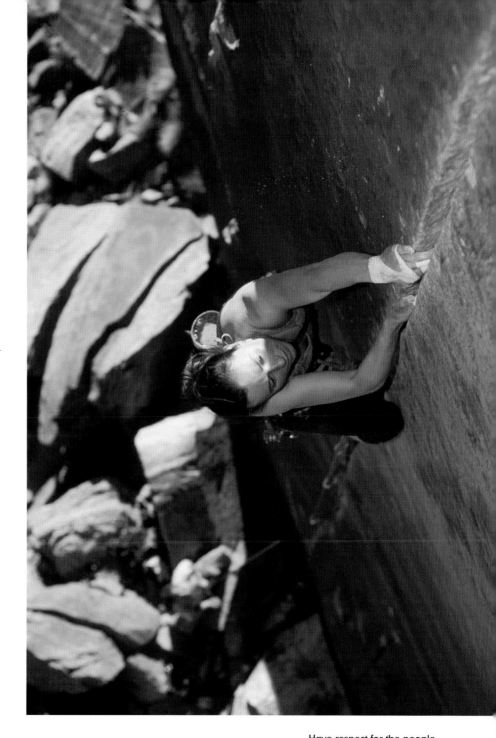

Have respect for the people you work with. Steph Davis, pictured here at Indian Creek, Utah, is a sponsored rock climber and mountaineer who asked that I not send the images I shot that day to several specific clients of mine, who were competitors of her sponsors. Of course, I agreed to work with her needs.

real coverage of a hired athlete or even an assistant. Since I shoot all over the world and in different states each and every month, this isn't a real option. So, the reality is—be careful! Of course, since I am not a lawyer, I can only speak generally on this topic. If you have questions about protecting yourself and your business, I recommend speaking to an attorney about these issues.

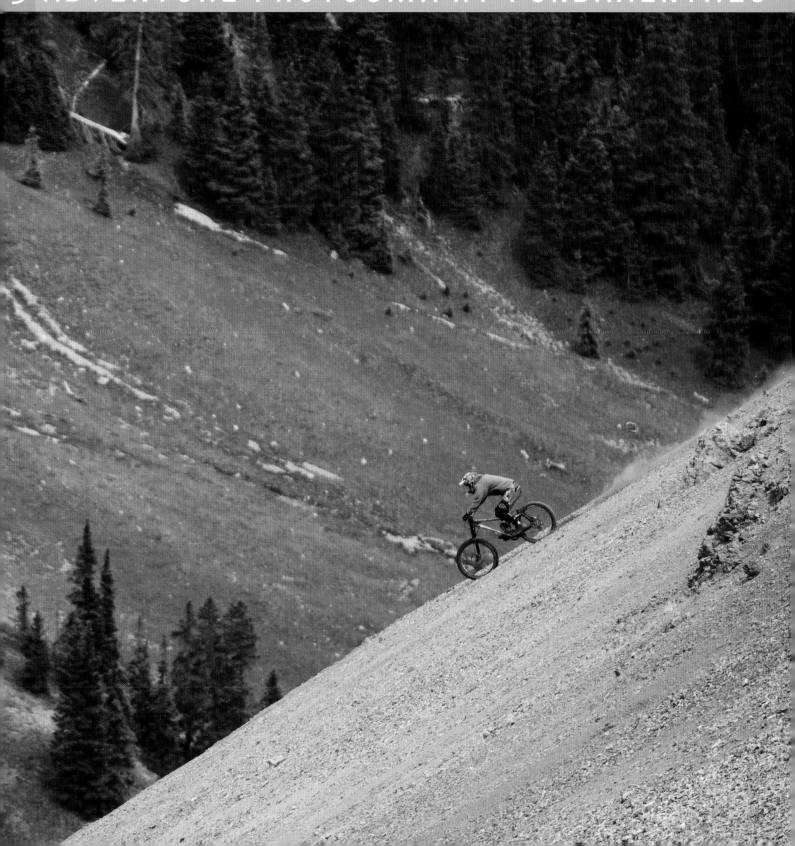

Ghost-like figures push up the sides of a hot air balloon at the 2007 Albuquerque Balloon Fiesta, the largest ballooning festival in the world. This image is a good example of using the rule of thirds and I would also classify this as one of my best pictures because it has that hard-to-define ingredient which takes it to the next level.

In theory, photography is a simple discipline. You take a light-sensitive box, put something interesting in front of it, adjust the exposure and focus, and then push the button. Voila—you've just made an image. Whether or not it is any good, well, that's another issue. If you are like me, then you are not shooting for just a good image, you are looking to create a great image. But before you can shoot great pictures, you have to learn how to shoot good ones. The reality is that creating a good image isn't that hard—it's a combination of three ingredients: interesting light, a subject or a moment that is interesting, and a solid composition that draws the viewer into the frame and keeps them there. Creating a great image—an image with that intangible, hard-to-define fourth ingredient that grabs your viewer and really resonates—happens only a few times a year, even for the very best professional photographers, and it's the pursuit of these images that will inspire your photographic process. Every time you take a picture, you have an opportunity to learn. And if you pay attention, especially with digital and its instant feedback, then you can quickly learn how to take good pictures, and sometimes even capture a great one.

BASICS

In this chapter we'll cover some of the foundations of photography—namely, light, exposure, composition, and perspective. Each of these subjects could easily be its own chapter, or even an entire book, but since basic photography is not the subject of this title, look to many of the excellent books or other resources (like photo workshops) available for general information on these topics. What I will focus on is how each of these topics relate to outdoor and adventure photography.

LIGHT

Light is the essence of photography. Without light there is no image. Every photograph is basically a recording of the light present at the moment the shutter snaps. With a digital camera, we are literally capturing the dance of trillions upon trillions of photons streaming through our atmosphere. Energy, in the form of photons, is absorbed by an object and is then radiated outwards from that object, and it is this radiated light that the camera records. This is obviously a very watered down explanation of the physics of image capture, but here's the point: when it comes to photography, we can break down how light interacts with our subjects and adjust our techniques for shooting in various conditions. As photographers, we have to be students of light. We have to learn to look at the world around us and to look with concentration. Light comes in many forms and flavors, and to some degree, it is available in a predictable fashion depending on the time of day, the location, and of course, the relationship of the light to the subject.

Jacopo Alaimo stems his way up EL Matador (5.10d) on Devil's Tower National Monument in Wyoming. While I planned to be shooting at sunset on this route, I couldn't have imagined just how good the light was going to be when the sun's last rays cooled the wall with these phenomenal pink and orange hues. Great images like this are usually a combination of planning and luck coming together perfectly.

Sunrise and sunset: Sunrise and sunset offer soft, sublime, and supremely colorful light. If you are an outdoor photographer of any kind, then dawn and dusk are your main working hours. Even the dim glow of twilight just before sunrise or after sunset is spectacular light not to be overlooked. In terms of adventure sports images, the hardest part about working at sunrise is getting the troops motivated to go out at such an ungodly hour. My advice? Learn how to make coffee that your athletes will beg for and learn the art of persuasion. Looking back over my career, some of my best images were a direct result of convincing my subjects that we could get unbelievable shots if they worked with me and got up for dawn patrol. Once they saw the fruits of our labor they were much more easily persuaded to get up early the next time.

Frontal lighting: As an adventure photographer, frontal lighting (i.e. where the sun is directly behind you as you shoot) is an ideal situation, especially if it also happens to be sunrise or sunset. This is the easiest lighting to deal with, and while it may not be the most interesting, it is very predictable. With a clean background and some wild action, it is pretty much like taking candy from a baby to get solid adventure sports images in these situations. When I arrive at a new location, I check where the sun will rise and set to see if I can set up a shot at these times that has direct frontal lighting.

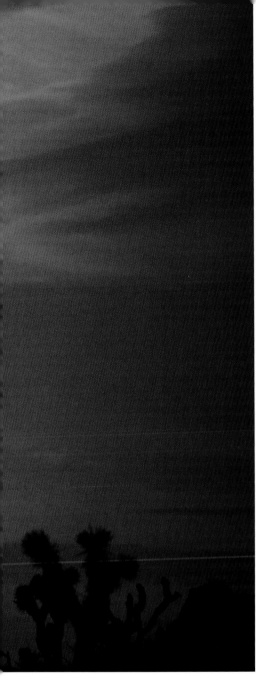

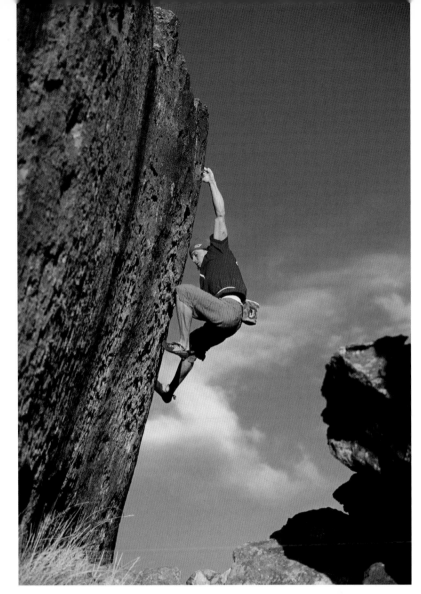

Timy Fairfield warms up on a casual V2 boulder problem near Ponderosa, New Mexico. This image is an example of a frontal lighting situation. It was shot just before sunset and the sun was directly behind (and slightly above) me when I shot the picture.

During sunset in Joshua Tree National Park, California, I was drawn to these incredible red clouds. I used the silhouetted Joshua trees as a visual anchor so the viewer would be able to identify the location.

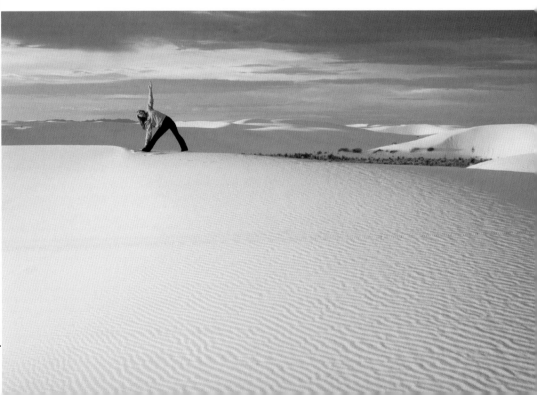

Sadhana Woodman practices yoga at sunrise just as the light hit the dunes, creating dramatic texture in the sand.

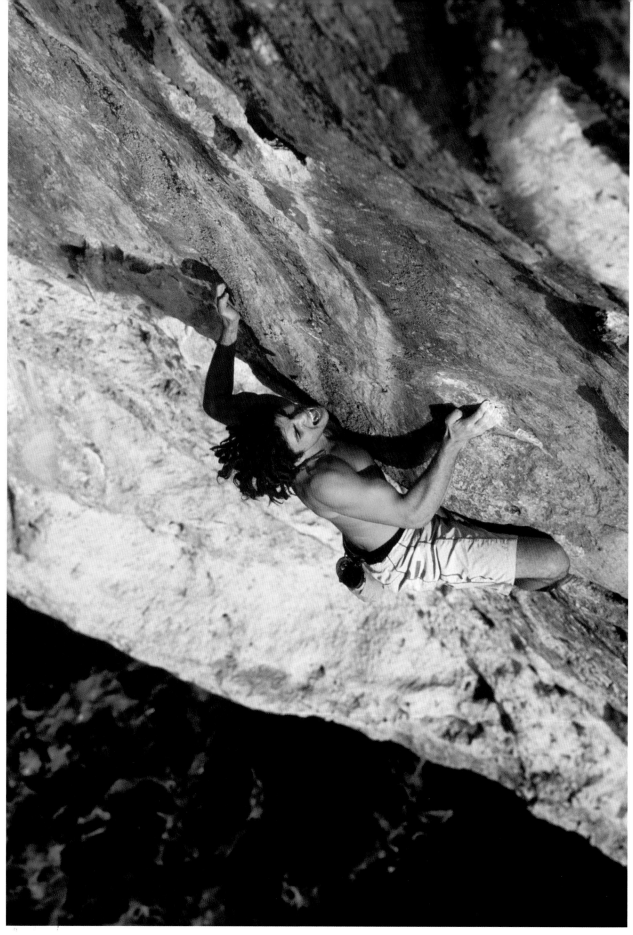

Nate Gold climbs All Cats Are Black in the Night (5.13a) in Mallorca, Spain. The sideways shadows help give a sense of his precarious position and the tiny holds he is grasping while climbing this steep sea cliff with no rope.

Side lighting: When the sun is to the side of your subject, the light becomes more dramatic. Because the shadows are extended and more visible, you get a three-dimensional effect that makes the image come alive. And since photography is inherently a two-dimensional medium (at least for right now) this will give your images a little more depth, which is very effective for landscapes and portraits. Watch your histograms, especially because many cameras' light meters can be fooled with this type of lighting (as we'll see in the next section on exposure).

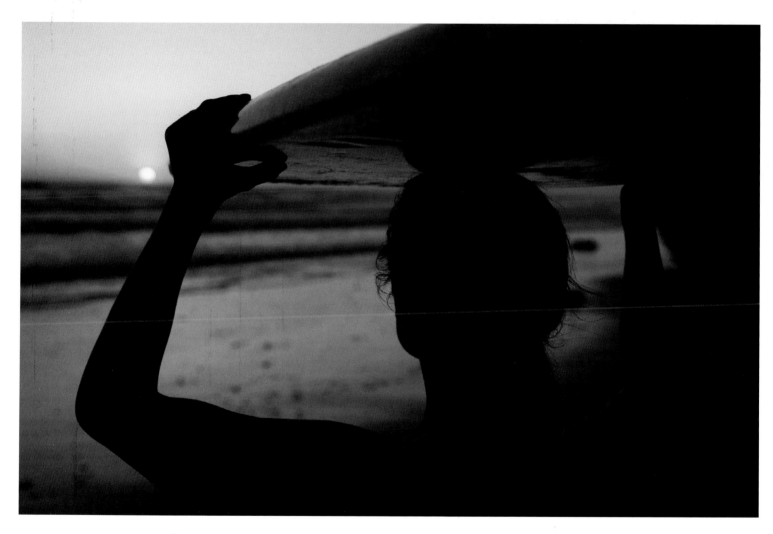

Back lighting: If your subject is lit from behind, or backlit, it can be hard for your camera to deal with, but it can also be a very interesting and visually stunning scenario. The obvious backlit image is a silhouette, which is the result of an extreme contrast from light to dark. Under less extreme settings, a backlit image can form a halo around the subject, which really pulls it away from the background and makes for an electric image. If there is some transparent object for the light to shine through, like a tent for example, this will only add to that effect. And since most backlit situations occur when the sun is lower in the sky or near the horizon, the color and saturation of the light overall makes for incredible images. In these instances, it is easy enough to move around your subject (and have them move with you) to create frontal, side, and backlit conditions—all with extremely nice light quality.

This backlit image of Laura Perfetti checking out the waves at sunset near Encinitas, California, is a perfect example of how shooting into the light source can create an effective image.

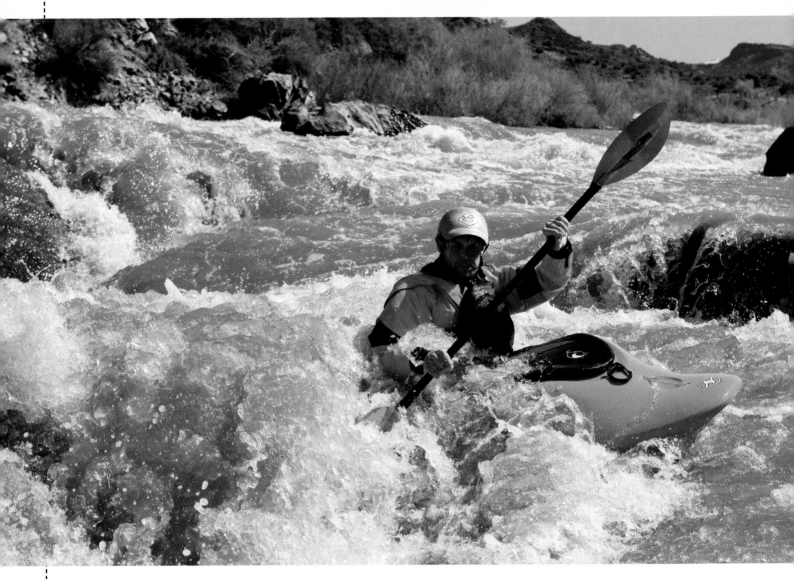

Adam Putnam kayaks on the Racecourse section (Class III+) of the Rio Grande river in northern New Mexico in very contrasty conditions at high noon. Because there is so much light reflected off the water, it helps soften the otherwise harsh shadows created by the midday sun.

Midday light: The reality of outdoor photography is that most of the time you have to work with the light as it is—and many adventure activities take place in the middle of the day. High contrast midday sun is normally a photographer's worst nightmare when it comes to light. The shadows are deep, dark, and usually very unflattering, but there are some times when the midday sun can help you out, particularly when it comes to kayaking and skiing. Because water and snow reflect a lot of light, the surface of a river or the snow can act as a huge reflector filling in harsh shadows. You see this a lot in images of skiers jumping off cliffs, even when the skier is backlit and the sun is in the frame. In theory, high noon is the time you pack it in, but don't stop shooting every time. You just never know how the light will look until you snap a few frames. With digital, it doesn't cost you any more to find out and you might just get some stunning images.

Diffused light: On cloudy or rainy days, the light is soft, the shadows are open, and the colors are rich. For digital cameras, a cloudy, low-contrast day means sensors can record the entire range of brightness and saturated colors. For the adventure photographer, a cloudy day is ideal for some situations, especially if you are shooting in a forest where harsh shadows normally create extremely difficult shooting conditions. Generally, an overcast day comes with bad

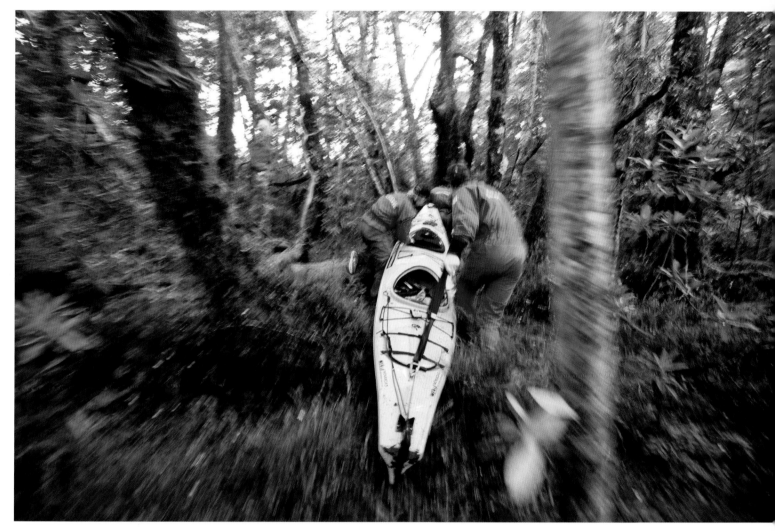

Overcast days are perfect for doing speed blurs. For this image, I followed the Helly Hansen-Prunesco team as they portaged their sea kayaks across a stretch of dense forest during the 2009 Wenger Patagonian Expedition Race. I walked at a fast pace and shot at 1/13 second and f/5.0 with a wide-angle lens.

weather, and while this can be hard to shoot in, it can also offer some of the most stunning light a photographer can ask for when the clouds begin to break up a bit—especially around sunrise or sunset. Even if the weather doesn't break up, head out into the rain, sleet, and snow because you can be guaranteed to get some very interesting images in those conditions. I remember a quote from Kent Kobersteen, a famed *National Geographic* photo editor who summed it up when he said, "The really strong photos come from those situations where the last thing you want to do is take pictures—when everything is going to hell, when the storms are raging and everyone is trying to hang on." It is precisely these stormy conditions where the magic really starts to happen in the form of rainbows, haze, mist, and fog. If you can capture an adventure image with the mood provided by one of these magical events, then you'll have a stellar photograph.

EXPOSURE

When talking about how to expose an image, I am going to assume that you already know how to work with your camera by adjusting the shutter speed and aperture. Because correct exposure is such a critical topic to the success of good adventure shots (and really, any digital photographs), this section will be very specific about how to dial in the best exposure.

I have found digital exposure to be quite different than it was back in the film days. Digital has a larger dynamic range when shooting RAW image files than the slide films I used to swear by, but it is also much easier to blow out the highlights on a CCD or CMOS silicon sensor than it was with film. There are three things I'll cover here to help compensate for this problem: using the histogram to adjust the exposure, "shooting to the right," and always shooting in RAW.

The histogram is the most important tool in any digital camera. It is a bar graph of the intensity of light in an image as recorded by the sensor. Like a bar graph, it is read vertically and horizontally. The horizontal axis spans the range of brightness from Black (0) on the left to white (255) on the right. The height of the bars indicates how many pixels on the sensor were exposed at that brightness level.

Digital devices are different in that they are linear devices, whereas film and our eyes are not; they are non-linear. Hence, a CCD or CMOS chip is just recording the number and intensity (amplitude and wavelength) of the photons that hit the sensor. Once the brightness level becomes greater than what the sensor can record, the chip just records it as white. This is why you have to watch your histogram and your exposure to be sure that you don't blow out important highlights. The reality is some highlights are going to blow out—it is just a matter of whether they are important or not. The other fact about digital and the linear relationship is that most of the image information is recorded in the first two brightest stops of the sensor's levels.

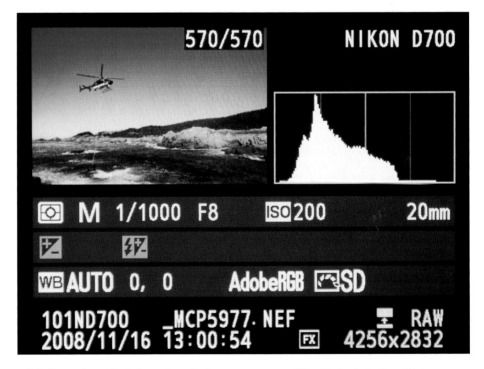

This figure shows the information display on my camera. The display includes a histogram (which is an average of the red, green, and blue channels) in the upper right corner.

If that sounds confusing, consider it this way: If you are shooting a 12-bit RAW file, there are a total of 4,096-segmented values of brightness on the histogram. Of those, 3,072 of the values (or roughly three-fourths of them) are in the brightest part of the histogram—which is the third of the histogram on the far right. Basically, this is a technical way of saying that if you underexpose your images, you are throwing away massive amounts of data from your camera's sensor and when you tweak the exposure of the RAW file, you'll start to see noise show up in the shadow areas of your images.

For new shooters, the common tendency is to underexpose to preserve highlights. Unless you are creating a silhouette, overexposing or metering as your camera suggests will result in much better image quality. I recommend that you always shoot in RAW mode and set your camera's exposure so the histogram is as far to the right as possible without blowing out any important highlights. This method is called "exposing to the right." Another reason for exposing to the right is controlling noise. When you expose to the right, the sensor creates less noise at any ISO than if you underexpose. This is a critical point if you are shooting at high ISOs, which is fairly often when shooting adventure sports.

Following this rule of exposing to the right is counterintuitive, and trust me, it will take some time to get comfortable with. When you first view your images in your RAW converter processing software (like Adobe Lightroom), it will look like you really messed up because the images will be a little overexposed and might be lacking in contrast. One can recover up to two stops of highlight detail using a RAW converter like Lightroom, and the image can be brought back down to the correct brightness so that it looks the way it should. This is one of the many reasons why you want to shoot in the RAW format and why you need to understand a complete digital workflow while you are out shooting to obtain the best digital exposure.

This is a before and after example of "exposing to the right." The top image is the RAW file as it was shot and first appeared in Adobe Lightroom. You can see that the image is lacking contrast and the histogram (in the upper right corner) is all the way over to the right side. In the bottom image, I have adjusted the image contrast and brightness as well as the white balance so that the image looks as it should. If you look at the histogram for the adjusted image, you can see that the big hump is to the left of where it was in the top image. This example is subtle, but if it weren't, then I would have had seriously blown out highlights that may or may not have been recoverable.

Understanding Histograms

As we have already mentioned, a histogram is basically just a bar graph of your image's tonal values. To judge your exposure, use your histogram. Do not estimate your exposure by looking at the image on the back of the camera. It is very likely that this is not an accurate representation of how the image will look when viewed on your computer screen. Keep in mind that there are no good or bad histograms. For example, a black and white wall will have two lines in the histogram—one on the left and one on the right. This isn't a normal histogram, but for this scene it is the right histogram. Similarly, if you are shooting a silhouette, your histogram is going to be stacked up on the left side because you have a lot of black in the image. Below are a few examples of histograms and the images they represent. Please note these are finished files so the histograms represent the final worked up image.

A

Figure B shows a portrait shot on a white background; we therefore see a large spike on the right side of the histogram, which makes sense. So in this case we don't have to worry about the blown out highlights because they should be blown out if we want a pure white background.

B

In Figure A, the histogram is heavily stacked up against the left edge, signifying that there are significant dark areas in the image. For this image, this is the correct histogram and it is okay because I meant for this to be a silhouette. When I exposed for this image I set the exposure for the distant setting sun, which resulted in the silhouette effect I was going for.

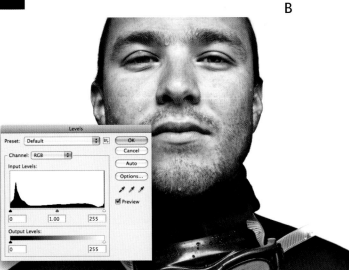

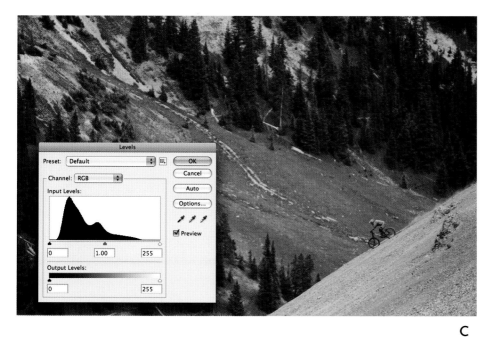

Figure C demonstrates a "good" histogram. Both the shadows and the highlights are fully contained—there are no spikes on the right signaling that the highlights are blown out and they are not stacked on the left showing that the shadows are blocked up. This image was shot on an overcast day so there were no deep shadows or bright highlights.

C

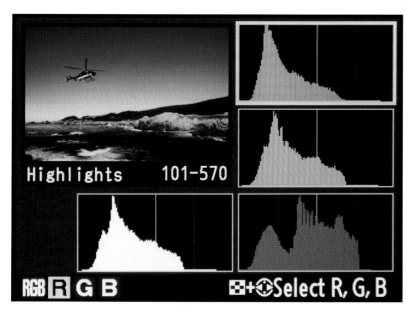

D

Some cameras just have one histogram, which is all three RGB color channels combined and averaged, as in the example on page 60. More advanced cameras will show you the histogram for each color channel, as in Figure D, so you can see if one channel is blown out or not. I prefer to see the histograms of all three channels; that way, I can tell what is blowing out and if it matters. In Figure D, my entire histogram is contained and there are no blown out highlights or shadows in any channel. While this is a nice, well-rounded histogram, I could have pushed the exposure to the right just a bit more, but I was hedging my exposure because of the big, rolling waves that were blowing out in a few images. This is an example of an optimal exposure for digital capture.

THE SIMPLE WAY OF
EXPOSING FOR DIGITAL

The simple way of exposing for digital is to always have your histogram active on your camera's rear LCD. My shooting workflow for getting a correct exposure in the field goes like this:

1. Set a custom white balance or use auto white balance, depending on the camera and how well the auto white balance works.

2. Take a photo of the subject at the camera's recommended exposure setting and then check the histogram. At this point I am not looking at the image, just the histogram.

3. By reading the histogram, I decide if I need to adjust my exposure (shutter speed and aperture). If the histogram is mashed up on the left, then I open up and overexpose to push the histogram to the right; conversely, if I have seriously blown out *important* highlights, I stop down (underexpose) and take another shot, then check the histogram again to make sure I have the optimum exposure.

4. Once I get the exposure dialed in, I then start shooting in earnest.

Notice in this shooting workflow that in the case of important highlights being blown out, I underexpose to move the histogram to the left. I call it underexposing because the camera's recommended exposure was too bright, as recorded by the histogram. This is the one case where I advise underexposing. Basically, the histogram is king. The exposure meter in your camera is just a guide to get you started—its recommendation may or may not be the best exposure. Forget about your in-camera meter once you have dialed in the correct exposure with the histogram.

Note: For portraits, I don't like to have any of the skin clipping or blown out in the highlights. If they are clipped, it is very difficult to render the skin tones accurately, and often you will see some subtle color issues surrounding those areas that are blown out, so pay special attention to your histogram when shooting portraits.

THE COMPLICATED
REALITY OF EXPOSING
FOR DIGITAL

The reality is that the "perfect" digital exposure has very tight tolerances—akin to slide film—within 1/3 of a stop. For the highest quality digital image in terms of noise and color rendition, finding the optimum exposure is paramount. Shooting in RAW mode is fairly forgiving and you can pull a lot out of an incorrectly exposed image, but getting a perfect exposure takes some serious experimentation. Being tethered to a computer with a calibrated monitor greatly aids in finding the correct exposure because it gives you a much larger preview of your image exactly as it will be when opened in your RAW processing software. Obviously, that is not practical or possible all the time, but it is something to be aware of.

Another important fact to remember is that the histogram on the back of all digital cameras is taken from an 8-bit jpeg, even if you are shooting in RAW. Hence, the histogram on the back of the camera is different than the one your final processed RAW image will have. This means that you have a little more room on the highlight side of the histogram than your camera is telling you—and that is where things get tricky. I would advise that you shoot pictures, download and process the RAW images, then compare the histograms from the back of your camera

to the final image in Photoshop. This way you can start to tell just how much of the highlights you can recover, and get a feel for where the line in the sand of overexposure really is.

After ingesting all of this information, one might balk that the creative urge is being hindered by the technical facts of digital image capture. This is just the balance digital photography forces us to accept for the many benefits it offers. If your head is spinning right now, realize that exposing correctly for digital takes time to get comfortable with. As with anything, experience makes a big difference and over time exposing for digital will become second nature.

COMPOSITION

How to compose an image is obviously a complex topic. The standard rules of composition are simple: stay away from putting your subject in the middle of the frame (use the rule of thirds), avoid lots of clutter in your image, fill the frame with your subject, and find a clean background. But before you even start to consider these rules when out shooting, you need to first ask yourself, "What is this image about?" Or even better, "What do I want this image to say?" Pretty much everything in terms of composition stems from these two questions.

For most of us, it is hard to distill exactly what we want an image to be about when we first put the camera up to our eye. A large part of composing an image is intuitive—it's that "I'll know it when I see it" mentality. If you have ever wondered why pro photographers shoot dozens of pictures (if not more) to get the perfect photo, you now know the answer. By shooting a lot of images, pro photographers are using a process that allows them to figure out exact-

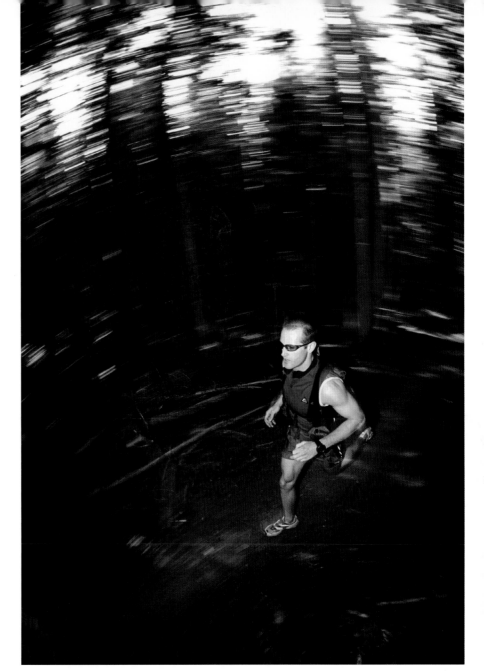

Thinking about composition in new ways often leads to more interesting angles and images.

ly what the image is about and what they want the image to say. This process is a way of culling our thoughts and our composition so that the final image says what we want it to in a clear, loud voice.

Even for myself, the first images at a new location normally include way too much information. For example, let's say we are photographing a rock climber; our minds lock onto the rock climber, but we also see the landscape surrounding the climber, and if we try to include too much of that landscape we'll water down the image and lose

the focus on the rock climber, which is what we were drawn to initially. In a case like this, I'd either move closer or use a longer lens so I can still capture some of the landscape but keep the climber from being too small in the frame.

In the case of fast moving action, like mountain biking or whitewater kayaking, you may or may not have the time to go through this process to find the best composition. In these cases, you simply rely on your gut reaction to determine your composition. The more experience you have the better the results will be. In many cases though, you can previsualize what is going to happen and get your composition set up before the action happens. If there is no time to set up a composition, another method is to choose an autofocus point where you want your main subject to be and keep that focus point on them as they move past you. This will effectively frame a certain composition based on your autofocus point choice (and it helps if you have a large number of autofocus points to choose from). We'll discuss some focusing methods in the next section that will help in this process.

Let's get back to the rules I outlined above. Simplifying your image and avoiding the temptation to include everything in the frame is the first step to radically improving your composition. A large part of creating a graphic image is finding a clean background against which to shoot your subject. A clear blue sky is often a good option when it comes to adventure photography and it is usually available just by moving to a lower vantage point. Next, concentrate on filling up the frame with your subject. As the veteran war photographer Robert Capa used to say, "If your pictures aren't good enough, you aren't close enough." This is especially true for a genre like adventure photography, where seeing the up close details of athletes' determination sometimes trumps a wider perspective.

Your composition will also be dictated by your position relative to the subject. The photo editors at National Geographic like to say you haven't covered something unless you have explored it from 360°, meaning check all the angles. Shoot from below or at a low angle, get on a ladder or a rope and shoot from above, from the side, and any other angle you can think up. Move in, move out, check out every vantage point you can get to and especially the ones that are hard to get to, as those are often the most interesting. And don't forget to think about mounting the camera in a specific place so it can capture the "point of view" seen by the athlete (see remote camera work on page 73).

The rule of thirds is one of those compositional ideals that I use all the time because it is quite rare that plopping the subject smack in the middle of the frame results in a good image. Basically, the rule of thirds says that if you divide your frame into thirds and draw a line on these horizontal and vertical axes, then those lines will intersect at four locations between the center of the frame and the four corners. By putting the subject at the intersection of any one of those four lines, a very dynamic composition can be created. In some cases, it is not the best composition, but it most certainly won't be the worst. Use your intuition and experiment by following this rule and also breaking it.

Another consideration in composition is light. The brightest part of an image is where your viewer's eye will be drawn first. And if that part of the image isn't part of your subject, it might just steal the show—so crop it out or recompose to eliminate it. Also, check the edges of your frame to make sure there aren't any extraneous objects poking in that clutter the image.

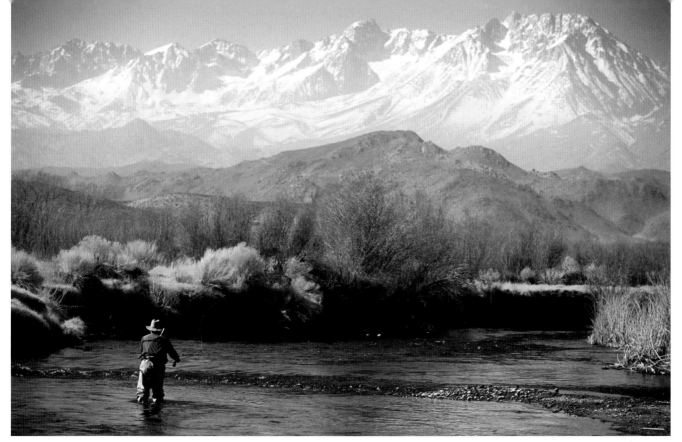

This image shows Julian Plowden fly-fishing on the Owens River just north of Bishop, California, with the Sierras looming above him. Even though he isn't placed in the perfect place dictated by the rule of thirds, the image is still very effective.

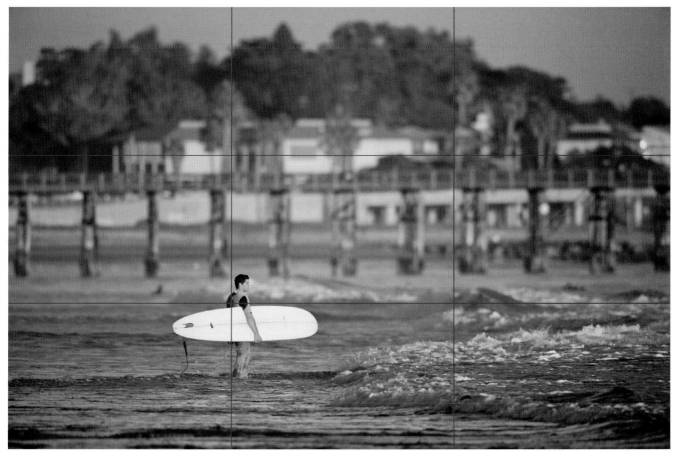

Red lines show the rule of thirds in action in this image of a surfer walking out into the ocean in Ventura, California. While using the rule of thirds might not always make an exceptional image, it will almost always make for a nice composition.

It's also important to think about composition in respect to how the viewer's eye is going to move around the image. This isn't easy to do in the heat of the moment, but if you train yourself to think about this while framing up the image before the action starts, then you will be able to craft a much stronger picture. The basic idea is that you want to avoid elements in the frame that will lead your viewer's eyes outward from the photo. A compelling image holds your viewer's attention by making their eyes continually follow in a circular or triangular motion from one strong element to the next.

Part of learning good composition is looking at a lot of photographs. I would highly suggest looking at the work of photographers you admire and thinking about how they composed each image. One of the most influential photographers in my career, at least in terms of composition, is the great war photographer James Nachtwey. He has some wild compositions that are so effective they will knock your socks off—if the subject matter doesn't do so first. I highly recommend seeing the documentary filmed with him several years ago, *War Photographer*, where a video camera was mounted on his still camera to show exactly what the environment looked like as he was shooting and how that affected the resulting still photographs. If you can find a copy of the documentary it will change the way you look at things. Also, my sense of composition is highly influenced by movies. I love movies and most cinematographers working on big budget Hollywood films didn't get their jobs by accident. Try watching some visually compelling movies like *The Matrix*, *Ronin*, or one of my all-time favorites, *The Big Blue*, and keep an eye on how they composed and set up each shot.

About the only thing that really separates the pro photographer from the amateur is the amount of work and thinking that goes into *creating* an image. Creating, not just taking images, is hard work. And if you want to take your photography to the next level then it will involve some hard work and planning, especially when it comes to adventure photography. How much work you put into getting a shot prior to pushing the button is usually directly proportional to how impressive the resulting image turns out to be.

Following some of the compositional rules outlined here will often result in a pleasing photograph, but remember that "rules are made to be broken." If breaking the rules reinforces what you are trying to say with an image—then by all means, break the rules. In the end, these rules are only guidelines.

Autofocus, Manual Focus, and Hyperfocal Methods

Since adventure photography includes fast-paced action, learning how to use your camera's advanced autofocus features and learning to anticipate how the action will play out is extremely important. Because the autofocus differs greatly from camera to camera, I'll simply advise you to read your camera manual and experiment with your camera and lenses to get the best results. However, there are a few instances where manual focus is a better

option. One case in particular is when remotely mounting a camera. Once the camera is mounted, turn off the autofocus and pre-focus the camera. I normally also tape the focusing ring with some gaffers tape so the focus doesn't shift if something bumps or rubs up against the lens.

Another option when shooting fast-moving mountain bikers, skiers, or surfers is to use manual focus and set the hyperfocal distance on the lens. This is a method used normally on prime wide-angle lenses like a 16mm fisheye, a 14mm, or even a 24mm. To achieve this focus setting you'll have to use a small aperture, anywhere from f/8 to f/22, depending on your preference and the lens. For example, lets say that I am shooting with a 24mm lens; on the lens there are markings for f/11, f/16, and f/22, as in the picture on the left. If I choose f/16 on the lens and set my aperture to f/16, then by aligning the middle of the infinity symbol with the f/16 mark on the top of the lens, I have set my hyperfocal distance so that everything between infinity and two feet (61 cm) should be in focus. I can tell this by looking at the focusing distances on the lens. Now that I have the focus set I can set up my composition and fire away without having to worry because I know everything will be in focus. This is how a lot of high-octane action is shot.

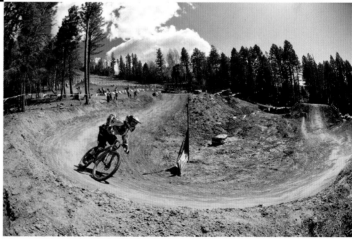

I used hyperfocal distance settings on a 10.5mm fisheye lens to get this shot of a mountain biker in Angel Fire, New Mexico. Using the hyperfocal distance method allowed me to concentrate on my composition because I knew everything in the frame would be in focus.

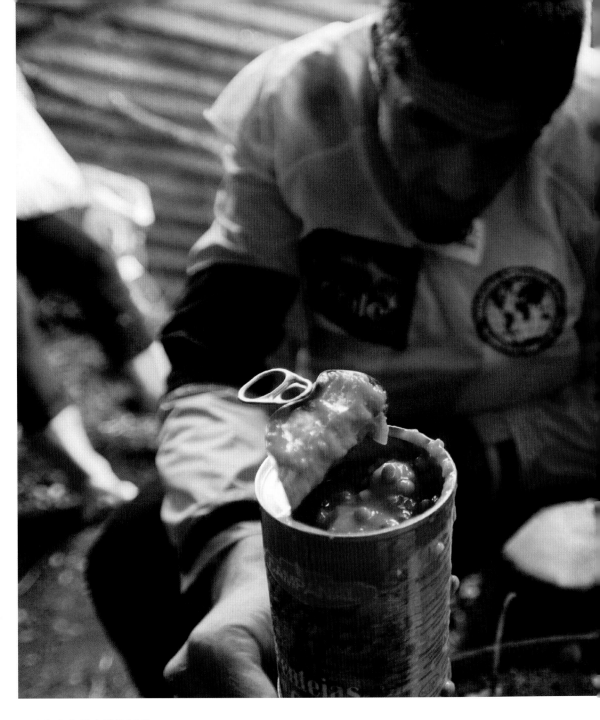

PERSPECTIVE

How you approach a subject will depend on the perspective you want to convey. Just as with composition, the perspective you choose will help tell the story and that perspective is dependant on the equipment and the techniques you employ. In this section we'll talk about using wide-angle and telephoto lenses, remote camera work, and aerial photography and how they can benefit your adventure photography.

Wide-angle photography: Using wide-angle lenses is an art. Used effectively, they can give you perspectives that no one has ever seen before. These days, pretty much every pro photographer on the planet owns a 16-35mm or 14-24mm lens. These are part of a standard kit that also includes 24-70mm and 70-200mm lenses. Fixed focal length wide-angles are also quite useful because they are lighter and have hyperfocal distance markings on the lens barrel. I own a 10.5mm fisheye (for cameras with APS sensors) and a 16mm fisheye, as well as a 24mm wide-angle.

Cyril Margaritis cooks a can of beans during the 2008 Patagonia Expedition Race. At this point in the race, Cyril hadn't eaten anything in over 36 hours because his team ran out of food. The expression on his face is one of sheer torture while waiting for the beans to warm up on the stove. I used a 17-35mm f/2.8 zoom to capture this wide-angle shot while backed into a tight corner.

There are a lot of times when fisheye is *the* go to lens and nothing else will be able to match its stunning perspective. Throughout this book, if you look close, you'll see a lot of images shot with a fisheye. For many adventure sports, they also work perfectly for remote camera work. It is a key lens for shooting mountain biking, skiing, and surfing. When I shoot freeriding, there is no other lens in my bag that can help communicate the scale or steepness of the cliffs the bikers are launching from the way a fisheye can.

Portraiture is another area where most people wouldn't think to pull out a wide-angle lens, but they are great for environmental portraits. I often shoot portraits with a wide-angle where I move in really close, thus creating a wild perspective. Don't underestimate the power of a wide-angle lens; when used well, it is one of the best tools in your bag. When I am forced to go light I always take a wide-angle lens. I might have to leave the telephoto in the car, but I'll always have a wide-angle zoom with me and a short telephoto like an 85mm.

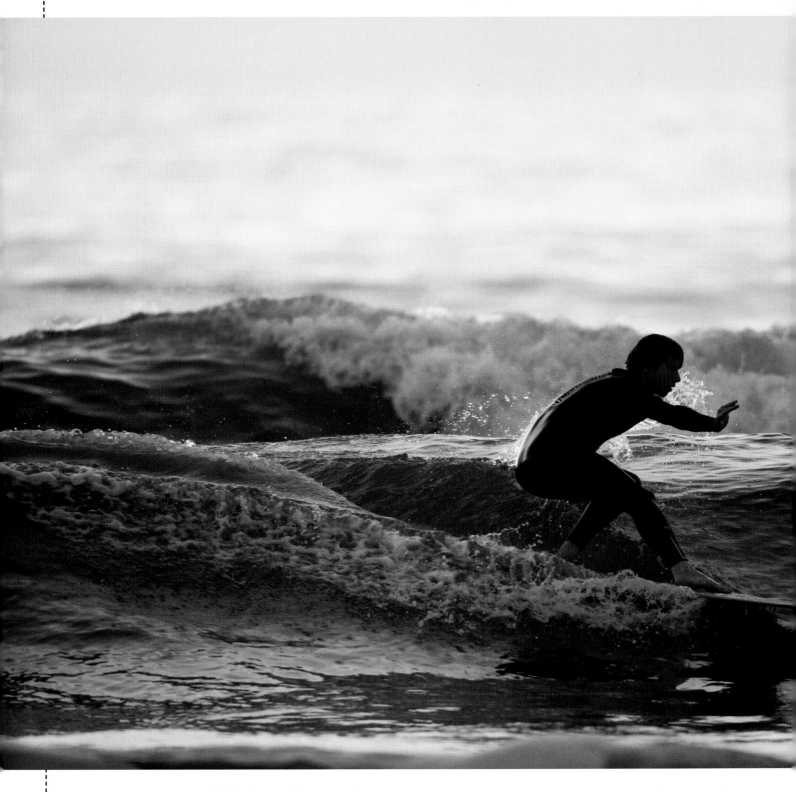

Telephoto photography: There are a lot times when you just can't get in close enough to use a wide-angle lens, and that is where the telephoto lens comes into its own. Surfing photography is one good example. Photographers do often get in the water with wide-angle lenses and waterproof housings, but shooting from the beach with a 600mm f/4 telephoto is a safer. For mountain biking photography, one of the "standard" lenses is a 70-200mm zoom because it gives photographers a comfortable working distance and allows the riders to perform without someone getting in the way. The telephoto perspective is also great for capturing details, like when a climber chalks up just before getting on a boulder problem. In this case, a 70-200mm allows you to zoom in and capture the chalk floating around the climber's hands as they sink into the chalk bag.

Daniel Bleicher surfs "old school" on a flat wooden Wegener board that has no fin. This image was shot with a 600mm f/4 telephoto lens.

Remote camera work: Finding a wild perspective often involves mounting a camera in an unusual location, like the seat post of a mountain bike, the front of a surfboard or kayak, or the wingtip of an airplane. In almost every instance, a wide-angle or fisheye lens is used to gain the widest angle of view and also because these lenses are generally lightweight, which helps keep the camera from getting spit off and damaged. Once the camera is mounted to an object it isn't accessible anymore, so most photographers pre-focus or set the focus using a hyperfocal distance method and use some sort of radio slave, like a Pocket Wizard setup, to wirelessly trigger the camera.

Remote camera work takes some pre-planning to figure out how the camera will be mounted, what direction it should be aimed at, and how to account for varying exposures. Generally, I'll put the camera into Aperture priority mode so that changing light doesn't force me to reset the camera once it is mounted. Depending on the light that day, I might even dial in -1/3 of a stop underexposure to keep any important highlights from blowing out. And I'll either pre-focus the camera if my subject is at a fixed distance or use the hyperfocal method when it isn't. I would also use large memory cards (8GB and up) so that the memory won't run out while shooting. If using an underwater housing, it pays to figure this stuff out before putting the camera into the housing. The last consideration is positioning the Pocket Wizard receiver so it can receive the signal from the handheld transmitter. This is all a trial-by-error type scenario, so testing out your equipment beforehand is paramount.

Remote camera setups are a lot of work, but the rewards are usually worth it if you can get a perspective no one has seen before. Having a few of these images in your portfolio will get you work and they encourage questions by those viewing your images, which is always good. Don't be afraid to get creative. I've mounted cameras on a cyclist's leg, a kayaker's chest, and all over mountain bikes. You'll find that you might have to take a few hundred images to get one that really shines, but with a bit of work it isn't too hard to get some stunning images.

Aerial Photography: A lot of adventure photography is now done from helicopters and air- planes. Much of the big mountain ski photography you see these days is shot from a helicopter with telephoto lenses. Likewise, big wave surfing photography has also seen an influx of heli- copter-assisted images. In reality, shooting from a helicopter or airplane isn't that big of a deal (unless you are deathly afraid of heights). If possible, you have to be able to open or remove the door so that you have nothing between you and the subject. In an airplane, depending on your speed and altitude, there can be a lot of turbulence and wind if you lean out of the door, but otherwise it is pretty casual. With a helicopter there will always be a lot of prop wash since you are right under the blades. Of course, being strapped in is a good idea. I normally take a climbing harness and clip myself into a few solid anchor points so I can concentrate on the images and not have to worry about safety. Other important considerations are communicating effectively with your pilot and the athletes, staying warm if shooting in winter conditions, and anchoring your camera gear so it can't slide around or fly out an open door.

I load my cameras with 8GB or larger memory cards so I won't have to change cards often, if at all. If I need to change lenses I ask the pilot to keep us steady for a second so nothing rolls out and I can zip my camera bag closed. In some situations I'll work with two cameras, one with a big telephoto zoom lens on it and another with a midrange or wide-angle zoom, and I'll lay that extra camera on the seat next to me so I can access it quickly.

In terms of holding the camera steady for still photography, I have not really had any issues unless there is extreme turbulence. Keep your shutter speed as high as possible to counteract any vibrations, especially in a helicopter. I'd recommend using a shutter speed of at least 1/1000 second to insure sharp images. In an airplane, if there is very little turbulence you can get away with lower shutter speeds depending on the situation. You'll have to experiment with what works, but lean towards higher shutter speeds as flight time isn't cheap and you don't want to find out later that your shots are blurry. This is one of those times where hav- ing a camera that can shoot at 800 ISO with very little noise is a great tool to have. And if any of your lenses happen to have vibration limiting technology, experiment with that as it can also help out, though in some circumstances it does try to counteract the motion so much that all you get are soft images.

Mounting a camera on an athlete or a piece of equipment can help show the action up close, as if the viewer were actually there. I used a Slik Clamp Head to attach the cam- era to this bike's seat post.

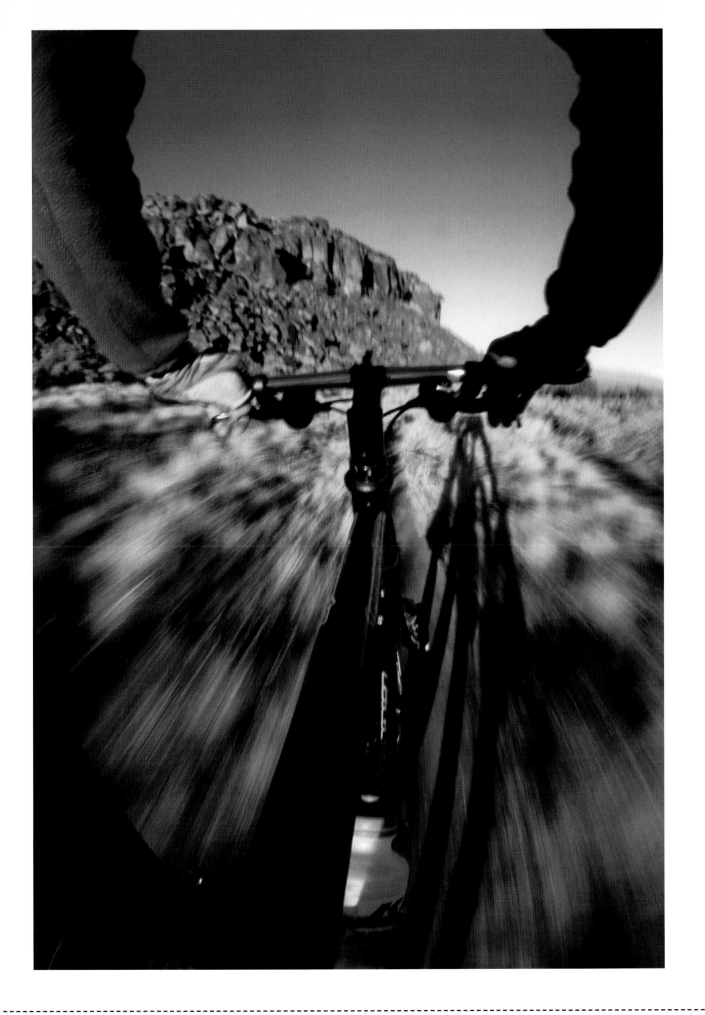

ARTIFICIAL LIGHTING 4

Learning how and when to use artificial light to enhance your images is a key step in taking your photography to the next level. By artificial light, I mean any light source that is available other than the sun. Whether using shoe mounted flashes, battery-powered strobes, hot lights, or even just a headlamp, these lights can add drama and depth to an image when used effectively. Like other general topics touched on in this book, artificial lighting is highly nuanced; instead of getting into too much detail here, I'll leave it up to the reader to explore the technical aspects of lighting. There are quite a few excellent books, websites, and blogs out there that go into great detail about using these tools. One of the best is the Strobist blog at www.strobist.com, which includes tutorials covering everything from basic to advanced techniques for all types of flash photography. What we'll focus on here is when and where to introduce artificial light, the equipment options, and some basic lighting fundamentals.

The pilots of the Henry 1 Helicopter Search and Rescue unit in Santa Rosa, California, set up their night vision equipment before taking off on a call. This picture was taken using two Dyna-Lite Uni400jr monolights with red gels, a headlamp (pointed at the pilot's face from within), and available light from the instrument panel to capture the cockpit at night. I used intense gels to accentuate and amplify the existing blend of already saturated colors.

WHEN AND WHERE TO INTRODUCE ARTIFICIAL LIGHT

Deciding when and where to use artificial light will depend on many factors. First, you'll have to decide if the existing light quality isn't working for you. The following are common situations for when you might want to add artificial light: the existing light is dull, lacking contrast (as it often is on cloudy days), or the light is too dark to use a fast enough shutter speed to stop the action. Another situation where artificial light helps is in high-contrast conditions, such as in a forest at high noon. Flash can be used in this situation to balance out the dark shadows and the bright highlights under the forest canopy. Most often, you'll want to use artificial light to add drama and give the image more impact than it would have otherwise.

If you decide you want to improve or alter the existing light, you'll have to consider the power your artificial lights offer. Are you working with shoe mount flashes? If so, they have limited power, so you'll have to be in a shaded area or shooting outside at dusk, dawn, or in the twilight. However, these small flashes work well for adding just a kiss of light, called fill flash, any time of day. With fill flash, you generally have to be pretty close to your subject, usually around 4-10 feet (1.2-3 m) away. If you have stronger strobes that offer 1000 watt/seconds or more of power, then you'll be able to overpower daylight with no problem.

Note: It has become common to use the word "strobe" when referring to the larger studio-style lighting kits. The term strobe derives from "stroboscopic" lighting, which is a quickly pulsating light. Technically, "strobe" isn't an accurate term for studio lighting kits, but because its use has become so standard, I use it here to describe battery-operated power packs with flash heads.

This image is an example of using a headlamp to get the classic glowing tent shot. It was taken while on a backpacking trip in Canyonlands National Park, Utah. I walked up to the tent during the 30-second exposure, shined the light inside the tent for a second or two, and then continued past the camera to create both the glowing tent and the light streaks.

Before a shoot, I normally scout the location to figure out if I'll need to use strobes to get the images I want. Even if I haven't scouted the location, I can previsualize the effect I am going for and decide whether or not it is possible, or even worth it, to really go all out with artificial lighting. In my experience, it helps a great deal to have an assistant if you are going to use strobes because they weigh a ton when you consider all the extras (like flash heads, light stands, soft boxes, reflectors, etc.). It also takes some time to get everything set up and to dial in the light output for each strobe. Having an extra person available to hold onto the lights is also a good idea so your $800 strobe head doesn't take a digger when the wind starts to blow.

In some situations, it isn't how much power you need, but how little. Usually with night shots and long exposures, lightpainting is the way to go. With this technique, you take a flashlight or headlamp and paint light onto your subject or through a surface, like a tent wall, while the camera's shutter is open. The camera records the light as it is "painted" onto your subject. It is very easy to control how much light is applied and where it falls with this technique. The "glowing tent" shot (above) is a classic outdoor trick that's best done with lightpainting. If you drop your shoe mount flash into a tent at night and fire it during a long exposure, you'll quickly find out the tent isn't glowing orange, but is white hot because the flash kicks out way too much light. In this situation, a headlamp or flashlight is the best way to go.

LIGHT SOURCES

There are numerous light sources available to the adventure photographer. We'll start with the smaller, lightweight options and work our way up to the heavyweights. The odds are good that you (and your athletes) will have a headlamp or flashlight as part of your standard kit. Think about ways to incorporate them into your images after sunset or before sunrise. Of course, since these lights don't normally have much firepower (unless you have a serious flashlight) you'll have to find creative situations where they will work, as in the glowing tent scenario.

SHOE MOUNT FLASHES

Most camera manufacturers have pretty phenomenal small flash units designed specifically for their cameras. Even though they are often called hot shoe flashes or shoe mount

flashes, many models work wirelessesly off-camera. I normally always carry at least one Nikon SB-900 Speedlight with me and sometimes multiple SB-900 and SB-800 units, depending on the shoot. Because they are so lightweight, and work wirelessly, these units are quick to set up and can yield some great results. As with all flash photography, if you want decent looking images you need to get the flash unit off the camera unless you are going for that "deer in the headlights" look. Either use the wireless capabilities of your system or buy a dedicated flash cord to trigger the flash unit off camera. I also recommend using the plastic stand that usually comes with the flash unit when setting it on the ground, and also buying some Velcro fasteners to lash the unit to a nearby tree.

I typically use shoe mount flashes when I am going light and fast, when shooting in low light or stormy weather, or when I want to offset harsh lighting conditions with a little fill flash. If I know I'll be using my flash

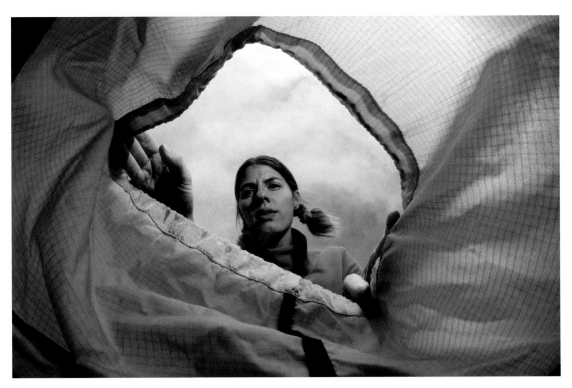

While on assignment for *Backpacker* magazine, I had Sara Stathas look down into her open pack to get this image. The camera was resting on top of several layers of clothing with a fisheye lens pointing straight up. I set the camera to self-timer mode and used a TTL cord, which came through one of the side zippers of the pack to trigger my Nikon SB800 flash, which was held a few feet away (1 m) on Sara's left. To soften the light, I used a diffusion dome. Since it was a cloudy day, and using the automatic functions of the flash worked very well, I only had to take two or three photos to get what I was looking for.

units on a shoot and we'll be stationary, I'll bring along a few lightweight light stands and even a few small collapsible umbrellas to soften the light. Shoe mount flashes are a harsh light source (because they are small compared to your subject), but when used in combination with other shoe mount flashes or with a light modifier, like an umbrella, a small softbox, or even bouncing the light off a lightweight reflector, you can easily soften the light output. In general, I normally don't point the flash head straight at my subject without a light modifier unless I am trying to spotlight a certain aspect of the frame. Instead, I'll raise the flash so it is pointing a little more towards the sky, which gives a nice fall-off as the light moves down my subject. This works especially well when using the plastic diffusion dome that comes standard with most units. But every situation is different, so work with your flash and check your LCD to figure out what setup works best for your subject. If you are using an umbrella, softbox, or snoot, then you will want to point the light source toward your subject.

Since these little flashes are fairly technical to use, I would highly recommend reading the manual and experimenting with them before you get out on a shoot. Most models work well as wireless units, though it will take some time to get them set up if you've never shot with them before. With Nikon's Speedlight models, you can shoot with as many units as you can afford (or borrow), and you have complete control over their output directly from the camera. Shoe mount flashes are the most economical choice for outdoor lighting, but if you need multiple units to pull off your lighting needs, the total price can start to add up rather quickly. Your needs will depend on the situations you want to use flash in, how much power output you'll need (shoe mount flashes generally produce about 60 to 125 watt/seconds of light), and how much weight you are willing to carry—and, of course, your budget. If you need more power than a few units can produce, then a

This image of Sadhana Woodman practicing yoga in White Sands National Monument, New Mexico, is a good example of using a small flash unit to mix natural and artificial light. The picture was taken about thirty minutes after sunset and it was getting quite dark, so I used a 1/15 second shutter speed and a Nikon SB800 Speedlight, triggered wirelessly, to add some light and keep on shooting. Because the flash was set on the ground, I pointed the head straight up and used the diffusion dome to soften and bounce the light.

battery-powered strobe may be a better choice. If you need a small, lightweight kit for shooting on the run and you don't need 1000 watt/seconds, then a few shoe mount flashes might be all you need. Most folks start out with the smaller units because they are cheaper and easier to use, but at some point when you start to yearn for more control and more power, you'll have to step up to the battery-powered strobes.

One of my favorite lighting tricks with a shoe mount flash is to use rear-sync mode and slow shutter speeds to create motion blur images. Usually, I set the camera's shutter speed to around 1/10 to 1/30 second, depending on how fast the subject is moving. This allows for a solid streak of motion before the flash unit fires with the closing of the shutter (thus the rear sync) and effectively freezes the action. I'll either stand in one position and snap the shutter as the athlete goes flying by, or I'll run with the athlete, holding the camera in position (usually not at my eye) while an assistant runs with the flash several feet (1-2 m) away. Since shoe

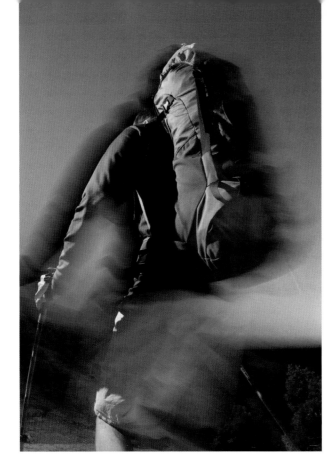

This picture is a great example of using a shoe mount flash in rear sync mode. For this shot of Steve Hyde backpacking near Los Alamos, New Mexico, I had my assistant walk with the flash just slightly in front of Steve and to my left. I was holding my camera at about knee level with a 16mm fisheye and used a shutter speed of 1/8 second. I shot about 80 images in the twilight and this was the best one.

mount flashes don't have a ton of power and I need a slow shutter speed for this setup, I wait until just after sunset to create this type of image. For this technique, the exposure is optimized for the background. Aperture priority exposure mode usually works phenomenally well in this situation because it will automatically adjust the exposure for the background and then let the flash fill in as needed. (However, make sure the aperture works with the range of the flash.) The process involves a lot of trial and error, but if you can get one image that really captures your vision, that's all you need.

If used in close proximity to your subject, shoe mount flashes can be used as fill-flash to open up harsh shadows during the day. The latest units can pretty much figure

out the amount of fill light needed without too much thinking on your part. And if the light output is too much or not enough, it is easy to add or subtract light via the compensation settings on the flash unit itself, or on your camera depending on your setup. Usually, shoe mount flashes also have gel filters included so you can warm up the light temperature, which helps create that eye-catching warm/cool effect so often used in movies. I have a light amber gel, which is the equivalent of a 1/8 CTO (Color Temperature Orange) gel, on my SB-900s almost all of the time.

As with any light source, you can use light modifiers to control the shape and feel of the light. A snoot is a great way to narrow the beam of light emitted from a shoe mount flashe. This creates a rather hard point source of light, which is great when you want to spotlight some aspect of your image. A cheap and lightweight method for creating a snoot is to cut down a piece of cardboard (cereal boxes work great for this) so that it is about five-inches (12.7 cm) long and surrounds the flash's head like a gun silencer. If you want to keep the output high so you don't lose any light as it travels through the cardboard, wrap the inner part of your snoot with aluminum foil. Of course, you can also buy a little attachment like the HonlPhoto Speed Snoot, which attaches with Velcro. HonlPhoto also makes grid spots that fit over the front of most Canon or Nikon flash units to narrow the beam. To create softer light, there are a number of miniature softboxes that are lightweight and designed for use with shoe mount flashes. The best one I have seen is the Lastolite EZYBOX Softbox, and it even comes with a bracket that mounts your flash unit onto the softbox. With any light modifier, you will lose at least a half stop of light output, sometimes more. If you need more power, you can always use multiple units. As shoe mount flashes continue to get more powerful and much more user-friendly, they will become the go-to gear for adventure photography lighting.

CONTINUOUS LIGHTING

Continuous lighting is used most often in the video or motion picture industry. Continuous lights are also known as hot lights because they produce a lot of heat. They are usually tungsten or daylight balanced lights that are always on once you plug them in. The advantage with hot lights is that you can see exactly how the lighting looks on your subject because the light is continuous. The disadvantage for the adventure photographer is that not much light is produced and they need a lot of electricity. Realistically, in the outdoors it is almost impossible to use hot lights without a serious production that includes a monster gas-powered generator.

BATTERY-POWERED STROBES

For the adventure sports photographer, the king of lighting tools is a battery-powered strobe setup. My top pick for a battery-operated strobe setup is the Elinchrom Ranger RX Speed AS used with the Free Lite A flash heads. This setup produces a maximum of 1100 watt/seconds of light and has a very short flash duration, which is perfect for stopping action. Profoto, Hensel, and Dyna-Lite also make kits that work extremely well. The Profoto 7B or the B2, as well as the Hensel Porty 12, in particular, are on par with the Elinchrom setup I use. Basically, what these kits give you is power. With 1000-plus watt/seconds of light, you have a lot more options than with shoe mount flashes.

This image of Ryon Reed freeriding at Bartlett Wash near Moab, Utah, was shot with a 10.5mm fisheye lens, a Dyna-Lite Uni400jr monolight, and a 7-inch (17.8 cm) reflector. The strobe, held by my assistant, was positioned off camera directly in front of Ryon and above the lip of the small cave I was tucked into. To get this image, Ryon rode by me several times until I got the shot. As is normal when shooting action sports with flash, you only get one shot each go-around because the flash has to recharge, so timing is key.

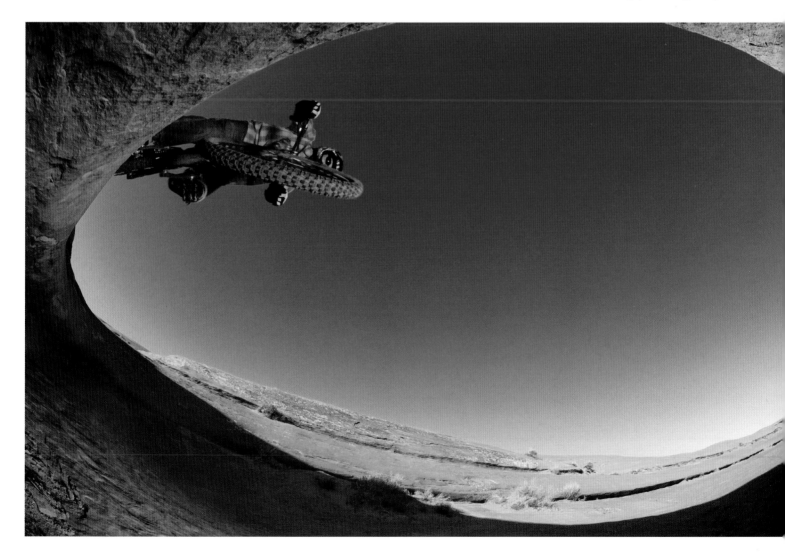

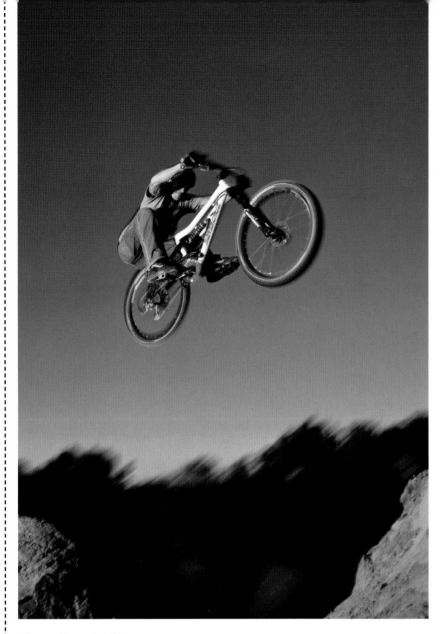

To get this motion blur image of Ed Strang freeriding near Santa Fe, New Mexico, I used an Elinchrom Ranger RX Speed AS pack with a Free Lite A head synced wirelessly to my camera via Skyport radio triggers. I used a shutter speed of 1/30 second and panned the camera with Ed as he flew off the top of the dirt jump. While this image was shot with a heavier lighting setup, it could have just as easily been shot with shoe mount units, but I feel the light quality is much nicer because of the larger setup.

shooting action. I haven't really found a super lightweight option that can match the Elinchrom Ranger setup, but the Uni400jr is the best system available when considering the power-to-weight ratio. In reality, these two options aren't lightweight strobes by any account, nor are they inexpensive, but if you want and need the best light quality, these choices are the ticket.

The battery-powered strobe setup is great for numerous genres of adventure sports, including skateboarding, BMX, whitewater kayaking, mountain biking, bouldering, and even roped rock climbing. I pull out the strobes when shooting rock climbing in a cave, mountain biking in the woods, evening BMX or freestyle mountain biking sessions, or even whitewater kayaking in deep shade. Whenever I want to add drama to an image I start thinking about ways I can use flash, what locations would work best, and the time of day I'll need to be there for the best effect. As long as you are willing to lug it in, it can be used anywhere. I normally set up one light first and see what I can do with it. If it seems like another light is needed, I'll add one more light and re-evaluate. I'll continue adding lights until I've overdone it or I have achieved the effect I want. In general, I'll have one light illuminating the athlete and one or more lights illuminating the background, if needed. Most of the time I can get away with one light if I pick the right time of day and have a colorful background, especially if I am shooting at sunset.

A lighter but less powerful lighting setup that I also use is the Dyna-Lite Uni400jr monolight (which has flash heads that have a power pack built into them) with the Dyna-Lite Jackrabbit batteries. While these units produce only 400 watt/seconds of light, the total weight of one flash head and battery is just over six pounds (2.7 kg). For those situations where 400 watt/seconds of light is enough and I have a long hike in, these units offer a lighter option than the Elinchrom Ranger setup, which is 19 pounds (8.6 kg) with one flash head and 23 pounds (10.4 kg) with two heads. The major downside to the Uni400jr is that at full power, the recycling time is approximately five seconds, which seems like an eternity when you are

In this image of Claire Bell bouldering at Horse Pens 40 near Steele, Alabama, I used two Dyna-Lite Uni400jrs to light the scene. One was tucked into the cave next to her and another was set up behind the boulders to light up the crack. In hindsight, I would have used a flag to knock down the light intensity of the rocks in the cave and I would have added a third light from my shooting position to add just a little more light. Still, this image serves as a good learning opportunity, which is why I included it here.

This portrait of Nicolas Danan was taken just after freediving at the Blue Hole in Santa Rosa, New Mexico. I used one strobe, the Elinchrom Ranger RX Speed AS, placed just behind me and above my head. A shoot through umbrella was the only light modifier used, proof that simple setups can still yield great portraits.

Aside from the action, I also use strobes for portraiture. When shooting portraits, a battery-powered unit will help keep the session moving because of its short recycle times. Most people don't like to have their picture taken, especially when they know it is going to be a portrait, so make sure you keep things moving. The more enthusiasm you show for the images, the more your subject will open up. We'll get more in-depth into portraiture and lifestyle photography in Chapter 8.

LIGHT MODIFIERS

A flash is only as good as the light modifiers that are used to channel and filter the light. So if you thought the basic kit is all you'll ever need, think again. One of the first things to consider when choosing a light modifier is the quality of light you want. Do you want soft graduated transitions from highlight to shadow areas? Or do you want a really hard-edged shadow or something in between? Your preference will determine the modifier you choose and also where you position the light. In general, the larger the light source in relation to the subject, the softer the light quality. The opposite is also true: the smaller the light source in relation to the subject, the harder the light quality.

If you want to render your subject in soft light, you'll need a large softbox or umbrella. The closer you put the softbox to the subject, the softer the light will be and the more

it will wrap around their face or body. One of the reasons I use the Ranger RX Speed AS strobe is that Elinchrom makes some of the best softboxes in the world, and they are specifically designed for use with their flash heads. Add to this the fact that they open like an umbrella and mount quickly and easily, which eliminates having to fiddle with speed rings and the funky poles standard with other softboxes, and it's a winning combination. One of my other favorite light modifiers for adventure photography is the beauty dish, which is either a 17- or 25-inch (43 or 63.5 cm) metal reflector that can be used with a diffusion sock over it. The reason I like it so much for outdoor use is that it is smaller and easier to set up than a softbox and still gives a soft light quality. It also catches a lot less wind than a full-blown softbox, which acts like a kite in the wind and needs a lot of weight to hold it down.

If you are going for a hard light quality with defined shadows, you'll need to focus the light coming out of the strobe with a metal reflector or grid spots. Grid spots are honeycomb patterned metal inserts that help corral the light into a narrow beam. A stan-dard or long throw reflector can also be used to focus the light, but it won't concentrate it as much as a grid spot. Also, placing the light with a small reflector close to your subject can create a softer hard light. If you take this same setup and pull it farther away, you will create a point light source similar to the sun, which results in hard-edged shadows.

Last but not least, gels should be part of any photographer's basic lighting kit, especially gels that are color temperature orange (CTO) and color temperature blue (CTB). These are rated according to strength with notations like 1/8, 1/4, 1/2, and full. A 1/4 CTO adds half the amount of Orange as a 1/2 CTO and so on. Blue gels will add cool color or blue light just as orange gels will add warm light. For a lot of my work, I tape a 1/8 or 1/4 CTO gel over my strobes. If I am looking for wild colors, I also have red and green gels in my lighting kit, but I tend to not get too crazy with gels unless the image already has some intense color in it that I want to amplify.

This is a shot of a lighting setup on location. Eric Barth, who was assisting me, stood in for a light-ing test. I had the Elinchrom Ranger RX Speed AS set up with a beauty dish (with a diffusion sock over it) and an additional diffusion panel just in front of it to further soften the light. I also had a 24-inch square 1/8th CTO taped onto the beauty dish to warm up the light. With this setup, the light nice-ly falls off towards his feet. To darken the background and give it even more contrast, I can adjust the shutter speed.

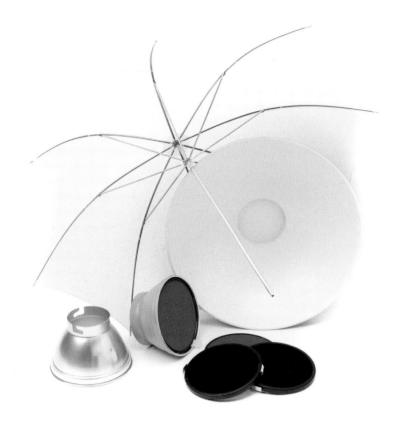

You'll need to use light modifiers to achieve the look you want in your images. This is a selection of items from my kit, including a few 7-inch (17.8 cm) reflectors, a set of grid spots, a beauty dish, and a medium size shoot through umbrella.

LIGHTING FUNDAMENTALS

Lighting is an art that takes years to perfect, and there will always be something new to learn. The suggestions here are by no means a complete outline of the fundamentals, but it will at least give you some things to think about.

CHOSE THE RIGHT LIGHT

I suggest always shooting with natural light first, and then making the decision whether or not to light the image artificially. Usually it is obvious when you'll need to use artificial light, but sometimes you can create an image that is much stronger by just using natural light.

When the natural light isn't bright enough, use flash to mimic the light already present. To do this, determine the direction and quality of the natural light. The direction part is easy: place your light in the same place the natural light is coming from.

Mimicking the quality of the natural light can be a bit trickier. Is it hard light or soft light? For soft light, use a large softbox or even several strobes with softboxes behind a huge silk for the softest light possible. For hard directional light, choose from grid spots, metal reflectors, or even the strobe's bare bulb without any light modifier.

Another trick for creating dramatic images is to avoid lighting the entire frame. Lighting the entire frame creates a situation where the viewer's eye has no place to roam, and this often equates to a boring image. There are a few ways you can control the light on your subject so that the entire image isn't lit, such as using many of the light modifiers we have already discussed. Another method is to use what are called flags, which are opaque pieces of material used to block parts of the light. A flag can be anything from a fancy piece of fabric to a cardboard box. If you don't want the ground lit, for example, put a flag under your strobe to block the light. The light will then spill over the edge of the flag, creating a nice graduated fall-off in the light intensity rather than an evenly lit area. When you want soft light and are using a softbox, you can graduate the light intensity cast on your subject by putting the light slightly above them and pointing down. This way, the light intensity will gradually decline the farther away it gets from the source and your subject's face will be perfectly exposed while their torso and legs will be darker.

ADJUSTING BACKGROUND BRIGHTNESS

As with all flash photography, remember that your aperture setting controls the exposure on the subject being illuminated by the flash while the shutter speed controls the brightness of the background, as well as the entire image. For most images, it's best to

This image is a good example of mimicking the natural light present in a scene. When we arrived, there was already light similar to what can be seen in this image, but it was very dark. I placed a Dyna-Lite Uni400jr and a Jackrabbit battery pack with a standard 7-inch (17.8 cm) reflector in the entrance to light the rider from behind. By placing a strobe in the entrance I not only pumped up the amount of light, but also created an interesting shadow on the opposite wall.

balance the foreground and background so that the subject stands out just a bit. Most of the time when I am shooting sports or portraits, I'll crank the light on the subject up to where I am a full or half stop brighter than the ambient light in the background. This is pretty easy to do. As an example, let's say I am shooting at twilight. I would use a hand-held light meter, or the camera's light meter, and take a reading of the ambient light. Since most D-SLRs can't synch with strobes faster than 1/250 second, I'll set my light meter to tell me the correct aperture at 1/125 second. This gives me some room to

adjust the shutter speed for the background. Let's say that the matching aperture for a correct ambient exposure is f/5.6. At this point, I will set my flash so that it exposes my subject correctly at f/5.6. To darken the background just a bit, I'll choose a shutter speed of 1/250 second, which is one full stop less light than my ambient reading. Thus, with my camera set manually to f/5.6 and 1/250 second, the subject is perfectly lit and the background is one stop darker than the ambient reading. Since it's twilight, if I wanted to brighten the background, I might shoot with a shutter speed of 1/125 second

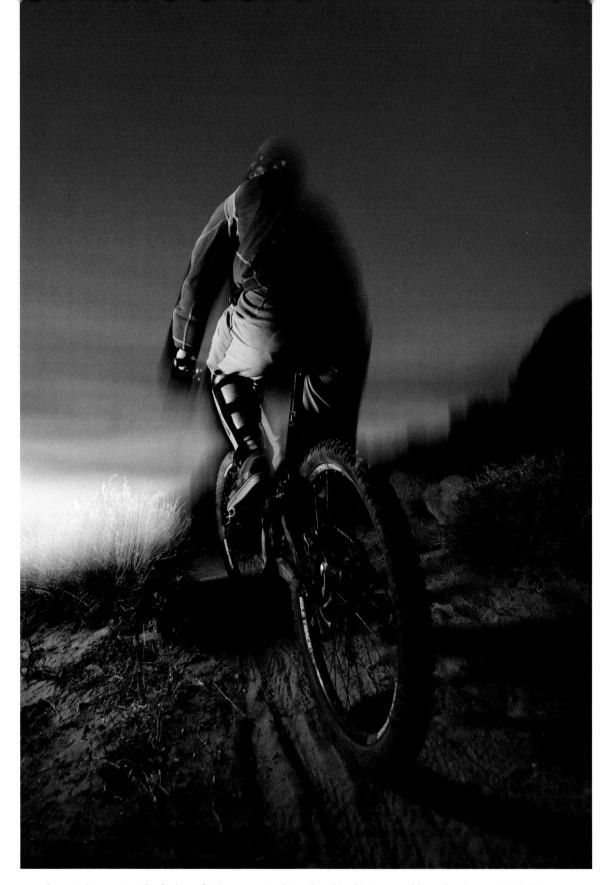

I wanted to capture the feeling of riding on a single-track trail in this image of Ryon Reed mountain biking near Moab, Utah. To create the pan blur effect, both my assistant and I ran with Ryon as he pedaled down the trail. My assistant ran with a Uni400jr monolight powered by a Jackrabbit battery pack while I followed with the camera set to a shutter speed of 1/10 second at f/7.1. I held the camera just below my knees with the autofocus engaged as we tried to keep up with the bike.

or 1/160 second, depending on how it looked in a few test shots. This is just one way to think about the process. You can switch it around and start with the aperture produced by your flash (which is dependent on its power settings) and work backwards from there. If this sounds confusing, remember that you are shooting digital and a quick look at the picture and histogram on the LCD will help as a guide. It is always advisable to snap a few photos at different shutter speeds to see what the images look like before you decide on your settings. If I prefer to have the subject look more natural, so it is difficult to even tell that flash was used, I'll match the ambient and flash exposure more closely, with only a 1/3 stop difference. Achieving this natural look isn't always easy and normally involves using large softboxes and bouncing the light or multiple strobes behind a large scrim to create a soft light source.

One way to really learn about lighting is to look at some of your favorite images that were shot with artificial light. Usually you'll be able to tell how many lights were used and the direction of those lights by the shadows cast. If you can see the subject's eyes, then you also have a reflection of the light itself, which will tell you what kind of light modifier was used on the strobe. If you look at the images I have included in this chapter, you'll be able to figure out a lot of my standard lighting tricks with the help of the detailed captions.

Using artificial light isn't an easy 1-2-3-step process you can repeat for every image. There are many setups that work very well for certain situations, but for the most part, the lighting will be dictated by the location, the look you are going for, and your knowledge. With that in mind, start the learning process now and expect it to continue for the rest of your life.

FLASH DURATION

Flash duration is yet another factor to think about when setting up a shot. Do you need a fast flash duration to stop motion, or is a slower, longer flash duration what you need to create a ghosting effect? For all shoe mount flashes and strobes (except Alien Bees brand strobes), setting them to a lower power output gives you a faster (i.e. shorter) flash duration. Alternatively, setting your flash to full power or a higher power output results in a slower (i.e. longer) flash duration. Flashes vary in what their shortest duration is, with the options varying from 1/2000 second to 1/12000 second. For adventure sports photography, a shorter flash duration is usually better to help freeze action.

During my last year of college, I took a rock-climbing course and quickly fell in love with the sport. It soon became all I thought about, and over the next few years I traveled the globe, visiting world-class rock climbing and mountaineering destinations. Spending this time in the mountains reinvigorated my interest in photography, and got me excited about the prospect of becoming a pro and documenting the world of climbing. Over the course of my career, as I expanded my outdoor experience and photography skills, I started to shoot other mountain sports, including mountain biking, ice climbing, mountaineering, and skiing. I soon realized that one of the great joys of being an adventure sports photographer is documenting elite athletes pushing the boundaries of what is physically and mentally possible. The moments when you watch (and record) someone achieve a feat previously thought impossible really stick with you. As an adventure photographer, your job is not just to capture the moment, but also to work with the athletes to create an eye-popping image so that others can share in the experience. By their very nature, mountain sports are what adventure photography is all about, and the combination of action and natural scenery usually offers up incredible visual opportunities for those with a creative eye.

When I teach workshops, one of the first questions I always hear is, "What gear do you use?" Because each sport is unique, and getting into position or even staying with the athletes can be difficult, I tailor my gear and how I carry it for the different sports I shoot. Of course, each sport has other photographic considerations that have to be taken into account, too. Shooting a kayaker is obviously going to be a different experience than photographing a rock climber. As we discuss each sport separately in the next three chapters, I'll share specific information on how to best document the action, what gear I use, and how I carry it to the location.

ROCK CLIMBING

Climbing photography is hard work. There is no getting around that fact. Lugging anywhere from 50 to 120 pounds (22.7-54.4 kg) of gear to the cliff, getting set up and established on the wall, and timing it so the lighting is perfect is hard physical labor that requires a lot of sport-specific know-how. If you want to shoot rock climbing, it obviously helps if you are already a climber—in fact, I'd say it is all but a requirement. You don't need to be an elite athlete by any means (I certainly am not), but you do need to be highly proficient in both free climbing and aid climbing techniques so you can get into position quickly, be comfortable, and safe in the vertical world. Beyond basic climbing skills, I would also say that you need enthusiasm and drive, because no one is going to work as hard as is required without a serious passion for the sport. In fact, I think being passionate about the activity is an overriding condition for shooting any adventure sport. Without passion and an understanding of a sport's subtleties, it's hard to understand what makes a strong, interesting, and informed image. With that in mind, we're going to look at important aspects of how to successfully shoot rock climbing, including getting into position, general considerations, and lighting. We'll wrap things up with a quick overview of photographing bouldering.

This image of Elaina Smith climbing Habenero (5.12a) on the Outrage Wall in Potrero Chico, Mexico, shows how timing can pay off. The sun was setting behind Elaina and the shadows were climbing up the wall below her. I asked her to do this move as many times as she could just before the shadow engulfed her as I shot from an adjacent route about 100 feet (30.48 m) away with a 70-200mm lens.

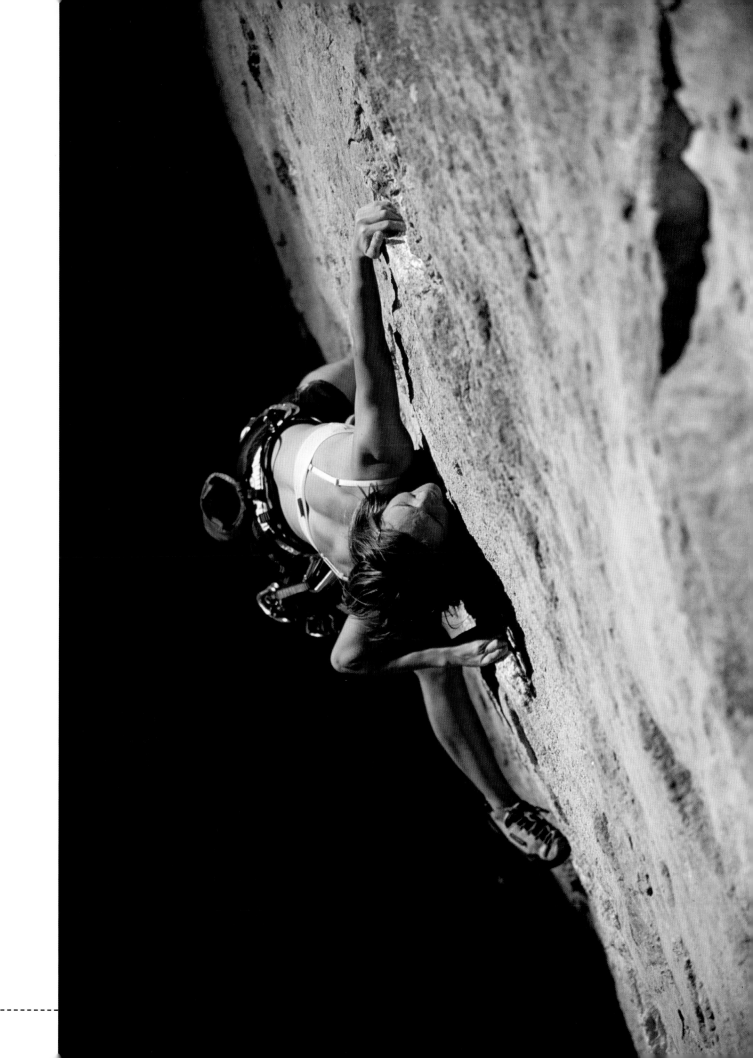

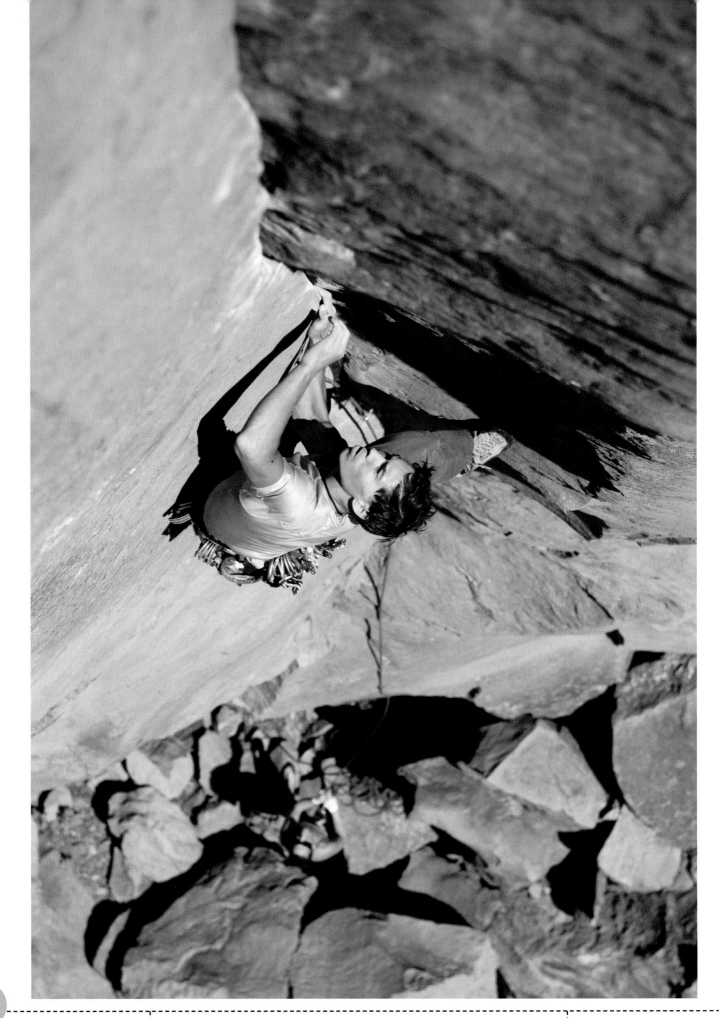

GETTING INTO POSITION

Once at the crag, the first thing you'll want to do is scope out the surroundings since figuring out the best shooting position is often determined by the landscape. If there is a nearby hill or gulley that can be used to safely get above or to the side of the climber, check that out first. Sometimes these positions offer unique angles you wouldn't get otherwise, even with hours of setting up ropes. Keep in mind that you don't have to be right next to the route in these cases; a telephoto lens will help capture the action from a distance. With climbing photography, and really with all adventure sports photography, finding the best angle is key. So always be on the lookout for perspectives that will produce unique or exciting compositions.

Typically, I prefer to shoot climbers on routes from above and off to one side or straight down the line of the route. This angle allows you to see the climber's determined face as well as the holds they are using, thus conveying the sequence and difficulty of the climb. While shooting from above the climber isn't always the best position for every route, it is guaranteed to be a good vantage point for many climbs.

Getting the rope set up, or fixed, to an anchor, is the first priority for shooting from above. For sport and traditional climbs, you'll often be sharing the route's anchors with your climbers. If I can aid climb a route, either with traditional gear or with a stick-clip (for sport climbs), I'll often fix a static line to the anchors myself. In some cases, you may be able to rappel in from above if there is access to the top of the wall. Generally, the ideal scenario is to have two equally strong climbers with you on a shoot; get one of them to climb the route first so you can see the moves and shoot from the side while still on the ground. Once the first climber reaches the anchors, they can pull your rope up and clip it in for you. You can then ascend the fixed rope and shoot the second climber on the route from above. This way, you are getting double the coverage of the route from the side and top. If using the anchors of the route you are shooting doesn't provide an interesting enough perspective, look around for nearby routes as other possibilities.

Once set up above the climber, try swinging on the rope and clipping into a nearby bolt or piece of traditional gear so you can shoot from different angles. You can also clip the rope into a directional piece of gear to achieve the same effect. This gear will help direct your fixed rope to the side of a climb, but allow you the freedom to move up and down the rope since you aren't clipped directly into a piece of gear. While ascending, I'll often move at about the same pace as the climber, staying just ahead of them as they climb. If needed, I'll sometimes ask them to "take" on the gear so I can adjust camera settings and change lenses or memory cards. While shooting from above, remember to pull your rope up to keep it out of your shots. I stack the extra rope into a rope bag that hangs from my harness. With this method, it is simple enough to "flake" the rope into the bag so that it is out of my way and easy to manage when I get to the anchors. (Also, remember to always back up your ascenders with a prusik knot or some other form of redundant protection.)

Depending on the steepness of the wall, there are a few tricks that can help you get into position and stay there. When shooting on an overhanging wall, it can be difficult to stabilize yourself while hanging out in space. To keep from spinning around on the rope, try to swing into the wall and clip into a piece of gear or a bolt. I usually have two five-foot (1.5 m) slings clipped to my harness, which allow me to always be clipped in as I move from bolt to bolt and prevents me from swinging out into space. In caves, where it's hard to do anything but hang at the mouth of the cave, you might just have to ascend the rope until you can get to the lip and stabilize yourself.

You don't have to stop shooting just because it's the middle of the day. In this image, Lee Brinckerhoff is climbing Paradise Lost (5.12), a hard crack climb at Paradise Forks near Flagstaff, Arizona. Because the sun was high in the sky, it illuminated Lee's face completely.

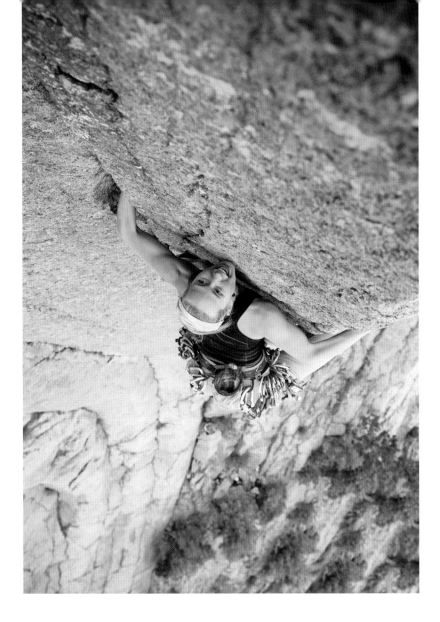

images on the fly. Make sure the climbers you are working with understand that they are there primarily for the photography. Sure, they will get some climbing in, but the focus is on the images. A big part of getting incredible climbing pictures is working with subjects who are very good at what they do and can perform again and again for the camera. Before I shot with the best-of-the-best, I photographed my friends who were strong climbers. If possible, seek out expert climbers in your area and set up a photo shoot with them. If you find you have to pay a modeling fee for your climbers' time, then so be it. In the end it's worth it to have creative control during the shoot and get the images you're after.

Depending on the position of the route, be sure to take the time to check out different angles so you can find the one that best matches what you have pre-visualized. Showing the exposed position of the climber is the entire point of climbing photography because you want your images to reveal just how steep the rock face is to the viewer. It will take some time and experience before you can judge which angle will best show off the climb and the climber—it isn't always obvious at first. But don't hinder yourself by thinking that a position is too hard to get to. If you need to get there, figure out a way. And when considering different angles, always try for a clean background that will make the image more graphic and focus the viewer's eyes straight to the climber.

Focus on a climber's movement and facial expressions. While you don't necessarily have to see the whites of the climber's eyes, you do need to see their face. One thing I tell every climber before we start is to look up as much as possible, not in an awkward manner, but when they reach for a hold I want them to look up at that hold so I can see their face. This point is critical. (One of the few exceptions to this rule would be if you are shooting a climber from the side, against a spectacular landscape, or from behind.)

CONSIDERATIONS WHILE SHOOTING

There are many general considerations to shooting climbing photography that seem obvious if you've been at it awhile. But for anyone just starting to shoot the sport, the topics covered here provide a good foundation of things to think about when planning shoots and composing images.

To start, if memorable climbing images are your goal, you'll usually have to work with the climbers, and they with you—it's really a team effort. Sometimes it's possible to snag a few decent images here and there while climbing casually with friends, but it is very rare. It takes too much time to get set up and into position to really get respectable

Emotions can run high when shooting climbers on routes at or near their limits. On this route, Jessica Kilroy is using every bit of fight she has to stay on Mr. Clean (5.11a) at Devil's Tower National Monument, Wyoming.

The best images usually occur when a climber is on a route that is at or close to the limit of their abilities because it forces them to strain hard, and the fear and concentration on their face pretty much says everything about the route. Watch them closely as they climb. If you see a section that creates a solid composition with an interesting body position, ask them to slow down or repeat that section a few times to make sure you get a good shot. I will normally shoot the entire route, but in reality, it ends up being those interesting sections that make the really good images.

While shooting, there are a few other things to remember. One tip is to get the entire climber's body in the shot. If the climber's legs are chopped off in the bottom of the image, it's hard to tell what they are doing. In fact, it might even look like they are simply standing on the ground. In some cases, like when shooting from above bulges, it is not always possible to have the entire body in the frame, but in these cases it is easy enough to lean out from the rock and show that the ground is a long way down and not just right below the climber.

In the old days (way back in the 1990s), photographers used to ask climbers to dress in bright colors. These days, I prefer to have climbers wear clothing with earth-toned colors like maroon, forest green, or smoky blue. I would avoid anything that is neon or too garish, and I would also avoid khaki, black, or pure white clothing as well. White clothing in general is not your friend, as it will overexpose or blow out in some cases. Because it is the brightest part of the image, it also attracts the viewer's eye to the clothing and away from the climber's face.

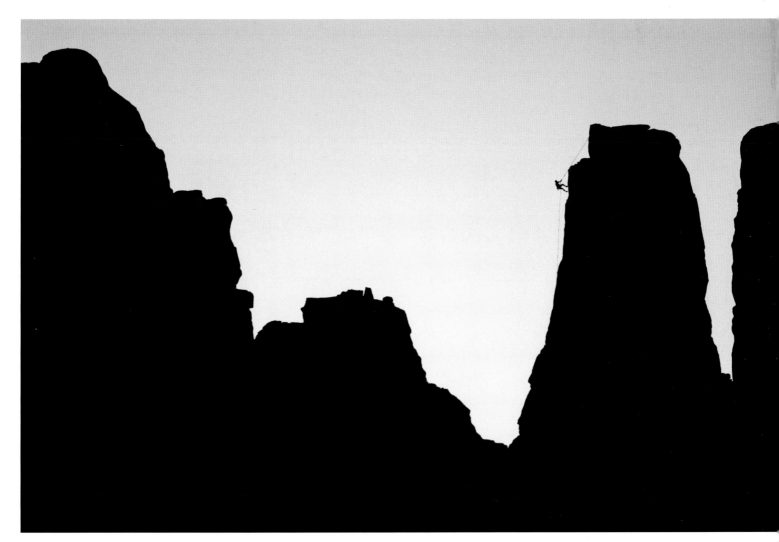

A climber rappels off Learning to Crawl (5.11) on the Bridger Jack Mesa in Indian Creek, Utah. I used a 300mm lens and a tripod to capture this graphic image.

Another tip is to use fast enough shutter speeds to overcome camera shake. After all, you'll be hanging from a rope up in the wind, so nothing is especially stable. A shutter speed of at least 1/125 second is advisable and with today's D-SLRs, it is easy enough to crank up the ISO settings to 800 or even 1600 (depending on your camera) if you are in the shade. On the flip side, it is kind of nice to have the climber's hand a little blurred as they desperately reach up to the next hold. As with everything in photography, experiment with the shutter speed if you want to capture a little blur. Just remember that in any blurred image there needs to be something sharply in focus; in this case, you would want the climber's face to be tack sharp.

As a final technical note, I usually shoot climbing in Manual mode, but if the light is changing quickly I'll switch to Aperture Priority because it allows me to control the depth of field more easily. Regardless of the exposure mode I'm using, the histogram provides feedback on the exposure and everything is adjusted according to the histogram as discussed in Chapter 3 (see page 60).

As with any adventure sport, the details tell a lot of the story. Be sure to watch out for good opportunities to get images of the climbers "crimping" on tiny holds, the rope running through a belay device, or hiking to the route. Adventure sports are much more of a lifestyle than more popular sports like football or basketball, and capturing this spirit is important, too. If you pay attention, there are some fantastic images to be had while climbers are packing up, hiking in, checking out the climbs, preparing to climb, putting on their shoes, chalking up, and organizing their gear.

IT'S ALL
ABOUT THE LIGHT

Dramatic light should always be your goal, but what form it comes in will vary greatly. If relying on natural light, keep the following basics in mind. If a route gets nice first or last light, come back with a climber and shoot at those times, especially if the route is an arête and you can get the sunrise or sunset behind the climber. Also at these early or late times, you can often get a nice shadow at the base of the route with the climber up in the sunlight, and that makes for some dramatic lighting. In many cases, high noon isn't a reason to stop shooting. At some crags where the rock has a lot of color, especially if it is red, you can shoot all day. In fact, if you'll be shooting from straight above the climbers, it might be nice to have the sun higher in the sky so their faces are well lit. Whether shooting in the mornings, evenings, or in the middle of the day, it's usually best to have the climber either fully

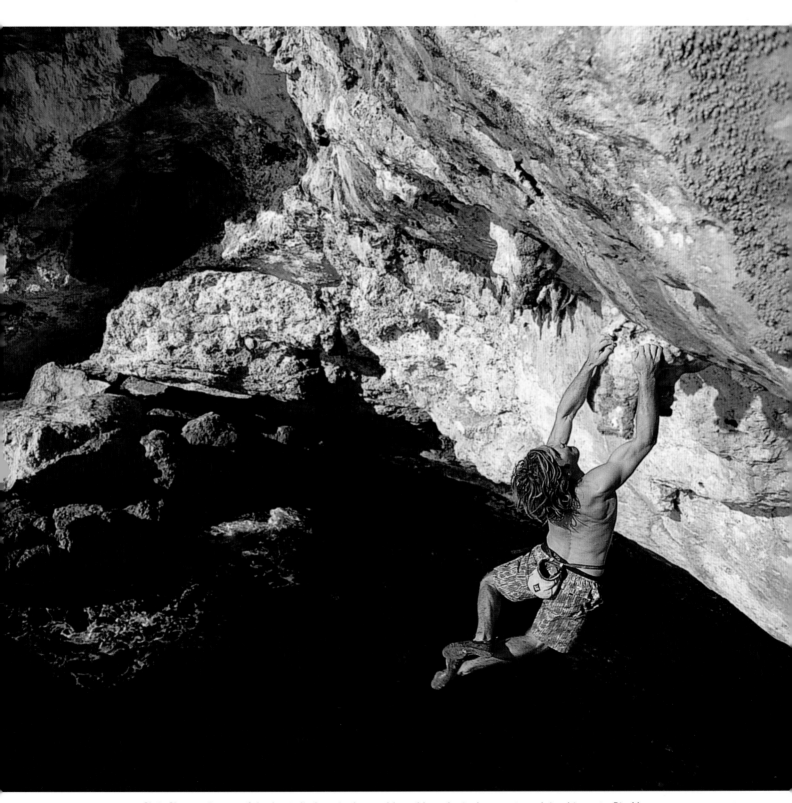

Chris Sharma is one of the best climbers in the world, and here he is deep water soloing his route, Big Momma (5.13d/14a), just after sunrise in Mallorca, Spain. For this shot, I fixed a rope above the climb and rappelled in to where the action would take place. Chris was climbing without a rope, so he climbed up to this hold to rest and hung there for about ten minutes before finishing the route.

lit or fully in the shade; otherwise, you'll have lots of contrast on the climber (which in some instances might be quite dramatic) instead of nice, even light. If you are finding that the light on a climb isn't that great, wait for it to go into full shade. If you know you'll be shooting at a climbing area for a few days or longer, watch the light closely on your first day and make a plan according to where the best light will be in the days to come.

Using artificial light for shooting climbers on routes can certainly be done, but it is most often used in caves or on shorter routes. Obviously, it would take a lot of time and effort to string lights up on a longer route. So most climbing photographers set up strobes on the ground and point them at the route if it isn't too high. This technique is used for shooting bouldering all the time now, which we'll talk about in the next section. Using artificial light for climbing photography is becoming more and more popular, but I would also caution that just because you have a flash doesn't mean you have to use it on every shot. Follow my advice in Chapter 4 and shoot with natural light first—it might be better than you think.

Most artificially lit climbing images are shot with the strobe pointed at the climber's back (i.e. perpendicular to the surface of the cliff) or from a slight angle to the side. The reason for this is if you move the flash too close to the rock, you are going to have some seriously blown out parts of the rock in the foreground and way too much light fall-off in the background. Setting the light perpendicular to the rock evens out the light hitting the wall and the climber. While this technique works, the climber is backlit and there is always a harsh shadow present. In my opinion, this style of climbing photography (which has become rampant) is getting old, and I'd suggest getting more creative with your lighting. Light painting is one example of a different artificial lighting technique that is rarely used and can result in some amazing images. For more specifics on lighting adventure sports, see Chapter 4.

BOULDERING

Bouldering is much easier to shoot than a route because you can simply stand on the ground or climb adjacent boulders to get exciting angles. Also, you need much less gear and technical climbing know-how. Because of this, bouldering can be a good place to practice before you step up to shooting routes. The tough part about shooting bouldering, however, is that the climbers are normally fairly close to the ground so it is difficult to show them in an exposed or risky position unless the boulder is huge. The focus instead needs to be on interesting perspectives and wild looking moves to make the image really exciting.

With bouldering, it's easy to move around and try a multitude of angles. Boulder problems with arêtes or bulges will allow you to get low and to the side, showing the climber's face, body position, and the route with a clean background like a blue sky. If possible, try to get on top of the boulder and shoot from above, again asking the climber to look up as often as possible. Sometimes the best angle is from the side because this shows the steepness of the route. Watch climbers on a boulder problem and you'll see that they probably face one direction more often; shoot from the direction where they are facing you the most. Also, no matter where you are shooting, whether in a forest or out in the open desert, a wide-angle lens will help you get in there and show the action up close and personal. A wide-angle is also great for pulling back to show the climber on the boulder with the surrounding landscape. In my experience, the best bouldering images are those that include the surrounding landscape to give a sense of place and scale. These pictures are shot from farther away and include the climber on the boulder, with a dynamic body position, so that the viewer can understand what is going on.

Details tell a lot about climbing; in this case, viewers get a sense of the climber's connection to the rock, both physically and metaphorically. I shot this image of Kurt Smith bouldering in Yosemite National Park, California, with a 70-200mm lens.

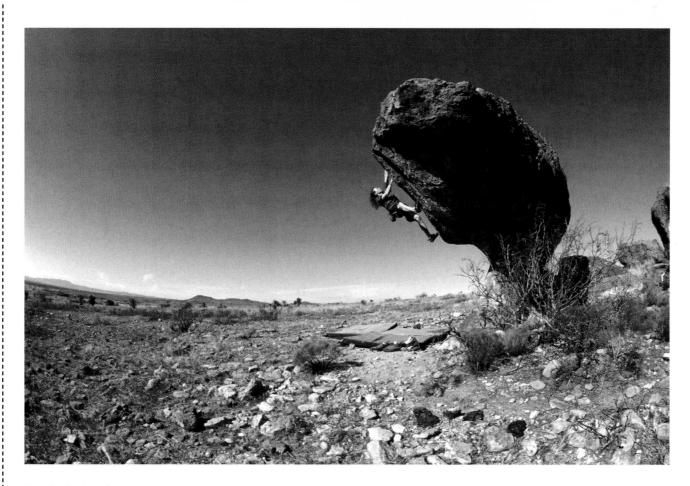

Timy Fairfield climbs the Anvil (V7) just outside of City of Rocks State Park near Silver City, New Mexico. I used a fisheye lens to create the wild perspective and was very careful to keep the horizon in the middle of the frame so there wasn't too much distortion.

Since boulder problems are often overhanging and shaded, using artifical lighting is a natural fit. Using strobes and shoe mount flashes adds another level of complexity, but they can also add drama to an image. A simpler and lighter alternative to strobes are flexible round disc reflectors. Reflectors are the old-school method to light boulder problems, and they are still very effective. I prefer a gold reflector and have several different sizes that I take with me when I shoot bouldering. The bigger the size of the reflector the better the light quality, and also the larger the beam of light you'll be able to reflect, which is key. My favorite size reflector is a 42-inch (1.07 m) Silver and Gold reflector made by Photoflex. Many disc reflectors are flexible, so they can be bowed a little, which in turn spreads out and slightly diffuses the light reflected off them.

When using reflectors, you will be limited by the angle of the sun to the climber, with the climber being positioned between you and the sun. I prefer to light the climber from above by having the person holding the disc stand on an adjacent boulder or to the side, depending on the shooting angle. This creates a light that looks more natural than just blasting them from behind. If possible, it is also nice to use multiple reflectors with one from above and one on the side of the climber. In some instances, I'll use reflectors and flash in tandem, either with shoe mount flashes or the Elinchrom Ranger battery-powered strobe setup. One note of caution: reflectors can be quite bright, so warn climbers not to look directly at them.

Keep in mind that if your subject is shaded (as when they are in a dark, overhanging cave), and your background is in the sun, the background will be completely blown out if you expose for the climber. The resulting images will look horrible. To balance out the foreground and the background, use fill flash, strobes, or a reflector, and remember to make your background a little darker than the foreground as we discussed in Chapter 4. In reality, unless you have a powerful flash, you won't be able to get enough light on your climber to balance the foreground and background. Shoe mount flashes generally aren't powerful enough for this situation, unless you are shooting at sunrise or sunset, so if you don't have a battery-powered strobe and are not shooting at these times, choose a different angle to eliminate the background or wait for a cloudy day and come back.

Basic Kit for Rock Climbing Photography

For rock climbing, my basic kit is minimal. What I take depends on the route, how much other equipment I have to carry (like ropes and gear), and the length of the hike in to the route or boulder problem. At the bare minimum, I take two camera bodies just in case one breaks down. My lens choices are three pretty standard f/2.8 zoom lenses: a 14-24mm, a 24-70mm, and a 70-200mm. With these three lenses, I can pretty much get any shot I want. If I think I'll need it for the location, I might also include a 10.5mm fisheye or a 300mm f/4. I also normally carry a Speedlight with me, but I rarely take it up on the rope.

To get the gear to the cliff, I use a large expedition-style pack and stuff the photo equipment on top of all the climbing gear. My camera and lenses are packed into a customized fanny pack setup consisting of the Lowepro Toploader Pro 75 AW, a Lowepro Street and Field waist belt, and lens cases for the 14-24mm and 70-200mm. The extra camera is packed in a neoprene Zing camera pouch. This setup lets me pick and choose what I will take with me up on the climb. All of the photo gear weighs in at around 25 pounds (11.3 kg), so this is not a lightweight adventure. With camera gear, one static line, ascenders, and the rest of my climbing gear, my pack usually weighs at least 65 pounds (29.5 kg). For shooting bouldering, where I won't need ropes or hardware, I'll take a more extensive camera kit with a few reflectors, multiple shoe mount

flashes, and possibly a lighting kit in addition to the basic kit described above. I'll pack it all in a larger bag like the Lowepro Vertex 300 AW for the hike in.

Normally, I don't take all of my gear up on the climb with me. I will break it down to just one camera body, the 14-24mm and 24-70mm lenses, and possibly the 70-200mm if I am shooting from a distance. As a security measure, because I have had a fanny pack with lenses in it come off and hit the deck from 100 feet (30.5 m) up, I thread a piece of webbing through the waist belt and the camera packs and I clip that to my harness. The camera is also clipped into my harness before I leave the ground. Changing lenses or memory cards is always exciting; I push my fanny pack around to the side and carefully make the switch.

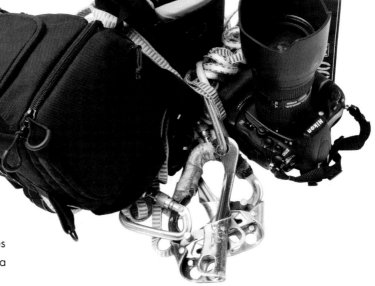

For shooting ice climbing, the techniques for using ascenders and static lines are still the same as they are with rock climbing photography, but you'll be wearing gloves, stiff boots, and crampons. I highly recommend using ascenders like the Petzl Ascension or Black Diamond nForce; these models have small teeth on the camming device that help keep the ascenders from sliding down if your static line gets iced up. These two options are also designed to work well with thick gloves. Speaking of gloves, wear some liner gloves that allow you to easily adjust your camera's settings. I have found neoprene gloves made for whitewater kayaking to be the "cat's meow" when it comes to shooting ice climbing. You will want to be equipped with ice axes and crampons as well, which will allow you to move around easily on the ice. Just be careful with your rope, as it is all too easy to stab it with the front points of your crampons.

The gear needed to shoot ice climbing is pretty much the exact same gear I use for shooting rock climbing. The only difference is that ice climbing involves even more outdoor gear, so I sometimes pare down the photo

ICE CLIMBING

Shooting ice climbing is a lot like shooting rock climbing since all of the same basic principles still apply. One of the big differences is that it's harder to get a fixed rope up on a route because it is so labor intensive to climb an ice route twice on lead, especially when it is really cold. It's usually a hard sell for most climbers to set up a fixed rope, so if you can find routes where you can approach from the top, this is a bonus that will make your job a lot easier. Anchors are also a bit different as ice climbs often have big trees near their tops that make great anchors. If no trees are available, then ice screws and rock gear will be your best bet. When photographing multi-pitch ice climbs, the easiest method is to work as two parties of two. As the photographer, you would follow a competent leader using ascenders on a static line and photograph the leader of the second party as they come up the same route.

equipment I take to just the bare necessities, which would be one camera body and a basic lens kit including a 14-24mm and 24-70mm lens, and maybe a 70-200mm lens depending on the location.

Because ice climbing usually happens in shady locations, fast lenses and D-SLRs that have low noise at high ISOs are a bonus. Don't be afraid to crank up the ISO to 800 or higher so your images stay sharp. If you are shooting an ice climb that is lit with full sunlight, check your histogram often because it is very easy to blow out important highlights. In this situation, where sunlight is reflecting off ice, it is common to have blown out highlights no matter what you do because of the blinding glare off the ice at certain angles. To minimize the glare, adjust your angle in relation to the climber. In terms of your camera's white balance settings, the latest D-SLRs seem to work just fine on auto white balance. Most ice climbers have spiffy outdoor clothing like Gore-tex shells or softshells, but I would ask climbers to wear colors that aren't too bright but still make them easily recognizable on the ice. And again, I would avoid black, white, or light blue colors.

The use of artificial lighting with ice climbing has become popular lately, and it is a much easier proposition than shooting rock climbing because so much light is reflected off the surface of the ice that hard shadows are minimized. If you are shooting ice climbing in a small gorge, like in Ouray, Colorado, it is easy enough to light the climbers from the top of the other side of the canyon with a battery-powered strobe, which also puts the light above the climber slightly. If you are hiking to the base of the climb, placing the light behind the climber and perpendicular to the ice works well, but the ideal placement would be off to one side and above the climber. Light painting is another option which results in some incredible images; just be sure your climbers are aware of how long they will have to hang completely still, and that they dress warmer than usual because they will be climbing in dark or in semi-dark conditions.

Cold Weather Photography

Dealing with extreme cold when shooting adventure sports usually isn't too rough—as long as you are prepared for it. The biggest difficulties with photography in cold weather are keeping your fingers warm (especially if your camera is mostly metal), making sure batteries don't run down too quickly, and keeping your lenses from fogging up. To keep my hands warm, I usually wear liner gloves inside of my larger and more insulated mountaineering gloves. With this setup, I can remove the outer gloves and have plenty of dexterity to change settings on my camera while shooting, but my skin is not exposed to the elements.

Batteries are somewhat allergic to cold weather. For the most part, I find that it has to be extremely cold, as in below 0° F (-17° C) before I see a noticeable decline in performance from my batteries. To extend the life of batteries in extreme cold, I will keep one fully-charged battery warm in an inside pocket of my jacket and switch the batteries out every twenty minutes or so. I will also carry at least two spare batteries with me and keep them warm in an inner layer of my clothing. If you are on an extended trip, be sure to keep all of your batteries in the sleeping bag with you at night.

For days when I am shooting in brutal temperatures below -10° F down to -40° F (-23° C to -40° C), like on summit days at high altitude, I sometimes tape a heat puck over the battery compartment or on the camera grip to help keep the camera and my hands warm. The heat packs need air to work, so put tape around the edges of the pack and leave the center exposed. Also, note that digital image sensors and heat are not a good combination since heat increases the amount of noise on a digital sensor. Therefore, place your heat packs as far away from the digital sensor as possible. Another issue with digital cameras in very cold weather is that the LCD on the back of the camera can freeze. Since the LCD is just behind the camera's sensor, I wouldn't tape a heat pack to it, but holding one to the back of the LCD for a minute or so should get it working again. If it continues to freeze, tape a heat pack on the bottom of the camera just under the LCD.

Another cold weather concern is condensation forming on your lenses; fortunately, it is pretty simple to deal with. Lenses fog up because anytime you take metal or glass from a cold, dry environment (like a ski slope) into a warm, humid environment (like a hotel room), the water vapor condenses onto the surface, especially on glass elements. If you are headed into a warmer environment, put your cameras into a padded camera bag; this will allow them to warm up slowly without any condensation buildup. Another good method is to bring plastic baggies, wrap your camera gear in them, and squeeze out as much air as possible before you make the transition into a warm environment.

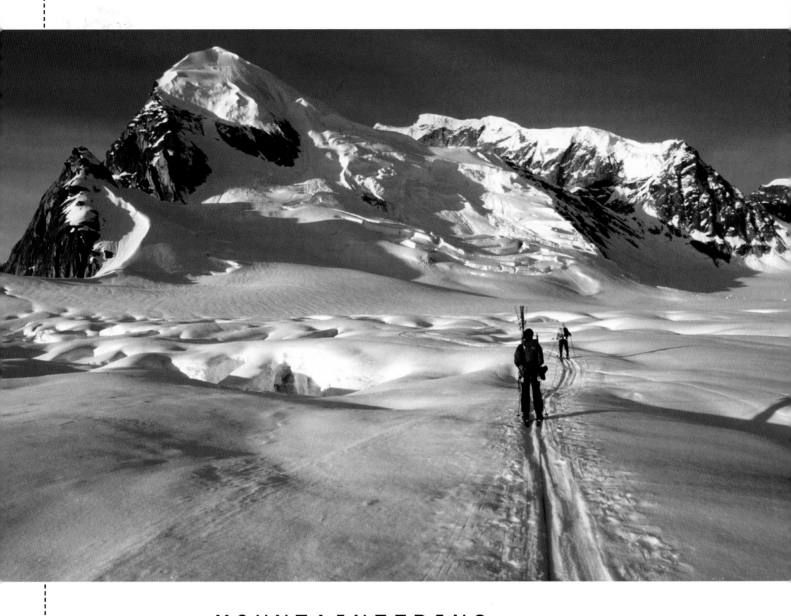

MOUNTAINEERING

The ultimate form of climbing is mountaineering—it requires well-rounded skills and knowledge in rock, snow, and ice climbing. And as any alpinist knows, there are some incredible photographic opportunities to be had in the mountains. The light at high altitudes is crisper, more elusive, and because the peaks extend up into the atmosphere, early or late light is intensely colorful. Some of the biggest issues with shooting while climbing in the mountains are keeping your camera handy, having the right lens, and mobility. The latter is drastically reduced in mountaineering, which makes it harder to get into different shooting positions. If you are roped up on a glacier, for example, you can't run around taking photos because you have to stay a certain distance from the climber in front of you for their safety and your own. Communication with the other climbers is crucial for getting the shots you want.

Mountaineering is incredibly difficult on its own before throwing photography into the mix. Get into shape so you can keep up or get ahead to shoot images when you can. If you are suffering like a dog, it will be pretty much impossible to get decent shots. This is definitely the time to strip down to the bare minimum in terms of the outdoor and camera equipment you carry. If you have the means to buy the lightest outdoor gear possible, that will really help. The lighter your pack is, the faster you can move and get into position to shoot. Also, realize that some of the best photo opportunities come when the weather turns bad, so don't put the camera away too quickly.

Owen Haggard and Tim Beynart traverse the Ruth Glacier in Denali National Park, Alaska. Because I was attached to the rope while traversing the glacier, I was unable to move around too much—a typical problem for mountaineering photography. I shot this image with a 28-70mm lens.

If you are headed out to shoot at a specific location and photography is the understood objective, then you'll have much more control over the shoot, but most mountaineering photography is done as part of an expedition or climb. In general, that means you'll be grabbing images on the fly. If you see something amazing, ask if the group can stop. Better yet, find a method to keep your camera ready so you can anticipate those moments (see the sidebar on the next page for methods to keep your camera accessible). Since alpine climbing is generally a race against daylight and weather, you won't always have time to set up the perfect shots—which means getting creative with the equipment you have and being quick on the draw.

Shooting on snow is challenging for digital cameras because there is so much light reflecting everywhere, so watch your highlights closely in the histogram. In the old days with film, an exposure reading was taken off a gray card, a hand, or clear blue sky to get an optimal exposure in snowy environments. This meant overexposing by at least a full stop to counteract the bias of the camera meter, which wanted to make the snow 18% gray. With modern D-SLRs this is less of a problem because some of them have color-sensitive metering and also because there is so much feedback with the histogram. As mentioned before, watch your histograms closely and make sure there is plenty of information being recorded in the highlights.

Mountaineering is not exactly a fast-paced sport. Images of climbers walking underneath or on massive mountain faces are the norm. Conveying a sense of action will be difficult, but you can use the exposure of the steep slope to your advantage if you can get off to the side and shoot across at a climber. If there is a nice landscape in the background, this is even more effective. Of course, getting in front of or above the group you are photographing is always a nice perspective. On glaciers, move as two groups of two if possible so that you can shoot the climbers behind or below you. One intense mountaineering maneuver is jumping across crevasses. If you can get set up inside the crevasse to shoot climbers jumping across the gap, this is a great photo opportunity and well worth the effort. In the end, good mountaineering photography is a result of anticipation, excellent fitness and preparation, and working as best you can within the confines of your partners' abilities (as well as their patience).

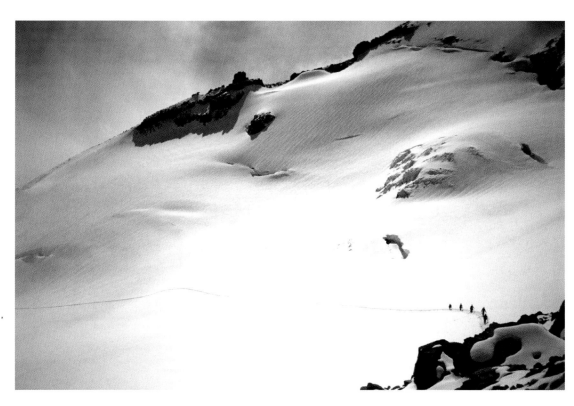

A roped-up climbing party traverses a glacier on their way back to Camp Muir on Mt. Rainier in Washington. I used an 85mm lens to capture this shot, which allowed me to show just how big the glacier was in relation to the climbers. The arc of the trail and the striations in the snow are what really make the image work.

Basic Kit for Mountaineering Photography

Because every gram counts when it comes to alpine climbing, you'll want to go as light as possible with the camera gear. I normally take one camera body, and at most two lenses: a 17-35mm and the 70-200mm. If that setup is too heavy, then I pare it down to one camera and a 24-70mm zoom, or even a 24-120mm zoom lens that gives me some flexibility. It isn't the ideal setup, but it is light and having some equipment to document the experience is obviously better than none at all. If you can get away with taking a small flash unit, it will come in handy for off-the-cuff portraits and shots around camp in the evening. If it is too much weight, using your headlamp can open up lots of light painting options. I also advise carrying a lot of memory cards so you don't have to worry about taking something to download cards on. Memory cards are very light and they are getting cheaper everyday, so carrying a 100GB of memory cards isn't as expensive as it used to be.

The balance of keeping the camera handy and protecting it from the elements is a fine line in mountaineering. How you carry your gear and keep it accessible will depend on a few factors. How difficult is the route? Are you going to actually have to climb or is it just steep walking? The answer to these questions will determine your setup. If it is a very technical climb, then a high-end point-and-shoot that records images in RAW format might be your best bet. If the climb isn't that technical, I put my camera into a fanny pack like the LowePro Orion. (Avoid chest pouches because they inhibit your breathing, which is already hard enough at high altitudes.) I wear the Orion fanny pack on the front with an alpine pack on my back for other gear. This setup allows me to have easy access to all of my photo gear. When things get a little technical or I need to adjust my harness, I swing the fanny pack around underneath my pack. If I am taking a lens like the 70-200mm, it is normally carried in my backpack and pulled out for those times when I can orchestrate the action. On summit day, pare down the kit to one lens, one camera, a few memory cards, and an extra battery.

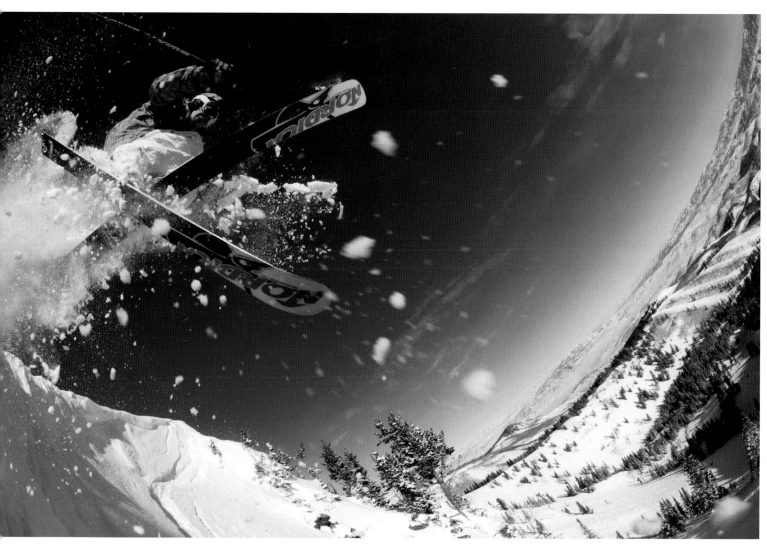

SKIING AND SNOWBOARDING

Ski photography is a ton of work, especially when you don't have a helicopter to ferry you around. The combination of hiking with skis or a snowboard, extra clothing, and camera gear, often in deep powder, makes shooting these sports rough. If you want to shoot skiing and snowboarding, it really pays to be skilled at one of them first. In general, it is much easier to get around on a pair of skis than it is on a snowboard since you can attach skins to climb up hills and traverse steep slopes. Skis simply give you more options. But in the end, it comes down to how you are most comfortable getting down steep terrain in the backcountry.

This image of Patrick Falkner dropping off a cornice at Park City Mountain Resort near Salt Lake City, Utah, was taken by my good friend, and fellow pro photographer, Mike Tittel. It shows how choosing a unique angle can add drama to a photograph. Using a 10.5mm fisheye lens, Mike positioned himself just below the cornice and had the skier jump over him. To add more action to the scene, he also had the skier cross his skis and jump from a point where he could kick up some snow. Photo © Mike Tittel.

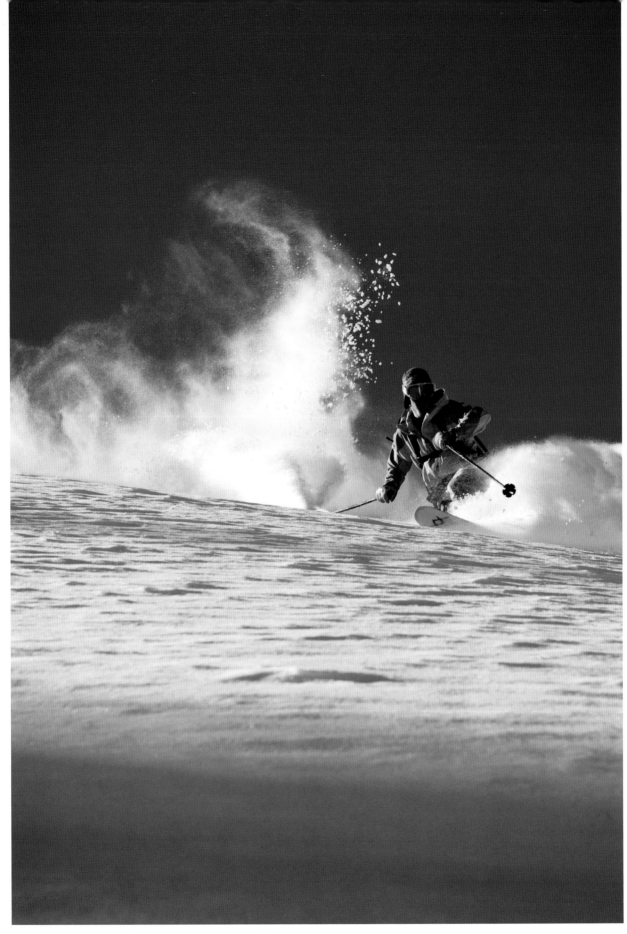

Knowing your location is key. Having shot at Solitude Mountain Resort many times, pro adventure sports photographer Mike Tittel knew the light would be most dramatic at this location in Honeycomb Canyon. Wanting a clean composition, he had the skier descend an untracked line on an aspect with a clean, backlit background, creating long shadows and illuminating the snow being kicked up behind the skier. Photo © Mike Tittel.

One of the main considerations with ski or snowboarding photography is timing. Because you want untracked pristine powder, you'll need to be Johnny-on-the-spot to get to the prime locations first. Watching the weather and getting to the location during a major storm or just after one is key to great ski photography. If you are looking to license your ski images, don't even waste your time shooting anything but untracked fresh powder. Images with tracked up slopes just don't sell. Also remember that once you get to the location, you'll have to communicate very carefully with your athletes as to exactly what line they should take because once it is tracked up, the game is over—you get one shot for each line. However, there is one trick that helps in these situations: when shooting in deep powder and shooting up the slope, or even across a steep slope, if you get low with a telephoto lens and use a very shallow depth of field (like shooting wide open at f/2.8), you can often hide the ski tracks and you'll get a nice out-of-focus background that really makes the skier pop in the image.

As with all adventure sports, the better the athlete you are working with, the easier your job will be. Find the hottest skier in your area or track down a pro and tag along on their next adventure if you can, assuming that you can hang with them in the skiing or snowboarding department. To find skiers and snowboarders that are top-notch, it is a good idea to call the ski area where you plan on shooting and talk with the communications or marketing department. They normally keep a list of talented skiers on file and will often give you and the skier a free day pass because they know the images are free marketing if they get published.

With mountain sports, always keep shooting when the weather turns against you. Even though these skiers were in the midst of an incoming blizzard in the Canadian Rockies, photographer Mike Tittel kept shooting to show the hairy conditions. Photo © Mike Tittel.

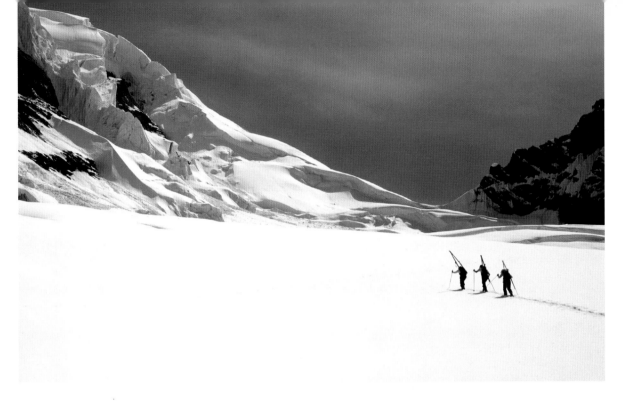

While on an expedition in Denali National Park, Alaska, I snapped this image of skiers hiking for turns above camp. While it isn't a radical ski image, it shows the reality of backcountry skiing in the remote Ruth Glacier.

Just as with climbing photography, creating the best images is usually a collaboration between the skier and the photographer. In most cases, I make a plan with the skiers before we even get on the lift or start skinning. I may not have been to the location they want to go to, but most skiers know what will look good in a photograph. If I am looking for a certain scenario, like a cliff drop for example, I might show the skiers a few images to give them an idea of what I have in mind and they can direct me to the best secret spots that won't get skied out too quickly. I recommend, as with any photo shoot, that you pre-visualize the type of image you want and then set up a shoot to get that image. Once you have it "in the can" so to speak, it is time to start getting creative and shoot up a storm, because you might find you can get something even better than what you were going for initially.

Normally, you'll want to use a telephoto lens to keep up with the action. A 70-200mm zoom and a 300mm lens will be part of the standard kit. For those deep powder days the telephoto zoom will be your mainstay, giving you enough room to capture the skier from a distance but also the ability to zoom out as they pass by. A 24-70mm is also a great lens for skiing as it allows you to put the skier in the landscape so the viewer can gain some perspective. And, of course, fisheye, and wide-angle lenses are great for getting in close. When shooting a skier dropping over a cliff, the go-to lens is a fisheye which makes the cliff look bigger and steeper than it really is. Use the hyperfocal focusing technique (see page 69) so you can concentrate on the composition. It normally works best if you tuck up under the cliff so you can get the best perspective below and just to the side of the skier. And even if you are shooting into the sun, the snow acts as a giant reflector bouncing light back up onto the skier, filling in any shadows nicely. In that respect, skiing is one of the few sports you can shoot all day long with great results. If you are in a ski area, or even the backcountry, you can move around throughout the day and follow the sun using the various aspects of the canyons and ridges to find different lighting angles.

Freeskiing is another popular form of skiing and snowboarding that offers potential for wild images. Whether in a half-pipe at a resort or in the parking lot, look for great situations to shoot with flash to give your images a look that is different than the norm. Using artificial light for ski photography is not easy; it takes a lot of work just to get the equipment out there and timing is key. You don't really need battery-powered strobes for a lot of ski photography because the fill light off the snow is so good, but for twilight shots with the sun setting, a strobe can really help make a killer image.

Basic Kit for Ski & Snowboarding Photography

The setup I take for shooting skiing and snowboarding depends on many factors, including the terrain, whether we are in a ski area or the backcountry, how much hiking we'll have to do and, of course, what type of images I am looking to capture. If shooting in or near a ski area, I take an extensive setup that includes a fisheye, a 14-24mm, a 24-70mm, a 70-200mm, and a 300mm f/4 lens in a photo backpack. A teleconverter is another good option; instead of carrying a 300mm lens, try a 1.7x teleconverter on a 70-200mm. Test this setup before heading out to see if the autofocus is still fast enough with the teleconverter to catch the action.

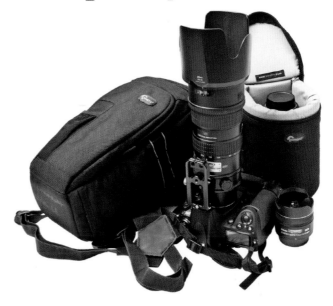

When heading into the backcountry, I'll pare down my photo gear quite a bit because I'll need to add clothing, food, and water to my pack. For these situations, I'll take the Lowepro Toploader Pro 75 AW and wear it as a chest pouch with my camera and the 70-200mm lens inside. I'll also carry a lightweight backpack with my outdoor gear, a wide-angle lens, and possibly a fisheye, depending on the terrain. For ultra steep terrain, I'll go even lighter and just take one or two lenses, chosen specifically for the type of images I am going for. I prefer the chest pouch, as it gives me a lot more freedom of movement when I need to attach or remove skins from my skis or adjust my bindings, and it seems to balance much better than a hefty backpack. It also means that the camera is very well protected since the odds of landing on my backside are much greater than landing on my chest if I should eat it.

For those times when I want to use artificial light when shooting close to the road or in a ski area, I will hire an assistant (who is a very good skier) to ski with my Lowepro Photo Trekker AW photo backpack loaded with the Elinchrom Ranger RX Speed AS setup. We'll use that up on the mountain for very specific setups and have the skier run laps at a certain distance, whether it is a jump or just a run past the camera in deep powder. When using the Ranger kit, I normally just take a standard reflector or a Varistar umbrella (made by Elinchrom), which is super lightweight, folds down small like an umbrella, and softens the light quite a bit. We don't take light stands for this setup; the assistant is the light stand and the added bonus is he or she can move the flash with the skiers so we make sure they are lit. I most commonly use the lighting setup at the end of the day when the skies are lit up with a lot of color from the setting sun.

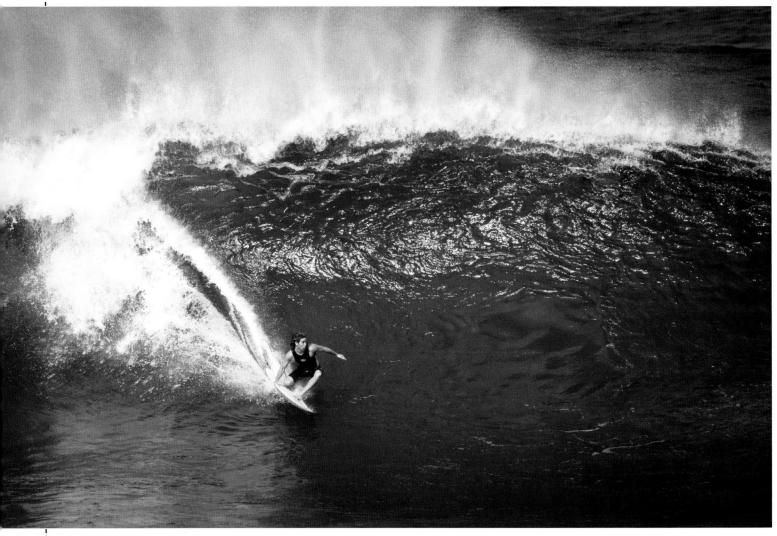

Mason Ho catches a solid wave at the famous surf break, Bonzai Pipeline, on the north shore of Oahu in Hawaii. I shot this image with a Nikkor 200-400mm f/4 zoom lens while standing on the beach.

Water sports comprise a large portion of the adventure genre. In this chapter, we'll cover four of the main water sports: surfing, whitewater kayaking, sea kayaking, and scuba diving. Surfing is hands down one of the most visually appealing adventure sports. Seeing a surfer ride down a massive wave never ceases to be inspiring. I owe a special thanks to acclaimed surfing photographer Brian Bielmann, who shared his insight and experience with me for this chapter. When it comes to fast-paced action and facing danger in the water, no other sport comes close to whitewater kayaking. Every time I shoot kayaking, my appreciation for the sport grows—as does my fear of it! By comparison, sea kayaking and scuba diving are fairly tame. Since most of my sea kayaking photography has been shot during adventure races, I gleaned a lot of insight on the sport from Mike Tittel, who specialized in sea kayaking photography at the start of his career. Finally, underwater photography is almost a genre unto itself; therefore, I enlisted another seasoned pro, Brett Seymour, and interviewed him for the section on scuba diving and underwater photography. Because of its popularity, let's start with surfing and then progress through the other water sports.

SURFING ———————

Surfing is one of the most exhilarating adventure sports. The athleticism and skill on display by surfers pushing the boundaries of what is humanly possible on huge waves is a visual feast for any photographer. Throw in some beautiful surroundings and colorful sunsets and surfing images can be more artistic than many of the other outdoor genres, and they often offer a nice blend of lifestyle and action photography.

There are typically four ways to photograph surfing, and five if you count remote camera options. First, you can shoot from the beach or a nearby pier. Second, you can shoot from a boat or on a personal watercraft like a Jet Ski. Third, you can get in the water and shoot from inside the wave or under it. And fourth (if you have the resources), shooting from a helicopter can provide some great angles and is also an easy way to stay with the surfer as the waves move forward. The fifth option is to mount a camera on the surfboard, which is costly and difficult. Let's look into each of these five options more closely.

This image, shot after the sun had set, shows how the reflective properties of water effectively extend the sunset. The surfer was backlit while waiting for one last wave before packing it in at Oxnard Shores in California.

SHOOTING FROM
A BEACH OR PIER

Shooting from the beach or a nearby pier
normally requires a 600mm f/4 lens or the
equivalent, depending on your distance from
the surfers. And unless you are Arnold
Schwarzenegger, you'll also need a sturdy
tripod and ball head that can properly sup-
port such a massive lens. It can be difficult
to track a surfer with such a heavy lens, but
an even more problematic issue is staying
ready to shoot at any moment. There are a
lot of distractions on the beach, and it's
also very easy to fall into a sun-soaked
lull. Because the surfers are catching
waves at will, you need to stay sharp and
pay close attention for the split second
they go for a wave. Any slip in your con-
centration could cost you the best shot of
the day. And with such a big lens, you
have to be looking through the viewfinder
and ready to shoot before the action starts
because it is difficult to move a large lens
quickly enough to recompose.

To get sharp images, I set the autofocus
to continuous mode so the camera will con-
tinually adjust the focus as the surfer moves
toward me. In this mode, the camera uses
predictive focus tracking to lock onto the
surfer and keep him or her in focus. To com-
pose, I choose a focus point where I want the
surfer to be in my frame and then put that
point on the surfer, being mindful of the shape
and size of the wave. In general, you want to
see the entire wave as it curls up above the
surfer, especially if it is a big wave.

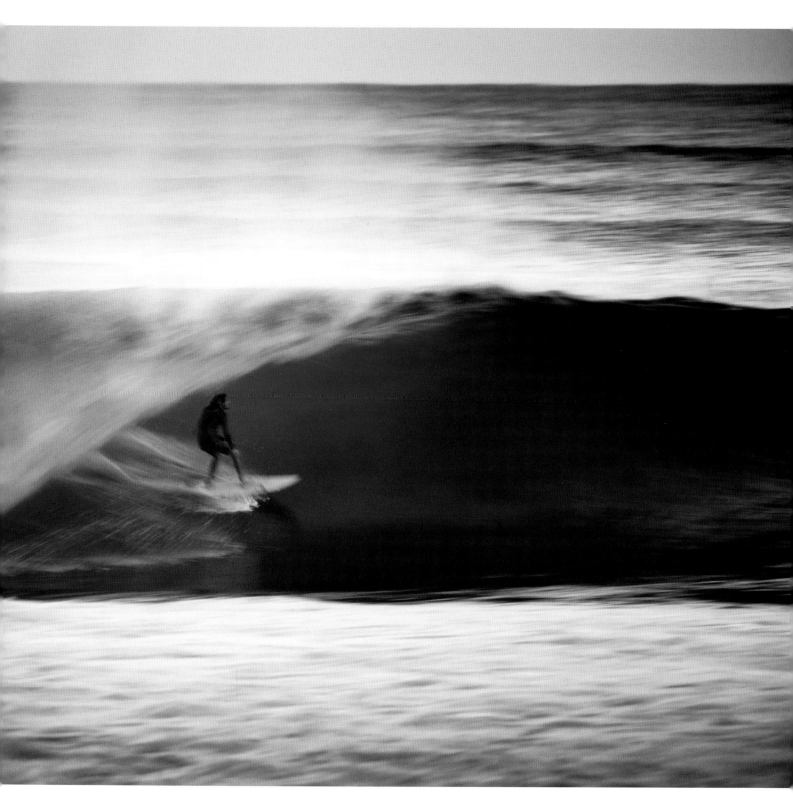

This pan blur image of a surfer at Bonzai Pipeline was shot in the evening when the light was failing. Because the sun had already set, I decided to pan the camera and lens at a slower shutter speed instead of cranking up the ISO to stop the action. This image was shot with a Nikkor 200-400mm f/4 zoom lens at 1/25 second.

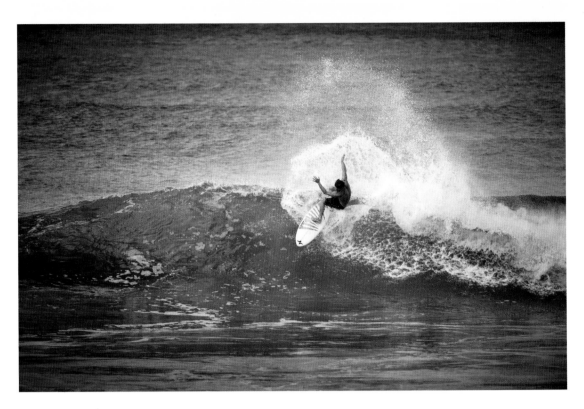

This is another image of a surfer at Bonzai Pipeline, on the north shore of Oahu in Hawaii. Because I had my eye to the camera and was paying attention, I was able to nab this shot as the surfer cut back on the wave.

To find different angles, it is easy enough to walk up and down the beach, but if you get too far away you'll need a 1.4x or 1.7x teleconverter and maybe even a camera with a smaller APS sensor (and its inherent magnification factor) to help pull in the distant surfer. How you position yourself relative to the wave depends on the surf break and what you are going for. If you position yourself perpendicular to the wave then you'll be able to shoot both sides of the wave if there is a left and right break or surfers are dropping in "off the wall." If you want to see the surfer as they ride in the tube, then you'll have to walk down the beach for an angle that lets you see into it and which also shows a bit more of the wave's shape. If there is a nearby pier or jetty, either option can offer a great way to line up parallel with the wave, which is an otherwise difficult proposition. And here's an extra tip when shooting from the beach: drape a towel over your $10,000 lens and expensive camera to keep them from getting worked over by the corrosive ocean spray.

SHOOTING FROM A BOAT OR JET SKI

Working from a boat or a Jet Ski isn't much different than shooting from the shore, but it does add some complications. You have to deal with the motion of the sea, getting into and maintaining your position, and protecting your camera. To deal with the motion of the waves, it's easy enough to shoot with a high shutter speed to overcome any movement. Also, use image stabilization for those times when your shutter speed isn't as fast as you'd like. To maintain your position, it is a good idea to have someone else driving the boat or Jet Ski. On a boat, you probably won't need anything to protect your camera, but when you are on a Jet Ski, use an underwater housing and a lens port from housing manufacturers like SPL or Aqua Tech. An Ewa-Marine bag is also a good alternative for this situation, but if you already own a housing, it is about the same price to get a lens port that fits your 70-200mm zoom lens..

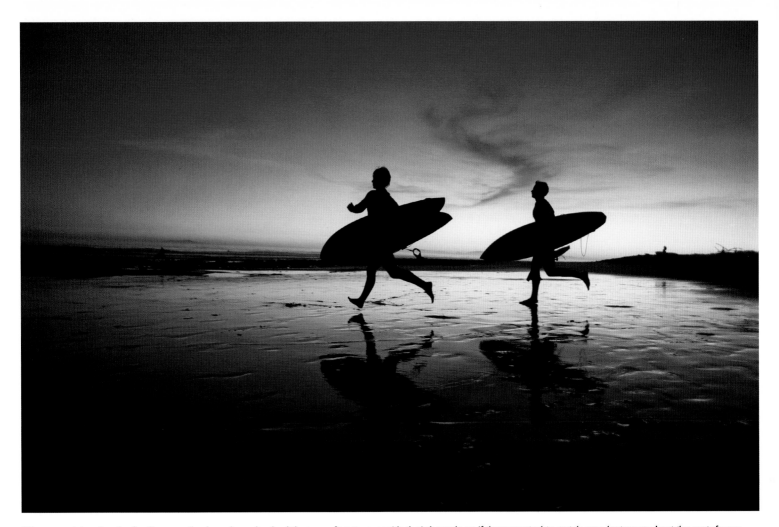

After sunset, I noticed reflections on the beach and asked these surfers to run with their boards as if they wanted to catch one last wave. I set the autofocus so that it would grab anything in or near the center of the frame, held the camera upside down a few inches (5 cm) off the ground (to maximize the size of the reflection), and ran with them, firing the camera at 8 fps for each pass. This image was the best of the 80 or so images I shot that night.

On a Jet Ski, a 70-200mm zoom will usually suffice since you are generally closer to the wave than when on a boat. If you are on a boat, you probably need a bit more reach—either a 300mm or a 200-400mm zoom; the latter is a great option. To get the highest number of sharp images possible, you'll need to be using top-end cameras and lenses with the autofocus motors built into the lens. However, I have noticed that my top-end camera focuses noticeably faster and more accurately than other mid-range cameras I own, so the camera body matters just as much as the lens.

SHOOTING FROM THE WATER

One of the big decisions any surfing photographer has to make when they get to the location is whether to shoot from the beach or a boat, or to get into the water. In reality, the decision might be made for you depending on the size of the waves and your swimming skills. Getting into the water requires an entirely different skill set than shooting from the beach. It certainly helps quite a bit if you are a surfer so you can judge when and where the surfers will be as they come down or across the wave. Because you will often have to swim quite a ways from the beach in sizable waves, you must be a very strong swimmer and in excellent shape. As you can imagine, there is a lot of technique to putting yourself into a wave safely, getting to the right spot, and snapping the shutter as the surfer comes past you.

Surfing photographers are brave souls. They take a pounding to get images while treading water at close proximity to surfers who have a lot more to worry about than hitting a photographer. I have seen images from a few photographers who have shot inside some of the heaviest waves in the world, which is the surfing equivalent of free-soloing a climbing route and shooting photos of your friend free-soloing just below you. It may seem obvious, but I'd recommend you take it easy and improve your skills in moderately sized waves if you are just starting to shoot surfing from the water. Also, I'd highly recommend wearing a lightweight, hard shell helmet (like those made for kayaking that protect your ears), fins, and a snorkel and mask. The helmet will save your life if you misjudge the distance and speed of the surfer you are trying to photograph and get whacked in the head by a fin, which, by the way, is pretty annoying for a surfer, too—so practice with friends before you go after the local pro. The helmet will also protect you if you smack the reef, which is usually a much bigger issue in many locations than getting hit by a surfboard.

In general, the go-to lenses for surf photography while in the water are either a 15mm, 16mm, or 10.5mm full-frame fisheye, depending on which brand of cameras you use and the format of your camera's sensor. And because you will be struggling just to get into position to get the shot, you'll want to turn off the autofocus and use a hyperfocal distance method to make sure everything you point the camera at is in focus (see page 69 for more on this method). To make sure that your foreground (i.e., the wave) is still sharp, you'll want to modify your hyperfocal focus so that you are just off the infinity mark on your lens. The odds are good that you'll be close enough so that the surfer is only about 10 to 20 feet (3 to 6 m) away, not at infinity, so this method works quite well. A good trick to remember is to tape the focus ring on your lens (with gaffers tape) before you put it in the housing so that when you are getting rolled around like a cat in a washing machine the focus you have set doesn't shift. If you forget to do this and your focus shifts, you'll be kicking yourself later.

When using a splash housing, you'll have to set most of your camera's settings before you get into the water, particularly the ISO. Because it is sometimes darker inside the wave, I would suggest setting the ISO to 400 so you can work with a smaller aperture like f/11 or f/16 to get as much depth of field as possible. And because most modern D-SLRs are diffraction limited (because of the sensor resolution and the density of the pixels), going past f/11, in most cases, will only degrade your image quality. Hence, I shoot for f/11 if I can get it.

Some photographers, like Brian Bielmann, whom I interviewed for this section of the book, sometimes choose to use a telephoto lens in the water to get a different perspective. Brian uses a 70-200mm f/4 zoom lens on a camera in an SPL housing, which allows him to sit a little farther on the outside of the wave. In our interview, Brian was talking about the big reef breaks in Hawaii. "The other day I was out at Pipeline and there were 35 photographers in the water. It was so ridiculous. There were 20 fisheye photographers all in a lump. These days, with digital cameras being so good, you just have to have the guts to swim into these really huge waves with a fisheye lens. Surfing photographers are now putting themselves into the most dangerous part of the wave, between the surfer and the lip, with their arm sticking out. It is totally death defying. They are putting themselves, every time, into a very scary situation. In some cases the photographers shooting with fisheye lenses are almost taking more risks than the surfer in these

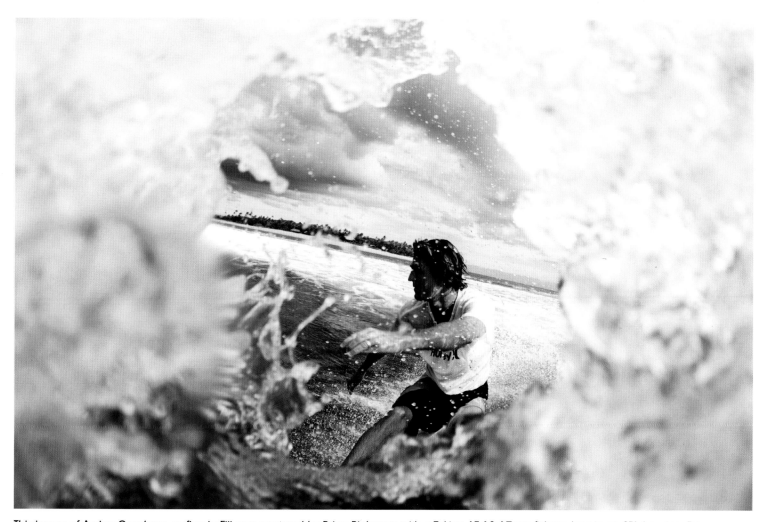

This image of Amian Goodwyn, surfing in Fiji, was captured by Brian Bielmann with a Tokina AF 10-17mm fisheye lens in an SPL housing. Brian was blasting away at 10 fps and his hand was the last thing to pass through the wave, so he was able to shoot through this hole and create a spectacular image. Photo © Brian Bielmann.

big waves." Talking about how the fisheye distorts the image and the size of the wave, Brian also said, "A lot of times when you shoot a big wave at Pipeline, you'll be shooting a 10-foot (3 m) wave with a fisheye and it looks like a 5-foot wave (1.5 m), whereas with a tele-photo setup, if you shoot a 5-foot (1.5 m) wave it looks like a 5-foot wave (1.5 m). There are still those few fisheye images that are really outstanding, but with a longer lens you see more of the wave and how thick the wave is. There are so many fisheye guys out there shooting, it doesn't matter if I am shooting fisheye. The world has enough fisheye surfing photos. I just want to get a different perspective."

SHOOTING FROM A HELICOPTER

If you or your client can afford to hire a helicopter to shoot big wave surfing, it will give you a unique and wild perspective. Because you can get so close with the chopper, a 24 -70mm and a 70-200mm lens will generally suffice, but I would also keep a 300mm lens handy. In most situations where surfing is shot from a helicopter, the surfers are riding huge waves like the famed surf break Pe'ahi (a.k.a. JAWS) off the north shore of Maui. When shooting surfing from a helicopter, the ideal angle is to be in front and to the side of the wave so you can see the curl and the roaring foam behind and above the surfer. This is the perspective that nearly all big-wave images are shot from, and it never seems to get dull.

REMOTE SHOOTING & LIGHTING

If you want to try shooting remotely with the camera attached to a board, there are ways to make it happen. SPL, the maker of the splash housings already discussed, also makes a board mount for remote photography. It isn't cheap, but it will work with one of their housings to get your camera in position. They also make a wireless remote trigger that will fire the camera. Aside from the difficulty of setting up the mount, it might be even harder to find a surfer willing or able to ride with such an attachment bolted to the front of the surfboard.

Another technique for shooting surfing is to use remote radio triggers and small shoe mount flashes to light the surfer while they are on a wave. If that sounds complex and difficult, well, that's because it is. Normally in this situation, the photographer is shooting from the water or the beach with a custom SPL radio transmitter attached to his camera that transmits a radio signal to a swimmer out in the water. The swimmer, who is holding a flash with a custom SPL receiver, both of which are in an underwater housing, positions himself in the wave at a certain distance from the surfer (to achieve the correct flash exposure). As you might imagine, this is a ballet of epic proportions. Everything has to be just right to get a decent image and the quality of your flash exposure depends on the swimmer's ability more than anything else. Some photographers are using two flashes (and two swimmers), which makes it even more complicated. Most of these images are shot at sunset or just after to take advantage of the failing light. I have only seen a few images shot like this, but they are quite a bit different than your average surfing image.

Basic Kit for Surfing Photography

For surfing photography, you'll need a fairly extensive kit to cover all the different angles. Because of the pricey telephoto lenses and underwater housings, surfing is one of the most expensive adventure sports to photograph. The basic requirements are a 16mm fisheye, a 70-200mm zoom, and a 600mm f/4 lens. You'll also probably need a few teleconverters to elongate the reach of that 600mm f/4, which many times doesn't seem long enough, especially if you shoot with a full-frame D-SLR. You'll also need a fairly substantial tripod and a beefy ball head on which to mount that monster lens. I have a Kirk BH-1 ball head that seems to work very well with the Nikon 600mm f/4, but an even better option is a Wimberley Head that gives you more freedom of movement (but comes with a larger price tag). Add to this the need for a splash housing (if you plan to get into the waves and mix it up with the surfers), and you are starting to talk about some real money. If you live in a major city, you can rent the 600mm lens, but that can be a bit dicey to procure on the day the big swell rolls in.

For shooting from shore, you'll need a 600mm f/4 lens and a heavy-duty tripod.

When it comes to underwater housings, there are only a few options. Forget about the Ewa-Marine bags; they would be ripped apart in seconds in any real surf—if you can even manage to hold onto it, that is. The two options for shooting surfing that I have seen are the SPL (www.splwaterhousings.com) and Aqua Tech (www.aquatech.net) underwater sport housings. The Aqua Tech housings offer a little more control of the camera and make it much easier and less time consuming to secure the camera in the housing. The advantage of SPL housings is that they are lighter and thus easier to hoist over your head at the last second as a surfer rides past you—and they are a little cheaper than the Aqua Tech housings. You'll also need both a pistol grip to go with the housing so you can hold it in position and a leash so you don't lose the camera while swimming in heavy surf. Lastly, be sure to get a lens port for a fisheye and a 70-200mm zoom lens if you want to shoot from a Jet Ski or outside the wave. Because each housing is specific to the camera model, choose your housing wisely and pay close attention when inserting your camera into the housing to avoid flooding your camera, which is an extremely expensive nightmare. I also highly recommend using 8GB or 16GB memory cards so that you don't run out of memory space while out in the water.

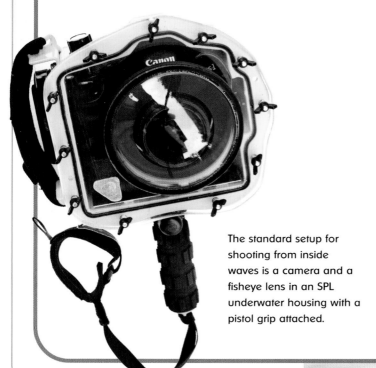

The standard setup for shooting from inside waves is a camera and a fisheye lens in an SPL underwater housing with a pistol grip attached.

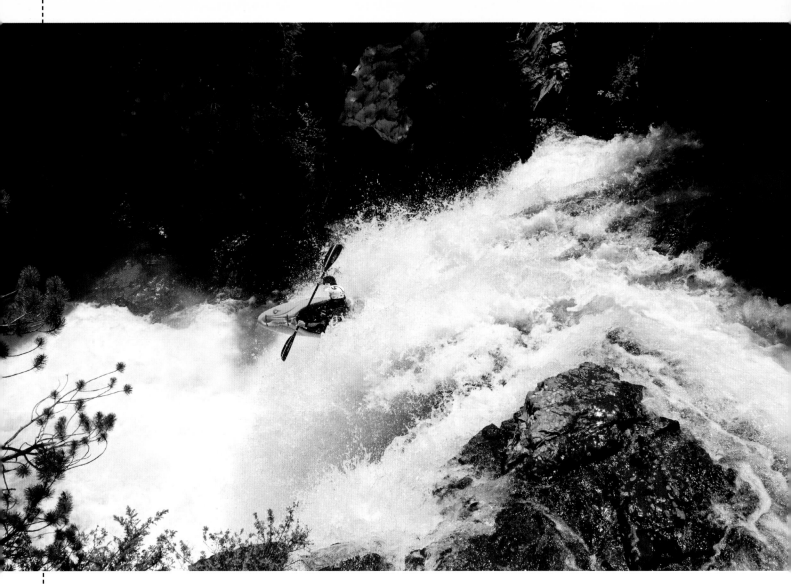

This image of David Strauss paddling over a waterfall on Oh Be Joyful Creek (Class V) near Crested Butte, Colorado, was shot with a 17-35mm lens at 8 fps. I first climbed down to just below the waterfall and shot a kayaker coming over from that position, but felt that this angle created a more dynamic image. It always pays to check every angle.

WHITEWATER KAYAKING

Whitewater kayaking is, in my experience, one of the most dangerous sports in the entire adventure genre. On six of my last ten whitewater kayaking shoots, someone had a very close call. And I don't just mean close as in something could have happened, but close as in boaters spent significant amounts of time under water and were lucky to live. Fortunately, you don't have to be a kayaker to get excellent images. Kayaking skills can be useful in some cases to gain access to areas that are otherwise difficult to reach, but they aren't a requirement. To overcome the fact that I am not an expert kayaker, I use all of my climbing and backcountry skills to get to the location and rappel into the deep canyons with big rapids. If you plan ahead, you might even get lucky and find a trail following the river.

Kayakers can generally tell you where the best shooting locations will be, or at least give you a rough idea of the terrain so you can decide where to position yourself for the best images. Often, the best shooting angle is at river level and downstream from the rapid you are photographing. In some cases where there are steep riverbanks or the river is in a deep canyon, another interesting angle is to stand on the banks and shoot down on the kayakers as they go through a rapid. For waterfalls, I always check to see if the better angle is at the base of the waterfall or at the top. In my experience, the better angle always seems to be from above, but be sure to check both. Getting farther away and shooting straight on is also nice for waterfalls, especially if you can include a landscape feature like a jagged mountain peak rearing up behind the waterfall. Another option for a different view is to string a rope across a river to shoot kayakers as they pass underneath (see Tyrolean traverse on page 43 for more information on rope work).

If you can find a river with a trail or road next to it, then you can shoot all the rapids by having the kayakers wait while you hike down and get into position. If the rapid is particularly good, ask the boaters to run laps on that section if they are willing. It is a lot of work to get out of the boat and carry it back up river, so be mindful of this fact and try to get the image you want in as few runs as possible. Because most rivers have fairly steep banks, carry a trekking pole and wear stiff-soled hiking boots.

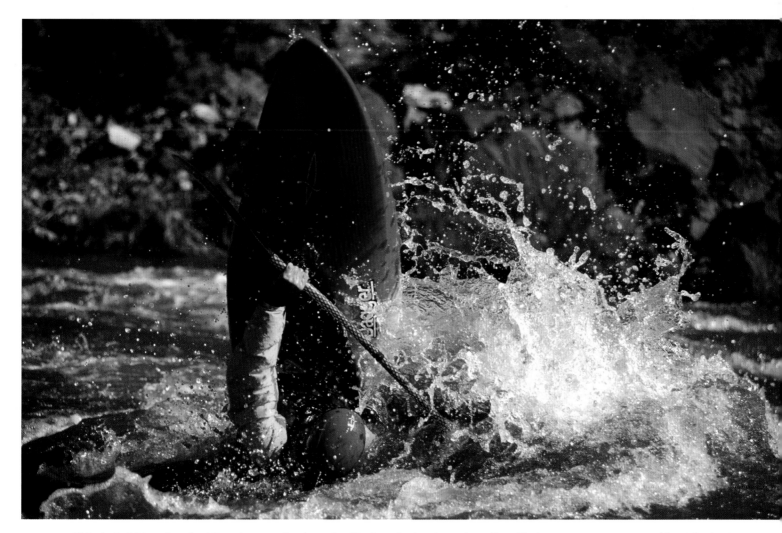

This shot of Atom Crawford throwing cartwheels on the Rio Grande river in northern New Mexico was set up so we could get the best morning light possible. Since I was able to get relatively close on the river's bank, I used a 70-200mm zoom lens and shot at 8 fps.

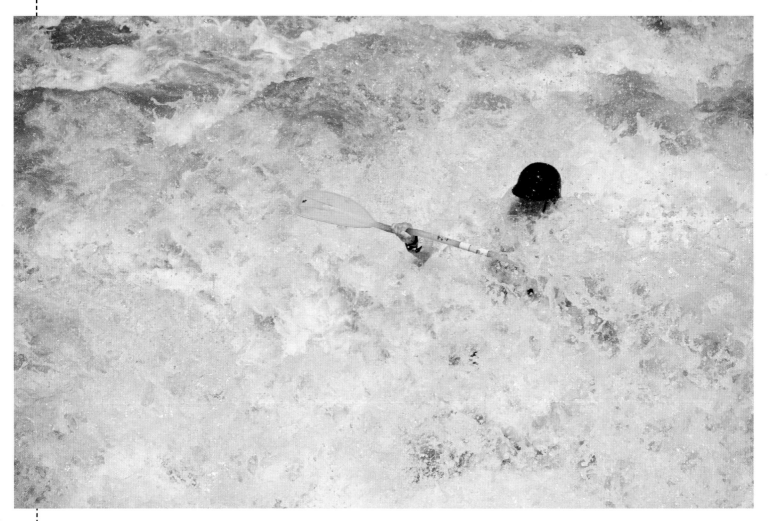

Atom Crawford fights to stay upright in Souse Hole on the Rio Grande. I captured this shot as part of an 8 fps sequence burst as Atom entered this big rapid, which is proof that it's sometimes best to use your camera like a machine gun and just blast away. It's not always possible to see what is about to happen or catch it, so let the camera do the work for you.

The classic kayaking images are a kayaker dropping over a sizeable waterfall, surfing on a static wave, throwing ends (or performing what are called rodeo tricks), and generally fighting to stay upright in a rapid. If you have some top kayakers and decent camera equipment, it isn't too difficult to get solid kayaking images. The trick, as with all action sports, is to combine the action, light, and composition in order to capture that extraordinary moment. Work with the best kayakers you can find. Their skills will open up many photo opportunities because they can run the more difficult Class V rivers with big waterfalls and lots of wild rapids, which will greatly improve the quality of your images.

As for shooting the action, your camera's framing rate will determine how well you can capture split-second images. I would recommend using a camera that shoots at a minimum of 5 fps, but 8 fps is ideal. On fast rivers, the kayakers are moving so quickly it is sometimes difficult just to keep them in the frame, let alone to try and capture an exciting moment when you see it. If you see the shot and don't already have the camera firing, then you've missed it. In these fast-paced scenarios, I generally use the camera like a machine gun. I set my focus point according to where I want the kayaker (or their head) positioned in the frame, and I set the autofocus to track the subject and fire continuously, whether or not the image is actually in focus. Once I have the camera's focus set up, I plant the autofocus point on the kayaker and blast away.

A key concern when using this quick-fire method is the size of your camera's buffer, or rather, how many shots you can fire off before your camera has to stop and record images to the memory card. With my Nikons, I can get about 20 RAW images before the camera basically locks up. That is just a little over two seconds of shooting, which means I have to choose wisely where and when to initiate a sequence of images; if I start too soon, I might miss the height of the action. If I start to blast away and I don't feel the action is all that exciting, I'll stop shooting and wait for it to start again, conserving my buffer. In the future, this will be less of an issue with faster in-camera processors.

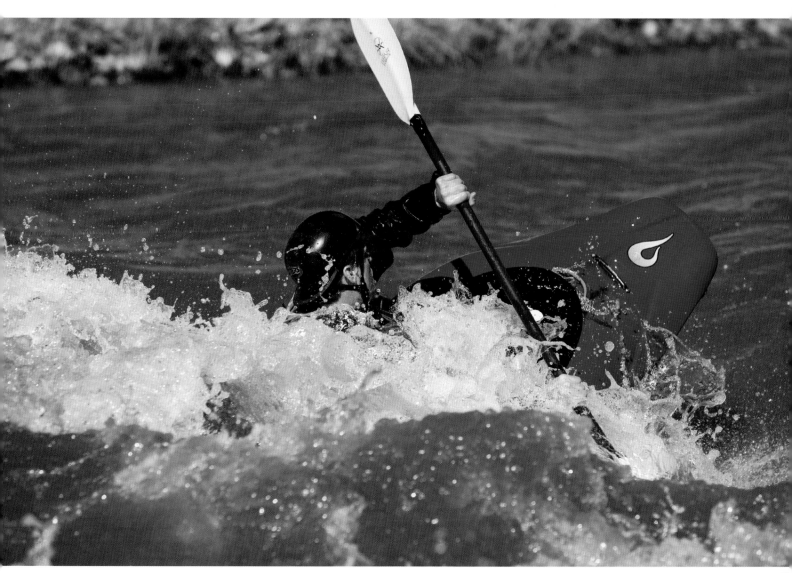

In this image of Joe Loux, who is surfing in a hole on the Rio Grande river, I was shooting from far away and behind him. There is nothing fancy as to how this image was shot, but it is a little different than your average whitewater surfing shot.

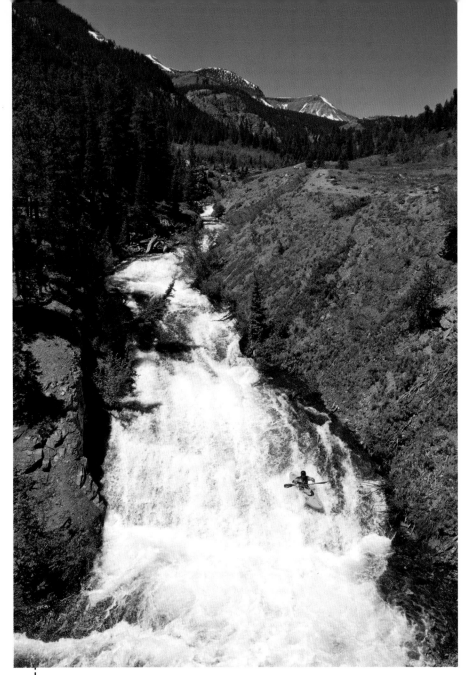

It's always nice to get a few landscape images when shooting whitewater kayaking. Here, Mike Pagel is descending an amazing rockslide on Oh Be Joyful Creek (Class V) in Colorado. I used a 17-35mm wide-angle zoom lens to include both the boater and the beautiful landscape.

tion, though SPL or Aqua Tech housings (as discussed in the surfing section) might prove to be more durable and safer choices. Mounting a camera on the front of a boat so it doesn't come off is going to take some work. The best option is to find an old boat that you can drill holes into and then mount the camera using a tripod head. A less destructive method would be to use a piece of Styrofoam under the camera and lash it down securely with webbing and duct tape, but any big hit on the camera could rip it off. With either method, make sure you have a leash that connects the camera to the boat so it isn't lost if it does get knocked off.

Strapping a camera to the kayaker's chest is a much easier task. Use an underwater housing like an Ewa-Marine bag; it is much easier and safer for the kayaker to deal with than a huge aluminum housing. To lash it onto the kayaker, use webbing or a chest harness and, once again, make sure there is a leash connected to the kayaker's PFD. The best lenses for remote work like this are fisheyes, either a 10.5mm fisheye for APS sensors or a 15mm or 16mm fisheye for full-frame 35mm sensors. (Note: If you want to use a fisheye you'll have to use one of the SPL or Aqua Tech housings, as the Ewa Marine housings won't accommodate a fisheye lens.) You might also try a wide-angle zoom like a 12-24mm or 17-35mm, or a fixed wide-angle lens like a 20mm. The benefit of the fisheye is that the boat will always be in the photo, giving the viewer a point of reference.

If you can mount the camera remotely, your odds of getting a unique, exciting image greatly improve. While it is somewhat expensive and complicated, it is possible to mount a camera on the front of a kayak, or even on the kayaker's chest. In both cases, the camera would be triggered with a wireless radio transceiver like a Pocket Wizard. Obviously, the camera will need to be in an underwater housing of some sort. Depending on the situation, an Ewa-Marine bag might suffice and is the easiest and cheapest solu-

Don't forget about the landscape in your shots. Whitewater kayaking happens on rivers in mountainous areas, so you can probably find a location that shows the kayaker surrounded by a beautiful landscape. Whether or not you need a wide-angle or medium telephoto lens to capture the kayaker and landscape will depend on the location. In general, if I am shooting a figure on a landscape—like a kayaker dropping over a waterfall—I try to get as close as possible with a wide-angle lens.

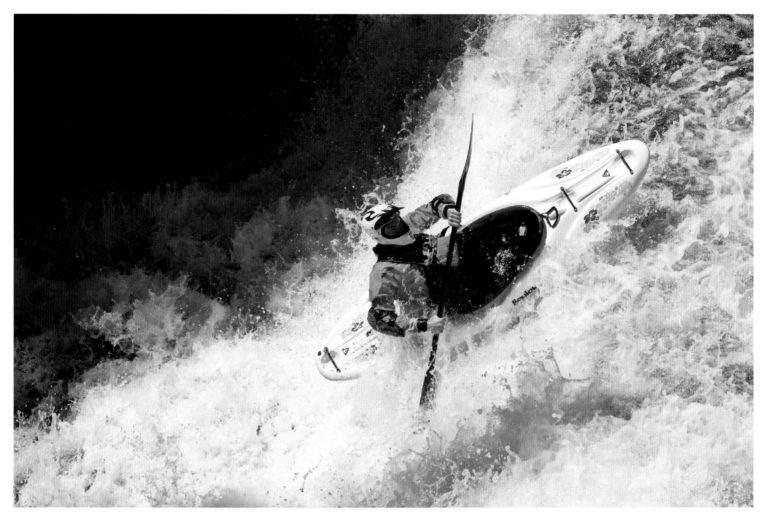

Kayaking is a sport where the athletes are not always fully in control, as this image of Tim Kelton kayaking backwards through some steep whitewater shows. When you shoot whitewater, you have to be very careful with your exposure and use the histogram to make sure you aren't blowing out important highlights. I took a meter reading off the whitewater in manual mode and then checked my histogram before Tim got to this spot. When he came into the rapid, all I had to do was concentrate on focus and composition.

I try to coordinate with the kayakers I'm shooting so we can be out during the best light, either early or late. If the river lines up east-to-west with the sun, then I'll shot with with either back or frontal lighting. In many cases, rivers are down in a shaded trench or valley where there isn't a whole lot of light. For these scenarios, I look for times when there isn't any light hitting the background, which would totally blow out if I was exposing for the shade, and I then use battery-powered strobes, like the Elinchrom Ranger set up, to add light. When using flash with kayaking, you'll need an assistant to point the flash head at the kayaker, and you'll also need to be at a semi-fixed distance to keep the exposure consistent. Shooting a kayaker in a play hole or as they go over a waterfall are specific examples of where this technique can be used. You don't see many kayaking images that are lit with flash, but it is something to keep in mind as a creative option.

Sunlight is definitely your friend when shooting kayaking. On a cloudy day, the river looks flat and there isn't much life to the images. Sunlight illuminates all those tiny drops of water flying around so they really accentuate the action. Even if the river doesn't line up for early or late afternoon light, the river itself acts as a giant fill light and allows you to shoot all day long. Of course, the best light will still be at sunrise and sunset if you are in a location where you can get it.

Basic Kit for Whitewater Kayaking Photography

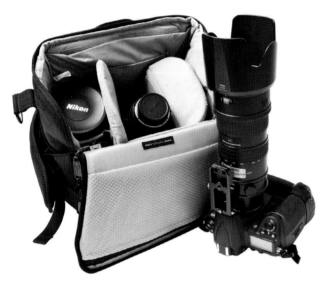

The gear required for shooting whitewater kayaking varies greatly depending on the location and access. My main setup for kayaking is a 14-24mm, a 24-70mm, and a 70-200mm lens along with a full-frame camera and an APS senor camera. If I need a bit more reach, I'll take a 300mm f/4 and use it on my APS camera, which is approximately equivalent to a 450mm lens. I also use the battery grip on both cameras, which allows me to shoot at 8 fps. There are faster cameras on the market that will shoot up to 9 or 10 fps and if you have the buffer upgraded, they will shoot at this rate for about 40 frames before the buffer has to stop to clear itself.

How you transport your gear depends on the location and how much you intend to carry. If you are hiking along the river you'll obviously have to pack lighter than if you are shooting kayakers at one specific location like a play hole. If I am going light, I'll take the basic kit in my Lowepro Specialist 85 AW, which is a large fanny pack that fits a 70-200mm zoom lens or a 300mm f/4 easily. If using lighting in one location, I'll take the Elinchrom Ranger power pack and flash heads in a separate photo backpack like the Lowepro Photo Trekker AW, along with a choice of light modifiers like a long throw reflector, a beauty dish, and grid spots. I hire an assistant to help get the gear to the location (they can wear one of the packs) and to help set up and dial things in.

If you are kayaking and carrying photo gear with you in the boat, I highly recommend using a dry bag, like the Chattooga model manufactured by Watershed (drybags.com). This bag will allow you to pack one camera and one lens in a Lowepro Toploader Pro 75 AW, and even a 14-24mm wide-angle zoom and fisheye as well, depending on your needs. Most kayaking photographers either slide their camera bag between their legs or under their knees so it is easy to access. A Pelican box is another good option, but they are so heavy and bulky that you'll have to store them in the rear of the boat, which makes access difficult.

SEA KAYAKING

Sea kayaking is, for the most part, a very tranquil sport mixed with occasional moments of high anxiety depending on the location, the skill of the kayakers, and the conditions. This is a sport that can be a luxury cruise or a cold, windswept fight for survival. Trying to launch boots or put into a remote beach in a big swell can make for quite a bit of excitement and some challenging shooting conditions. Add in cold weather and water conditions requiring a fair bit of gear just to stay warm, and creating photographs could soon be low on your list of priorities. For the most part, however, sea kayaking is a relatively low-key sport enjoyed by a different, slightly older segment of the population than other adventure sports.

Sea kayaking is a sport that is all about access to wild environments and landscapes. When shooting, you will want to communicate the experience of a sea kayaker in a landscape. That isn't to discount images that show a sea kayaker on the ocean with no landscape visible, but the landscape establishes where the kayakers are and why they chose to venture to that location.

Normally, the best images are going to be found close to land. You'll have a lot more freedom shooting from the shore than you will in a boat. I spoke with sea kayaking photographer Mike Tittel, and he told me that 80% or more of his sea kayaking images are shot from land, because the higher perspective helps establish the environment. He also added that it is hard to do this from a boat, especially in large swells.

I wanted to show how remote and small the kayakers were in contrast to the surrounding landscape in this image. Since the light was reflecting off the calm water, I shot from as low as I could in the boat so that the patterns in the water would lead the viewer's eye to the kayakers. You might also notice the camera mounted on the front of the sea kayak, which was shooting images via a Pocket Wizard radio trigger.

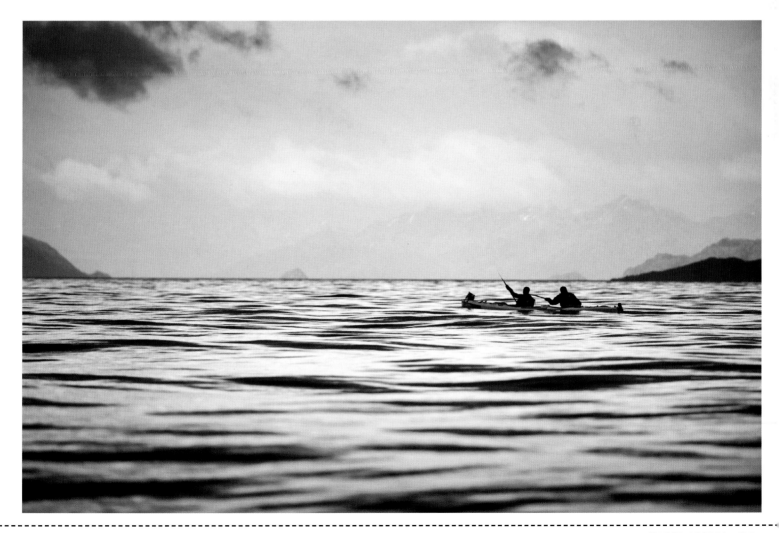

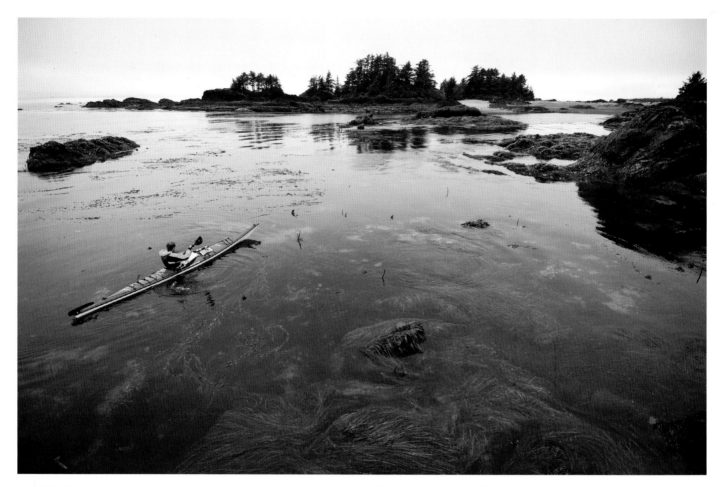

Mike Tittel wanted to give the viewer an idea of what paddling in the Pacific Northwest is all about: rocky inlets, small beaches, and waterways abundant with seaweed, sea grasses, and marine life. He shot from an elevated perspective using a 12-24mm lens and a polarizing filter to help cut the glare on the water, giving a hint of what was underneath the surface. Photo © Mike Tittel.

If you can find an inlet that isn't too large, it is easy enough to scout shooting positions on either side of it, which also gives you a lot of options in terms of the light. An island gives you the same options without as much scouting, and since you can walk around it (if it's a small island), you'll be able to get the lighting you want just by having your kayakers circumnavigate it.

Sea kayaking is also a great sport to shoot with remotely mounted cameras. Using a camera and an underwater housing mounted on the front or back of the boat can produce some wild images. I have mounted a camera with a wide-angle lens on the front of a sea kayak using an Ewa-Marine bag, some foam padding (underneath the camera), copious amounts of gaffers tape, and a few caribiners (as a safety in case the camera came off). It is a low-tech solution, but it works well. I set up the camera with a small aperture (like f/11) to keep everything sharp, and I pre-focus the lens and tape it with gaffers tape so the focus isn't affected by waves hitting the bow of the boat. I also use a Pocket Wizard transceiver to remotely trigger the camera, which is set to Aperture Priority mode to deal with changing light as the kayaker moves. If you

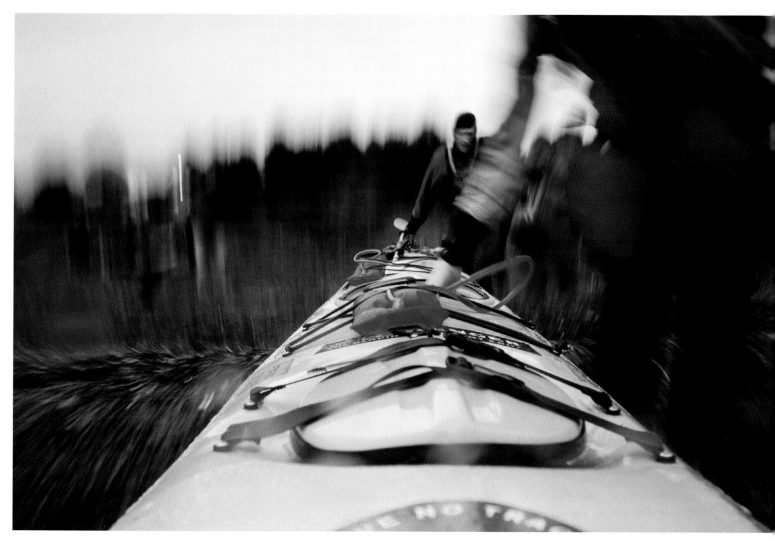

In this image of racers casting off during the 2009 Wenger Patagonian Expedition Race, I had an APS Sensor camera and a Nikkor 17-35mm wide-angle zoom mounted on the front of the sea kayak in an Ewa-Marine underwater housing. Because the team cast off at 6 AM and the shutter speed was 1/5 second at f/5.6 at ISO 400, the conditions created a blurred image as the team slid their boat into the water.

can time it just as the bow slices into a wave or ocean swell, you can get some very interesting images with the water splashing on either side of the kayaker as they paddle.

For underwater housings, I have found the Ewa-Marine bags to be the best choice for sea kayaking as they are really lightweight at only a pound (454 g), and they can be used in a variety of situations. Just make sure you get one that can accept your camera, especially if you have a large diameter wide-angle zoom like the Nikon 17-35mm, which has a 77mm filter thread. I have the U-B100 Ewa-Marine model, which does not have room for a flash. This isn't an issue because I don't use flash for most topside or surface level photography. For those

times when I am using the camera in a remote setup, there is also enough room for a Pocket Wizard radio transceiver inside the U-B100. If you choose to go with either an SPL or Aqua Tech housing, it will be a lot heavier and take up a lot more room in your sea kayak than the Ewa-Marine option, and it is much more complicated to set up a remote using a transceiver.

Another consideration when shooting sea kayaking is the subject's body position. Shooting sea kayaking is, in a sense, similar to shooting running. The classic running image needs to have the runner's legs apart at full stride. Just about any other part of the stride looks awkward in a still photograph. Sea kayaking is no different. In general, you want the sea kayaker to have their paddle on a diagonal, as when they are just initiating a stroke; anything else (aside from having the paddle parallel to the water) looks a little strange. To solve this problem, you can either blast away with a high frame rate or wait for the kayaker to initiate a stroke and catch that moment. I prefer to shoot in short bursts that catch the stroke as it is initiated all the way through to where it looks awkward so I am sure to get the perfect moment.

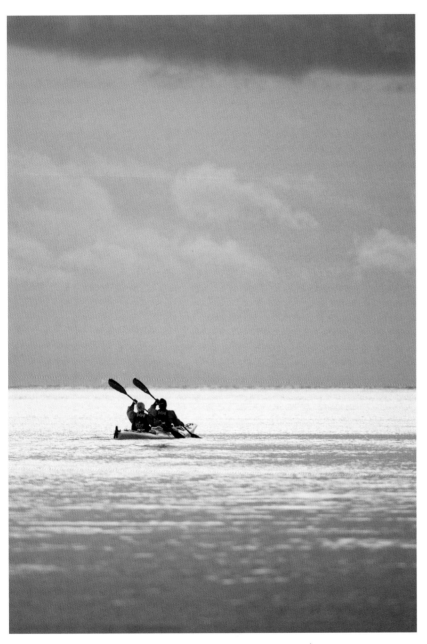

Two team members sea kayak on the open ocean on the southern coast of Chile during the 2009 Wenger Patagonian Expedition Race. I purposely shot bursts of images at 8 fps in order to capture natural looking paddle strokes.

There are an infinite variety of situations you can find yourself in that will make for stellar sea kayaking photos. If it is at all possible to get above your subjects, you'll be rewarded with a great, uncommon view of the landscape and the kayakers. If the water is clear, then your landscape might even include some underwater formations like rocks or a coral reef. As with any adventure sport, look for those off-the-cuff moments to capture the lifestyle of sea kayaking. As noted earlier, the demographic that really gets into sea kayaking is a bit older than the average adventure sports enthusiast, so be sure to demonstrate that in your photos, as well as how the tranquil sport of sea kayaking fits into their lives.

As with all photography, you will want to work with the best light, either early or late in the day. A key point to remember for sea kayaking is that the golden hour is extended because the water reflects so much light. For approximately a half hour before sunrise or a half hour after sunset, there are pink, red, and golden hues of light reflected by the water, which creates spectacular shooting conditions. If your subject is backlit, then you'll most likely end up with a silhouette. In that case, it is a good idea to include a mountain range or some landscape element in the frame as well. Frontal lighting or side lighting at these times will create soft, subtle light on the kayaker. In these situations, you

might need to crank up your camera's ISO settings to 400, 800, or even higher depending on the available light. And as you might imagine, having a camera that can shoot at high ISOs with very little noise will be a great asset. These situations are also great for using a slow shutter speed and panning the camera with the kayaker to get images that show a little motion. Just how much blur you want will depend on your tastes and how slow a shutter speed you choose.

Basic Kit for Sea Kayaking Photography

For sea kayaking photography, you can get away with a basic photography kit with just a few additions. A lightweight and easy-to-pack D-SLR is ideal. You won't need super fast frame rates for this sport, so a heavier camera with a built-in vertical grip isn't an advantage over a smaller camera. In terms of lenses, the standard 14-24mm, 24-70mm, and 70-200mm zooms will give you pretty much everything you'll need. A 16mm or 10.5mm fisheye might also come in handy for remote camera setups depending on your underwater housing. And of course, a few flash units are always a good idea. Since very few photographers have tried to light sea kayaking images, try to get something unique by using flash to create pan-blur images out on the water.

There are a lot of options for managing and carrying your equipment while on the water. If you are a confident sea kayaker and the water is calm, then using a bag like the Lowepro Toploader Pro 75 AW is a great option since it can be used with a chest harness. Mike Tittel often uses this setup and just puts his camera in a two-gallon plastic bag to protect it from the odd splash or spray. The safest option for your camera is to always have it in a waterproof housing, but with that setup you can't easily change lenses or memory cards without a big fuss that generally requires pulling into shore. Having your camera a bit more exposed but accessible is really the best method—just be careful.

To have access to your other lenses and accessories, it is a good idea to use a waterproof roll-down deck bag to store these items. This way, the alternate lenses are right in front of you and a quick lens change only requires semi-calm water. Another method is to store your camera bag in an empty compartment in your companion's boat; simply pull up next to them so you can access your gear. And one last note on gear: CompactFlash memory cards are pretty much indestructible. If you drop one in the water, it might be difficult to retrieve, but if it gets wet, not to worry—let it dry out and you'll most likely be able to use it and download images without any issues.

SCUBA DIVING —— AND UNDERWATER PHOTOGRAPHY

Brett Seymour works for the National Park Service as the lead underwater photographer for the Submerged Resources Center. Brett is one of the rare divers shooting underwater today that regularly dives to depths in excess of 200 feet (61 m), so he has expertise in working with cameras in extreme environments. Here, he shares his experience and expertise in underwater photography.

Michael Clark (MC): Because equipment is so central to underwater photography let's start there. What equipment do you use?

Brett Seymour (BS): Equipment is always evolving. In the underwater world there has been a huge evolution thanks to digital photography— we aren't limited to 36 frames on a roll of film anymore. I have always shot with Aquatica underwater housings; they are a group based in Canada that makes custom housings for specific camera bodies. Their housings are depth-rated to 300 feet (91.4 meters). The reason I shoot with them is that they are pro housings that allow me to control every aspect of the camera, and they are carefully pressure compensated. One of the biggest problems with mechanical housings is once you get down deep, all of your buttons get sucked in because of the pressure and you can't control your camera. Aquatica uses heavy-duty springs to counter the pressure.

I currently shoot with a Nikon D2Xs. My favorite lens has always been the 24mm or its equivalent, depending on the sensor size. For the D2Xs, because of its smaller sensor, I shoot a lot with a 14mm f/2.8 lens. I also use the 10.5mm and 16mm fisheye lenses. You have to remember that underwater there is a 25% magnification factor. In other words, everything appears closer than it actually is, so you need the widest lens you can find. Also, your lenses need to take sharp images with the lens port attached to your underwater housing. Some lenses work well, like the fisheyes and my 14mm f/2.8 lens, while others don't—like the 12-24mm Nikkor that, for some reason, just doesn't produce sharp corners underwater in the housing I use. You have to match the properties of the lens, the air space between your lens and the dome port, and the shape of the dome port. So it takes some experimentation to find those lenses that work well with your housing.

Brett Seymour, chief underwater photographer for the US National Parks Submerged Resources Center, ready to get in the water for a training exercise.

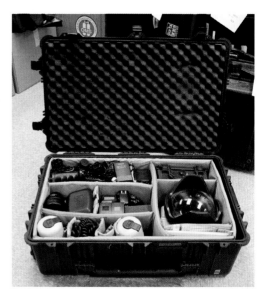

Brett Seymour's Pelican case with all of his camera gear for underwater photography.

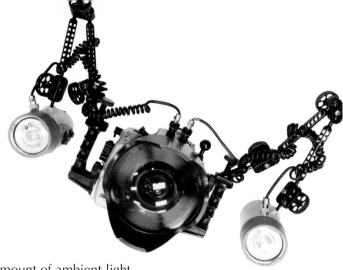

MC: Do you carry multiple bodies with you or just one body with a high capacity memory card?

BS: I carry just one body and I normally use 4GB memory cards with the D2Xs. That gives me about 200 RAW images on one card, which is normally enough. You also only have so much oxygen, which limits your time underwater and how much you can shoot, so 4GB is normally plenty before I have to come up for another tank.

MC: Do you always use flash? How do they work underwater?

BS: Underwater, light is everything. Even if you have a great camera, if you don't have flash, then you can pretty much forget about quality images. At the moment, I think Ikelite makes the best flashes for underwater photography. I have two 160-watt/second flashes that I have used extensively, and I use them both for every shot. Not only do you need that massive amount of light if you are deep, but you also need a lot of light for fill flash if you are working in shallow environments.

The lights are manual and daylight balanced. You use your experience to set the exposure, and then with the feedback from the LCD you can fine-tune the flash settings. Most flashes have four or more power settings, which can be changed just by turning a dial on the side of the unit. I use auto white balance with the flash, which seems to work pretty well. If the white balance is off, I can adjust it in the post-processing, but generally it is pretty good. At 13 to 15 feet (4 to 4.6 m) you start losing your primary colors. Even if you are working in the Caribbean, where there is great ambient light, you are still going to get a lot better color saturation using flash to fill in the light. And just as when using flash topside, you can control the amount of ambient light recorded with the shutter speed you choose. I usually don't shoot with a shutter speed lower than 1/30 second so I can get sharp images.

What a camera sees underwater is not a picture. Cameras are designed to work in a non-liquid environment. They are set up to expose for 18% gray, so when you put them into an underwater environment and shoot on automatic you don't get what you think you should get. That is why I set everything manually except for autofocus, which works well underwater with the help of a modeling light available on almost all underwater flash units.

Brett's Aquatica underwater housing, custom built for his Nikon D2Xs, Ikelite flashes, and 14mm lens.

MC: Are there any other factors that affect how you shoot underwater?

BS: The major limitation for underwater photography is visibility. Visibility is everything. Every day is different, the light is different, you are at different depths in different locations with different amounts of what we call "snot" in the water, which is basically floating debris. Naturally, your camera settings will be different depending on all of these factors.

Topside photography is all about light. With underwater photography, visibility is often more important than light because you can always create light artificially. There is visibility you can control and visibility you can't control. If you jump into a muddy area then you just have to accept it and work with it. In areas that are clear, you still have

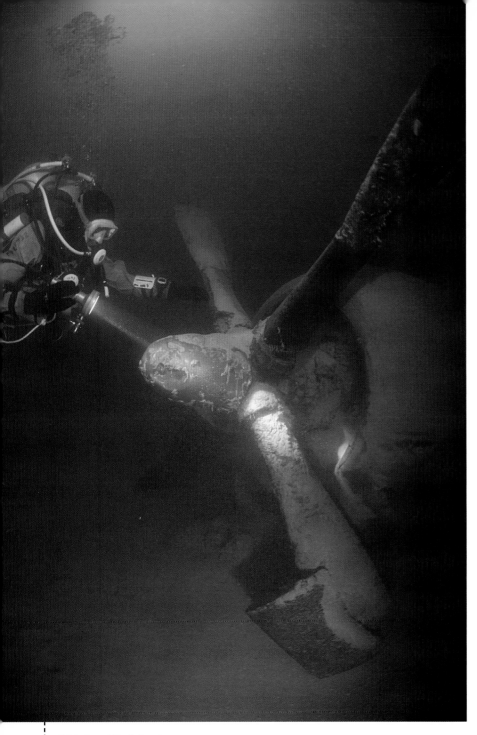

A National Park Service diver examines the engine of a B-29 Superfortress airplane at the bottom of Lake Mead, near Las Vagas, Nevada. To get to this plane, the divers had to use mixed gas to descend to a depth over 200 feet. The image was taken with a Nikon D2x and a 10.5mm fisheye. Photo © Brett Seymour.

I have shot at some locations many times and know them very well, so I might have a certain image in mind but when I get down there and it has rained or there is a current, things may be completely different. So going in with a game plan is good, but you always have to be ready to adapt to the situation. There is always particulate matter or snot in the water that you have to assess, even in the clearest ocean water. Not to get on an environmental soapbox, but in terms of the ocean's decline, with the rise in pH, global warming, and the coral reefs dying out, we have seen a lot more contamination in the water than there used to be even ten years ago. The blooms from runoff and industries are having a huge effect on the ocean and, because of this, places that used to have incredible visibility are disappearing rapidly. The best visibility right now is in spring fed caves and not in the ocean.

MC: How close do you usually get to your subject?

BS: How close you get is dependant on visibility, but generally you are five to ten feet (3 m) away. If visibility is only a foot or two (30.5 cm to 61 cm), it doesn't really matter how much light you pump into the scene, you'll just be illuminating more particulate matter and creating more backscatter. If visibility is that limited, then I'll be eight inches (20.3 cm) away from my subject with a fisheye, just to simply get an image. If you are somewhere with great visibility, like the Caribbean, then you can back off and use a slower shutter speed to get as much of the scene as you can.

to be careful, as it is easy to stir up the silt and create poor visibility with just a few poorly aimed fin kicks. Once it gets stirred up you'll have to wait for it to settle again and you only have a finite amount of time and oxygen. You have to really have great buoyancy control and you want to get in position first before others have gone in and stirred up the snot or the silt on the bottom.

MC: Do you have any advice or tips that are not obvious for someone wanting to get into underwater photography?

BS: There are a couple of things. Know your equipment, know how you can grow into it, and take the time to practice with your gear. As with many pursuits, you are limited by your equipment. You don't necessarily have to go out and get the most expensive setup, but there is always a feature set that can help you get to the next level. So, when purchasing gear, think about what you want to grow into, not what you need at that moment.

On my last trip I had a dome lens port that was leaking and I had drops on the dome the whole time. I didn't stop shooting because I could take care of it in the post-processing with Photoshop, but it just goes to show that you always have to check your gear closely before you start diving in earnest. And of course, make sure you put your camera into the housing correctly and all the seals are working so you don't flood your camera. It sounds obvious, but when you are in a rush to get in the water, you can miss small details.

Even though I dive all the time, I wish I had more time to practice in a pool to play with new settings, work out vignetting issues or lighting scenarios, and make sure I have my shooting process dialed in before getting into the ocean and having to deal with tough shooting situations. And of course, I should have said this upfront, but it really helps if you are a very skilled diver. Because underwater cameras are so accessible these days, many people seem to get certified and start shooting underwater before they are really comfortable as a diver. That can be dangerous.

A diver explores the Blue Hole in Santa Rosa, New Mexico, during a training dive.
Photo © Brett Seymour.

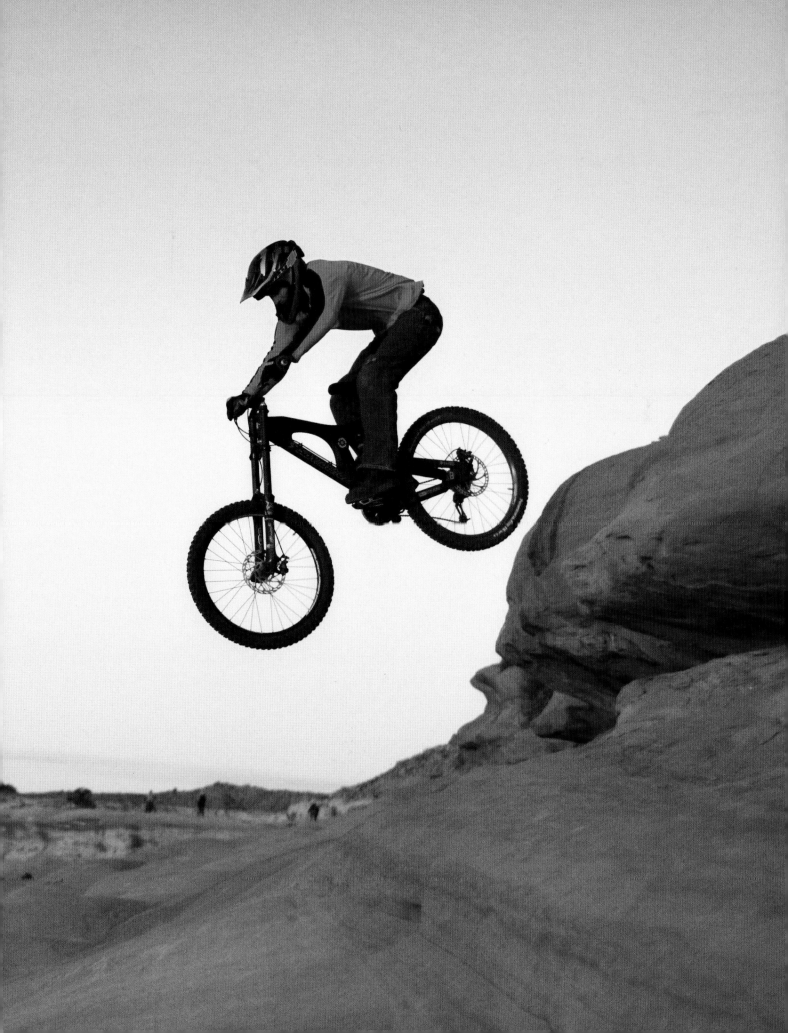

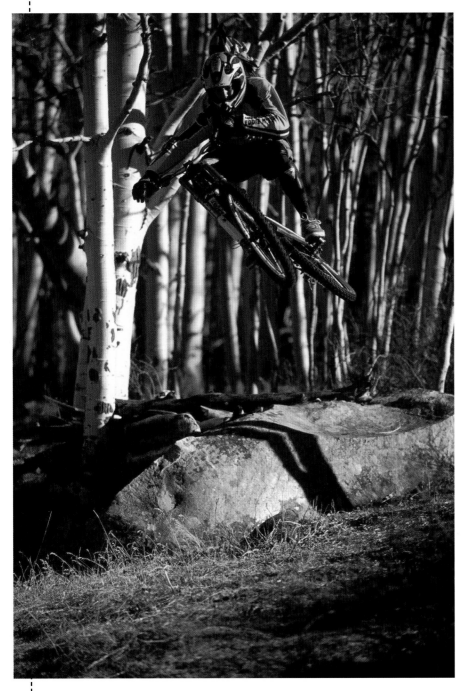

Telephoto lenses can provide a comfortable working distance for mountain biking photos. Because this rider was moving so fast, I moved back with a 70-200mm zoom lens to capture him flying off this rock on the Hazard County Trail near Moab, Utah.

While all adventure sports require incredible endurance on the part of the athletes, and sometimes even the photographer, mountain biking, backpacking, and adventure racing often demand a commitment to covering long distances and overcoming obstacles along the way. Part of photographing these sports is conveying the sense of moving over rugged terrain, whether it is a high-speed descent as with mountain biking or a casual jaunt like trekking. Though it has fallen out of favor here in the United States, adventure racing is a hugely popular sport in Europe and many other countries in the world. From what I have seen covering some of the longer races, adventure racing can be one of the ultimate endurance tests, on par with the Tour de France, the Marathon des Sables, and the Iditarod. In comparison to other adventure sports, I have never seen athletes suffer as willingly as adventure racers do. Suffering aside, let's jump in and get started with mountain biking, which has become a staple of the outdoor industry.

MOUNTAIN BIKING

When compared to many adventure sports, mountain biking is relatively easy to photograph. There are no major concerns about getting into position, using a rope, or having to deal with avalanches—in many cases, you can simply walk to the location if you have too much gear to ride with. There is always fast moving action and it is amazing to witness what expert riders can do on two wheels—it all makes getting solid images relatively easy. The bike also lends itself to an array of remote camera options, which result in stellar images, giving a feel for what it was like for the rider.

One of the greatest difficulties with photographing mountain biking is that riders are moving very fast, so you'll need some very specific gear to have a fighting chance at capturing sharp images. I highly recommend using a camera that shoots at 5 fps minimum, but a camera that shoots at 8 or 9 fps is even better. Fast framing rates give you more options in the end because you can only catch so many frames as the riders blast past you. If you have a camera that can shoot 8 or 9 fps, then you'll have an extra image or two to choose from, and that might make the difference between getting a good image and a great one. In addition to fast framing rates, you'll need the best autofocus you can afford. How well your camera can track moving objects will have a big impact on how many images are truly sharp. I have found that lenses with the autofocus mechanism built into them are radically better than those that use a screw drive system. In general, the lenses made by the camera manufacturer will also focus faster than those made by a third party.

For this blur image, I ran next to Ryon Reed as he rode the Chili Pepper Trail above Moab, Utah. I held the camera about a foot (30.5 cm) off the ground and shot at 5 fps while Ryon rode at a slow pace so I could stay with him. I used a 12-24mm wide-angle zoom and a 1/10 second shutter speed to create some blur, but not so much that the scene was unrecognizable.

Freeriders near the Rio Grande River just outside of Santa Fe, New Mexico, show the flipside of freeriding, which is pushing your bike back uphill for another run.

Using a telephoto like a 70-200mm zoom allows for a good working distance from the riders, but also allows you to fill up the frame. A 300mm lens gives you even more reach, but since it is quite heavy, it will depend more on your location as to whether or not you use it. Carrying a teleconverter (1.4x or 1.7x) with you is a great option if you need more reach and want to carry less weight. On the flip side of the focal range, a fisheye is one of the lenses I always take with me when I photograph mountain biking. By using this lens for cliff jumps, remote camera setups, and line-of-fire shots with the biker buzzing by only inches away from the camera, it's possible to get some incredible images that really give the feel of what it was like to be there.

Most of the mountain biking photography I do is of a sub-genre called freeriding, or downhill mountain biking. Freeriders jump off cliffs, ride very steep rock walls, and blast their way down unforgiving mountain trails. They are pushing the boundaries of what can be done on a mountain bike, and it really makes for incredible images. Normally when I am shooting freeriders, I hike into the location with them since the terrain is beyond my skills on a mountain bike. There are a few tried-and-true combinations of gear and positioning that really convey the intensity of this sport. For instance, when I am shooting a cliff drop, my go-to lens is the fisheye (10.5mm or 16mm), because it makes the cliff look larger and steeper, and I move in tight underneath the drop, just to the side of where the rider will come off. I use a hyperfocal distance method to achieve focus (see page 69); this way, I know that everything is sharp enough and I can concentrate on the composition. If the image is better served with a wide-angle like a 14-24mm zoom, I'll move a little farther away and shoot from the side with the autofocus engaged. If the cliff drop happens to have an incredible landscape behind it (like the image that opened this chapter), then I'll move back even farther with a 24-70mm lens and include the rider and the landscape. Or if there is no cliff drop at that particular point on the descent, I'll pull out the 70-200mm zoom and try to capture the rider ripping down the trail and the dust flying behind him to show the concentration and speed involved in this wild sport.

Downhill mountain bikers move incredibly fast. For this image, I used a 70-200mm zoom and a fast shutter speed to stop the motion. By shooting at 8 fps, I was able to capture the rider just as he was hopping a small tree on the trail at the Silverton Mountain Ski Resort, Colorado.

When shooting cross-country mountain biking, I usually ride with the athletes. There aren't as many "stunts" with cross-country riding as there are with downhill or freeriding, so the focus is more on the location, the experience, and conveying a sense of speed. I look for open areas, whether they are in a forest or a mountain valley, that allow me to communicate the setting with a rider flowing through the frame. Depending on the situation, the scene could call for anything from a wide-angle to a telephoto lens. It just depends on how far away I am and how large the landscape is in relation to the rider.

To relay the rider's experience, one of the best tricks is to use a remotely mounted camera on the bike. I have a clamp made by Slik (Slik Clamp Head - 65), which mounts to any cylindrical object up to about one inch (2.54 cm) in diameter. When I mount it on the bike, I either wrap up the shoulder strap or remove it altogether so it doesn't get caught in the wheels. Most often, I use a Pocket Wizard to trigger the camera, which is usually mounted with a prefocused fisheye lens. I'd suggest experimenting with different mounting spots on the bike, but I have found shooting from the seat tube to be one of the best bets.

I tend to shoot a lot of motion blur images with cross-country riding to give a sense of speed. For these shots, I usually ask the rider to pedal at a moderate pace and I'll either run with them using a wide-angle lens (like the image on page 147) or back off and use a medium telephoto (either the 24-70 or 70-200mm) and pan with them as they go by me.

In either case, whether I am shooting freeriding or cross-country riders, I work with the riders to capture specific images. To get the best images, you'll need to do this so you can predict exactly what is going to happen and get a few chances to catch it. I usually have the riders do a cliff drop or fly past me a few times if possible, which allows me to change shooting positions and have more opportunities to get the best angle. With freeriding there is quite a bit of inherent danger, so I am very concerned with the rider's safety and try not to push the envelope too far. In some cases, I'm there just to document what they are doing. However, I may ask them to do it again if it isn't too scary and they are confident they won't get injured.

Often, using artificial light to shoot mountain biking can result in some amazing images. Towards the end of the day, you can get away with using small flash units, but for the best light quality a larger battery-powered strobe setup gets better results. Keep in mind that whenever you are using artificial light, it slows the shooting process down, so the riders need to be willing to work with you. A large part of the delay is the recycle time of the power pack. In general, you'll get one shot for each pass of the rider, so your ability to catch the height of the action will be tested. When I use flash, I work with a crew of mountain bikers that can perform in consistent intervals that allow my flash to recycle. This way, I have more chances of getting the best image. Another factor to consider is that the exposure setting is related to the rider's distance from the flash, so it is critical that the riders can perform whatever action it is you're trying to capture at the same distance over and over. Of course, a foot (30.5 cm) closer or farther away isn't a huge thing—which is why you are shooting RAW—but this is just one more thing to think about when using flash.

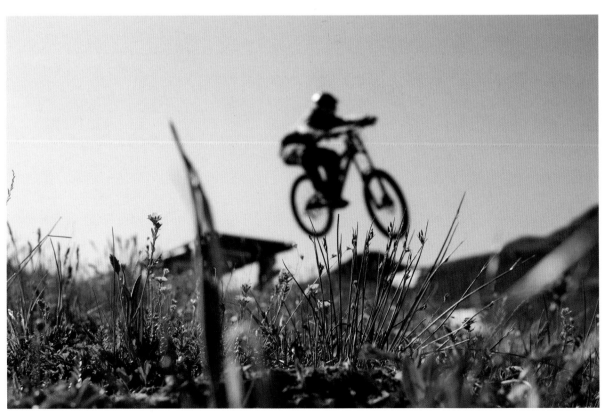

Mountain biking photography can be very artsy and creative. Here, I focused on the foreground and let the rider, downhill pioneer Josh Bender, become part of the image but not the main focus. The picture now says more about the pristine mountain landscape near Silverton, Colorado, than it does about the rider.

Basic Kit for Mountain Biking Photography

There are a lot of options when it comes to shooting mountain biking. What gear you take and how you carry it depends on whether or not you'll be riding and how far it is from the car to the location. For those times when I am shooting freeriding and the location is relatively close, I often just hike in with an extended kit of gear—sometimes it's even the whole kit loaded into my Lowepro Vertex 300 AW photo backpack or a smaller kit packed into the Lowepro Specialist 85 AW fanny pack. If the location is a long way in and the trail isn't too crazy, I'll ride with a full or semi-full pack to the location. If I am really ambitious and carry a lighting kit out to the location, I'll normally have an assistant help and we'll carry the camera gear in one bag and the lighting kit in another photo backpack. In these gear-heavy situations, I will be working with the riders on specific images that we have planned out in advance.

If I ride with the athletes, I obviously have to pare down the kit pretty drastically. The trail and difficulty of the terrain will dictate how much or how little I take, especially since I am not a pro mountain biker. At the very least, I take my a full-frame Nikon and the battery grip, which allows me to shoot at 8 fps. For lenses, the 70-200mm zoom is

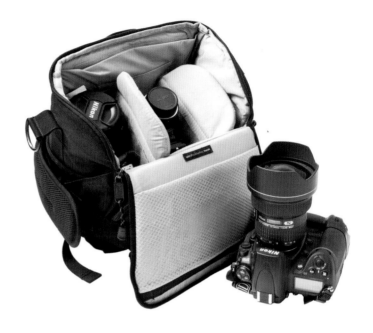

a must, and if I can carry a 14-24mm and a 1.7X teleconverter, I'll add those (packed in a Lowepro lens case to protect them) to my Camelbak hydration pack that I wear on my back. The 70-200mm f/2.8 is a key lens for cross-country mountain biking and is pretty much indispensable. I have this lens attached to the camera and I carry that setup in a Lowepro Toploader Pro 75 AW pouch that I wear on my chest because, if I crash, it is easier to protect the camera and lens on my chest than it would be on my back. This setup also gives me super-fast access so I can ride ahead and pull the camera out quickly to capture the action.

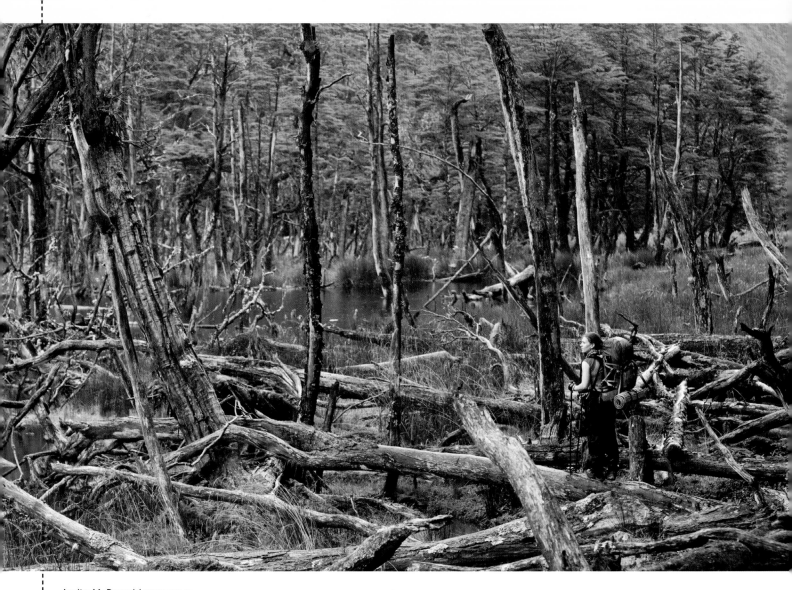

Lydia McDonald surveys a beaver dam in her path while hiking unmapped terrain in the Darwin Range at the very southern tip of Chile. The chaotic and remote landscape really makes this image work, but it helps that I caught Lydia in a pensive moment as she considered the work ahead.

BACKPACKING

Getting good images of backpacking takes some creative thinking because the action isn't as inherently dynamic as other adventure sports. If you're aiming to be a pro photographer, think about what a client (like a gear manufacturer or a magazine) would need and license and shoot accordingly. Typically, this boils down to images of backpackers using outdoor gear, like hikers wearing packs, cooking on a camp stove with a tent in the background, or a group packing up for a day hike. To add more drama to images, I like to get creative and use panning and blur techniques to make hiking with a pack look more exciting. Of course, incredible landscapes are what backpacking is all about, so choose a location that is so wild and beautiful that it does half the work for you.

Backpacking, unlike mountaineering, usually doesn't involve technical climbing, really steep hiking (at least, not too often), and thin air; so while it shares some of the same principles as mountaineering photography, the need to go super light is not quite as important. Still, it pays to have lightweight outdoor gear so you can take more camera equipment. When I used to work as backpacking guide in the Grand Canyon and all over the southwest, we had gargantuan packs that weighed in excess of 75 pounds (43 kg). Fortunately, there has been a lightweight revolution in backpacking gear in the last decade. These days, it's common to go on a four- or five-day backpacking trip with only 25 pounds (11.3 kg) in the pack (not including camera gear). There are a number of companies making incredibly lightweight gear that won't

break the bank; check out GoLite, Granite Gear, and Black Diamond. As with any outdoor activity, the lighter you pack, the more ground you can cover. We'll get into the lightweight gear in more detail when we talk about adventure racing in the next section. If any outdoor user group is pushing the boundaries of light and fast, it's certainly the adventure racers.

For most images of backpacking, a wide-angle lens will be your mainstay because it allows you to get in close and create interesting perspectives of the gear in use and the person using it. Since backpackers normally set up and break down camp in early morning or late light, use these times to your benefit and ask your fellow hikers to work with you while they are cooking dinner or getting the tent organized. Also, don't forget to explore interesting angles below and above your subjects, either at camp or while hiking. Shooting from inside the tent through an open door is a great angle. If there is a sweeping panorama visible when setting up camp, make sure the front door of your tent opens towards it. As we talked about earlier in the lighting section, it is easy to get the popular glowing tent image using your headlamp, just make sure you include a wild landscape along with the tent. Basically, everything hikers do while backpacking (save for bathroom breaks!) can be interesting to photograph, especially if it is the golden hour or the weather is bad.

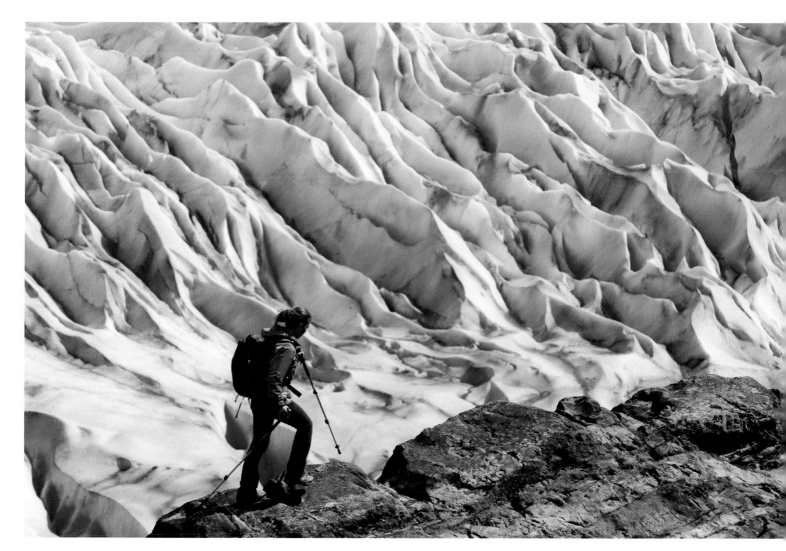

Lydia McDonald hikes above the Glacier Gray in Torres del Paine National Park, Chile, during a five-day backpacking trip. I had a shot like this in mind before the start of the trip and we scouted locations until we found this spot. It always pays to plan ahead and have a list of shots to look for on your adventures.

I used the doorway of a tent to frame this image of a couple relaxing at camp near Los Alamos, New Mexico. Clean pictures of couples camping and using outdoor gear can be very sellable.

Often, I'll head into the backcountry for 36 hours or so with a couple and photograph specific types of images, like winter camping for example. This way, I can build a collection of stock images that will fit a buyer's needs. The reason for the short duration of the trip is that I want the gear to look really clean and the couple to not look like they have been worked over the coals in the outdoors for a week. These cleaner lifestyle images tend to be much more sellable. On the flipside, nothing says "adventure" more than some wild hairdos and the thick, uneven sunscreen typically seen on an extended trip. In the end, it just depends on the look and markets you are going for with the images.

Landscape photography is a perfect fit with backpacking, and often the entire point of the trip is to get to the incredible landscape in the first place, so take a tripod, an alarm clock, and a warm puffy jacket so you can get up and shoot at sunrise. On most multi-day trips, my friends are good for a few days of getting up at sunrise if I want to include a hiker in my landscape images, but I am careful not to burn them out. Instead of asking them to get up everyday, I'll get up early and shoot pure landscapes on those days when they aren't into it. You don't have to have a tripod for landscape photography—I have used everything from tree branches to just setting the camera on the edge of a boulder for long exposures—but if you are serious about your images, you'll want to pack one. In the end, it comes down to balancing how light you want to go versus what the focus of your backpacking trip will be.

While my companions were cooking diner, I went out to shoot landscapes and caught this wild sky in the Needles District of Canyonlands National Park. By shooting at ISO 800, I was able to get a sharp image with a 70-200mm lens without a tripod. Some of the best light for shooting landscapes or adventure sports happens just before sunrise or after sunset, so go early and stay late.

Basic Kit for Backpacking Photography

For backpacking trips, how much photo equipment I take depends on the terrain, the length of the trip, and how much camping gear I already have in my backpack. If the purpose of the trip is specifically to create images, then I'll split up the group gear (like food, tents, and stoves) among my friends and carry a basic photo kit consisting of my full-frame Nikon and three lenses, including a 14-24mm, a 24-70mm, and a 70-200mm. I'll also take a flash unit, memory cards (lots of them), and extra batteries, as well as a Lenspen to clean my camera and lenses. I try to take a lightweight tripod for landscape images, which are a large portion of my backpacking photography.

To carry all of this gear so at least some of it is accessible, I use the same fanny pack as I do for mountaineering, the Lowepro Orion (not the AW). If I want to include a few more items in the fanny pack, like an extra camera body, I take the Lowepro Inverse 200 because it can hold just a little bit more than the Orion. If I feel I'll need an easily accessible longer lens, then I'll wear the Lowepro Toploader Pro 75 AW as a chest pouch. Either way, the gear that isn't in the fanny pack or chest pouch gets packed away in the backpack, and if I see an amazing image I'll ask everyone to stop so I can shoot.

As for going lightweight, I have recently come across a cool little gizmo that replaces my tripod and only weighs one pound (454 g)! It is the Joby Gorillapod Focus—a small "tripod" with bendable legs. It isn't as tall as a real tripod but it is much more versatile, not just for the camera but also for mounting remote flashes on trees or rocks because its three legs can bend around an object. It is also a relatively inexpensive option for when you need to go light but still want something to support the camera for long exposures.

ADVENTURE RACING

Adventure racing is kind of an oddball in the adventure sports genre. It falls into its own class of lunacy since a race normally entails some combination of trekking, mountain biking, sea kayaking or canoeing, climbing (in the form of ascending fixed ropes), and sometimes trail running. Some races last only a day while others can last as long as ten. In either case, especially for the longer international races, the athletes are incredibly fit.

Obviously, adventure races require that athletes are well rounded, and the same holds true for the photographer trying to successfully capture the action. It makes sense that we cover this topic here at the end of the three sport-specific chapters, because adventure racing calls on much of the knowledge we have gained so far. For the amateur photographer, it is unlikely that they will be interested in shooting an adventure race because there isn't necessarily a lot of action and access is difficult, unless they are participating in the race itself; however, pros are often called upon to photograph them, and they can be quite challenging to cover. How to actually get into position and cover a race depends on many factors, including how the race is set up, the landscape, the length of the race, and if the race organizers have a budget for helicopters and other transportation to ferry photographers around.

Back in the old days of exotic, televised adventure races like the Eco-Challenge, photographers were carried around in a helicopter that they shared with a television crew. The beauty of this setup was that photographers could take as much gear as they wanted, within reason, and basically live out of the helicopter. This is about as good as it

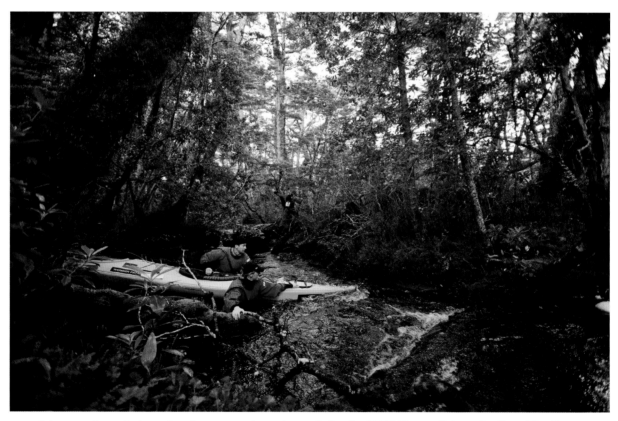

A team portages their sea kayaks across a deep stream during the 2009 Wenger Patagonian Expedition Race. To get this image while following the racers, I had to travel light and fast with only one camera body and two lenses—a 24-70mm and a 17-35mm. This image was shot with a 17-35mm at 17mm to give a sense of the surrounding terrain, which was an incredibly dense forest.

gets for covering an adventure race, but rarely, if ever, do we have this type of cushy transportation with modern races. More often, photographers are traveling in a Jeep to cover the mountain biking sections and in a small boat for the sea kayaking sections. Any trekking sections are usually shot by hiking into strategic locations with the racers or meeting them at certain checkpoints. For smaller races, where the course is easier to access, it isn't too hard to get to the location by backtracking from the checkpoints. Many times, the race organizers have hired multiple photographers and assign each one a particular part of the course to cover. In the larger races that typically take place in extremely remote and unmapped regions, like the Wenger Patagonian Expedition Race, photographers have to be in great shape because they must hike with the racers in the trekking sections through dense forests, steep mountains, and generally epic terrain. Covering an adventure race will tax all of your skills as a photographer and as an athlete. After all, if you aren't in good enough shape to keep up, you won't be in position to get the image. Since adventure races usually include some form of trekking, climbing, mountain biking, and kayaking, we'll cover each sport in detail.

TREKKING

The trekking sections of an adventure race are the most difficult to cover because the racers are usually in terrain that has no trails and is not near any roads. If you have the luxury of a helicopter then you can be dropped into a location to meet the trekkers, but more likely than not you'll have to pare down your gear to the bare minimum. The racers are carrying at most 20 to 25 pounds (9 to 11.3 kg), so you'll have to be carrying about the same weight or less just to stay with them. Look for those moments when the team stops to discuss route options, look at the map, or when they are crossing huge rivers. Ask the team to wait for a minute (if they are willing) so that you can cross the river first and photograph them waist deep in its raging waters.

To go as light as possible in the trekking sections, I'll take a barebones kit with one camera body and two lenses: a 24-70mm and 70-200mm. Even this kit with large zoom lenses is still pretty hefty. There are times I've thought about taking lighter lenses, but I am stickler for image quality so I'd rather take better, heavier lenses. However, If I want to go super light and don't think I'll need the extra reach of the 70-200mm, I'll just take the 24-70mm wide to medium telephoto zoom. To carry the gear I use the Lowepro Toploader Pro 75 AW with a chest harness so it is out of the way and doesn't restrict me while hiking or crossing waist-deep rivers. I also put the 70-200mm zoom lens, if I take it, into a lens pouch and have that clipped to my pack's shoulder strap so it is easily accessible. If the terrain isn't too tough, and the section is short, I might even bring a flash unit—it all just depends on how much weight I already have. And just as with the sea kayaking set up, I use super-lightweight roll top dry bags to waterproof my cameras and lenses, so that if the river crossing is deeper than I thought or I get swept away, the camera equipment is safe (to some degree).

This image shows one of the few times I have been able to pose a shot during an adventure race. To get a better view of the Patagonian landscape, this racer climbed up onto the boulder to better see the terrain. I asked him to hang out there for just a few minutes, and being completely exhausted, he was happy to oblige.

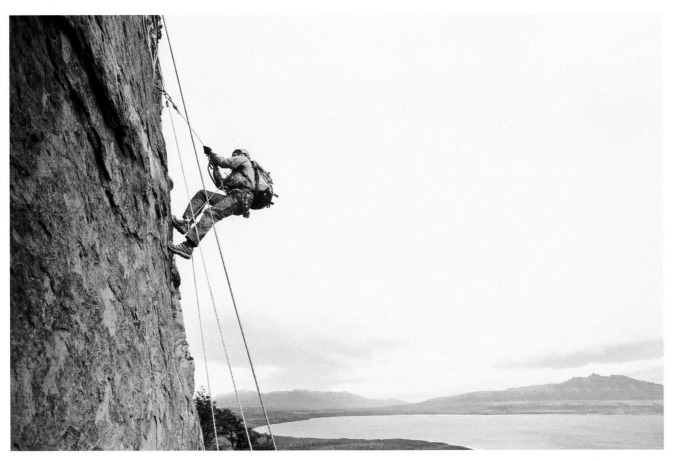

While hanging from a nearby rope, I pushed myself as far back as I could to get this image of a climbing guide ascending fixed ropes during the 2009 Wenger Patagonian Expedition Race. I used a 17-35mm lens and made sure to keep the horizon line in the background level in the viewfinder.

CLIMBING

While I don't consider climbing a fixed rope with ascenders all that adventurous, it is a part of most adventure races. If you plan to cover this part of the race, then your rope climbing skills will have to be top-notch since you'll be moving up and down the ropes quickly to get in position. Luckily, teams tend to move into this section over the course of a day and you will have multiple chances to shoot each team as they work their way up the rope. Because the racers are usually wearing backpacks, they will be moving a little slower and this allows you time to move up and down or side to side on the wall to find the best angles. Shooting from a rope isn't the only option, but because the rope sections are at least 100 meters, being on a rope gives you a lot of options you won't find standing on the ground. I tend to get above the racers at the start and shoot with a longer lens, like the 24-70mm. As the racers get higher on the wall, I will wait for them and switch to a wide-angle zoom, like a 14-24mm, so I can get an image of them with the landscape in the background, which shows how high they are off the ground.

Shooting the climbing sections of an adventure race is no different than shooting rock climbing, except the climbers are on a fixed rope. I always ask the race organizers to set up an extra rope for me so that I am not on the same one as the racers. I normally take just one camera body and carry two or three lenses: a 14-24mm, a 24-70mm, and possibly a 70-200mm. Depending on the background and scenery, I'll decide where to position myself and what lens to use.

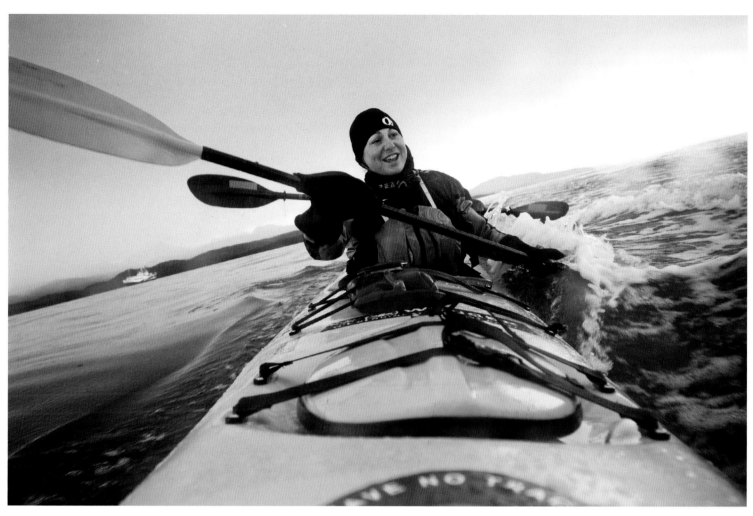

KAYAKING ────────

Things to look for in the sea kayaking sections are a nice landscape and big waves. If there is a wild landscape, as in a glacier or snowcapped peak in the background, get low and include it in your image. If there are sizable waves on the ocean that day, make sure to catch the kayakers as they crest one of those waves, while still trying to include a stunning landscape in the image if possible. Another option already discussed in the sea kayaking section (see page 135) is to mount a remote camera on the front of the kayak. This will help you get up-close images that show what the racers are going through.

The sea kayaking or canoeing sections of a race are generally shot from a small boat like a Zodiac. Because these boats have a motor, you'll have to be a certain distance from the kayakers to avoid having your own wake in the image, and this necessitates the use of a telephoto lens. The two lenses I use in this situation are the 70-200mm f/2.8 zoom and a 300mm f/4. The 300mm f/4 has a lot of reach and is light enough to handhold while bouncing around in the boat. I also sometimes use a 24-70mm lens for when the kayakers get close and pass us. To protect my cameras I use a plastic rain sleeve, made by Op/Tech, that fits over the camera and protects it from the odd splash and ocean spray. I also use large lightweight roll top dry bags to waterproof my cameras and lenses while they are in the camera bag. Using an underwater housing would provide even more protection, but since we are in a boat and the odds of falling out are low (hopefully), I prefer to have the flexibility provided by a rain sleeve, which is very lightweight and inexpensive.

I mounted a camera on the front of the boat for this image of adventure racers sea kayaking on the open ocean during the 2009 Wenger Patagonian Expedition Race. The camera was protected in an Ewa-Marine bag and was gaffer taped to the front of the boat. I triggered the camera with a Pocket Wizard radio trigger.

Racer Daniel Pincu's strained and weary face speaks volumes during a mountain biking section of the 2009 Wenger Patagonian Expedition Race. Always look for moments of emotion and fatigue when shooting racers since suffering is all but synonymous with adventure racing.

For mountain biking, a standard kit with 14-24mm, 24-70mm, and 70-200mm lenses will work quite well. A 300mm lens might be useful as well, depending on how far away the riders are—and how close to them you can get. In a lot of adventure races the terrain is so difficult that the racers end up carrying their bikes as much as they ride them. Hence, the closer you can get the better. And the riders will not always be on a road, or even on a trail, so be prepared to hike or run into scenic locations with the bare minimum of gear.

MOUNTAIN BIKING

For the mountain biking sections, it is often possible to leapfrog the racers with the help of a Jeep. Some of the best mountain biking shots are of the riders carrying their bike through a river or muddy section. Alternatively, think about how you can capture the movement of the racers by using slow shutter speeds and rear-sync flash. To get slow enough shutter speeds for this technique, look for those times either early or late in the day, on a dark and rainy day, or when the riders are in a densely shaded forest. Just as we described in the mountain biking photography section (see page 147), finding an area where you can include the riders and the landscape provides a powerful sense of location and what they are going through, both physically and mentally. In the world of adventure racing in particular, the racers are enduring a serious amount of pain and exhaustion, and if you can find a racer whose face conveys those sentiments in any section of the race and combine that with an artistic composition, then you'll have a real winner.

SHOOTING ON THE RUN

In any section of the race, you need to be prepared to grab a camera and a few lenses and run with the racers to get what you can. Think about the image you are trying to get in any scenario before you get there. If you can keep a list of potential images in mind during the race, this preparation will give you a much better shot at capturing them when the right situations come about. Be on the lookout for those times when you can tick off that image you have been thinking about for days. Sometimes you get it and everything comes together; other times it doesn't quite work out the way you wanted. Getting the best images of an adventure race is about being ready at all times and working hard to get into the location ahead of the racers.

In essence, you are basically working as a photojournalist when you shoot an adventure race. You will have to draw on all of your photographic experience and use your intuition to compose images on the run. This is where shooting all of the other adventure sports will come in handy because you can look at a landscape and know where you need to be to get the best images.

Basic Kit for Adventure Racing Photography

Because you'll most likely be working out of a truck or boat, or hiking with the racers, you'll need to have a few different ways to break down your gear so you can go as light as possible in each section of the race. My standard kit for covering an adventure race is to take my Lowepro Vertex 300 AW and pack two camera bodies (one full frame and one APS sensor), two flash units, and lenses ranging from a 10.5mm fisheye up to a 300mm f/4 telephoto lens. I take pretty much the whole kit because we'll be traveling by boat or truck for a large part of the race. For carrying a subset of my gear, I will also take the Lowepro Street & Field (S&F) series setup including a Toploader Pro 75AW, with a belt and chest harness, and two lens cases— one for a 70-200mm or 300mm lens and another for a 24-70mm or 14-24mm lens. Between the S&F camera bags and the backpack, I have enough options to work with in each leg of the race and can pare my gear down to just the equipment I'll need for each section. Carrying a lot of memory cards (50GB or more) or a device for downloading your images is also key. However, these devices are dicey if you only have one, and carrying two for backup starts to get a little heavy, especially when you are trying to go lightweight in the trekking sections.

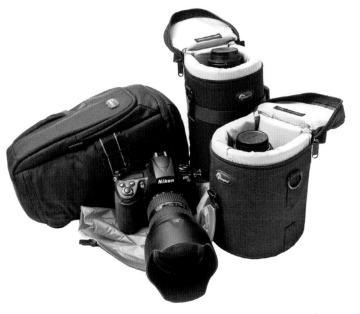

Memory cards are by far the most durable and reliable storage option for your images, so having a good supply of them is the safest option.

When shooting an adventure race, there always seems to be a compromise between keeping your equipment accessible and protected, especially when shooting races in very rainy or even dusty locations—which is where most of them seem to be held. You'll just have to accept that your gear is going to get worked over. It's times like these when choosing the higher-end cameras and lenses will pay off because they will be able to stand up to the elements and keep working, even when it is raining sideways for days on end. Adventure races are tough on camera gear and I have killed a few cameras and lenses while covering races, so I highly recommend getting solid insurance for your gear.

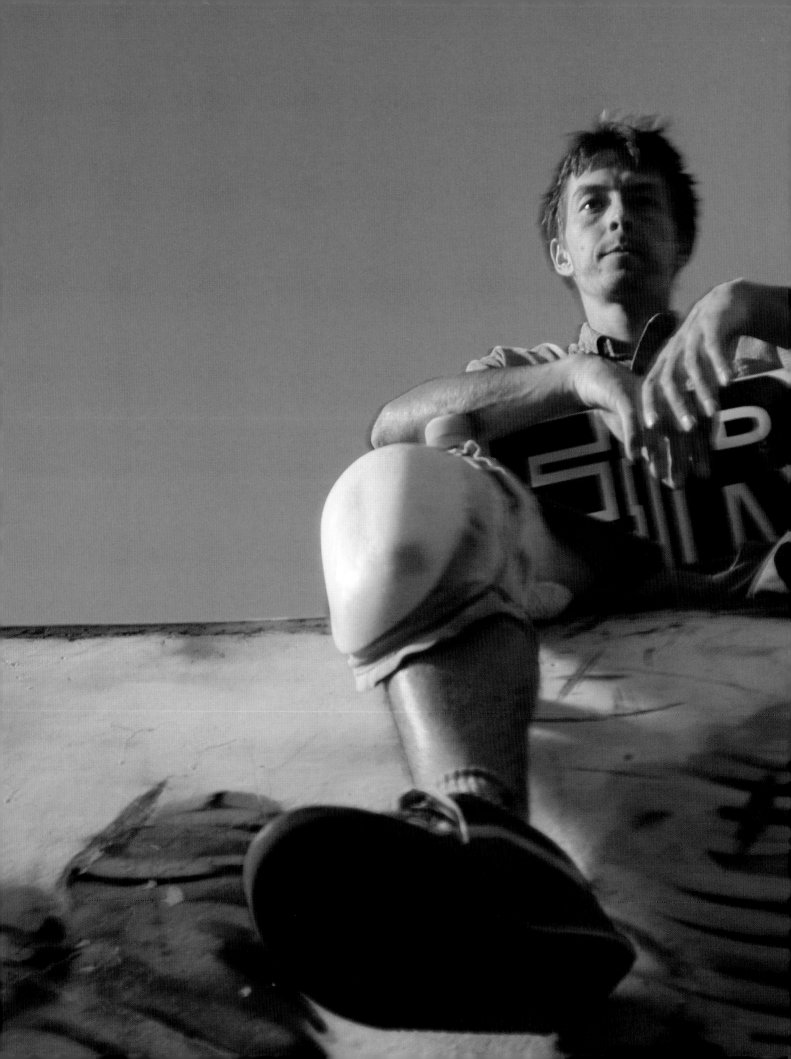

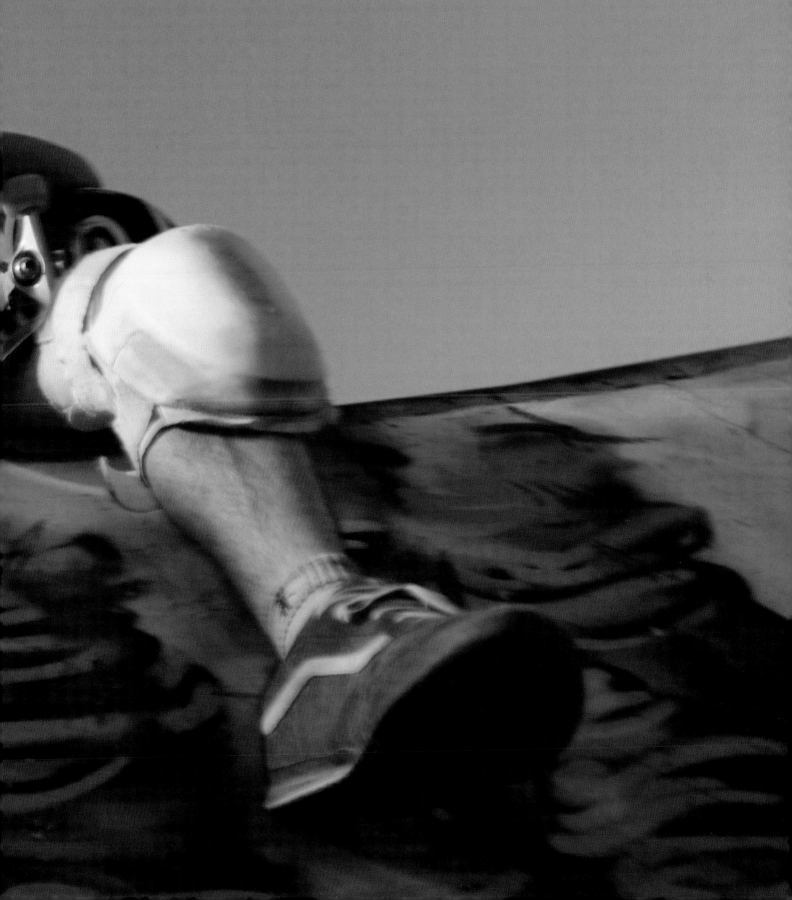

When most people think of adventure sports photography, they generally don't think about portraits or lifestyle images. The first images that usually come to mind are probably those of a climber hanging off a cliff or a surfer charging a huge wave. In the world of adventure sports, however, getting a solid portrait or capturing an authentic lifestyle moment is just as important as capturing the action itself. These are the images that will help tell the whole story. And for anyone who wants to make a living from their adventure photography, portraits and lifestyle images have become one of the most lucrative areas in the genre. Dialing in your portraiture skills and being able to capture the lifestyle of your athletes, either as it happens or by recreating it in an authentic manner, can make the difference between success and poverty.

When I started out as a professional photographer, I wanted to be an action photographer. I concentrated pretty much 100% on high-end action and thought little about the in-between moments or taking a portrait. My idea of portraiture was the stuffy family photos you got when you were 12 years old when your mother made you dress up in uncomfortable clothing and carted you off to the mall. However, I quickly learned I needed to focus on getting more lifestyle images and sharpen my portrait skills as well, or my dreams of being a full-time pro would vaporize. In my mind, any book that talks about outdoor sports would be incomplete if it didn't at least touch on portraiture and lifestyle photography in the context of the adventure world. So we'll start with portrait photography and then get into lifestyle images. Just as with the lighting chapter, there are entire books devoted to both of these genres of photography, so I won't get bogged down with lighting ratios or too many of the technical aspects. My emphasis here will be on how to approach these types of images and how to capture some of the nuances that might not be so obvious so you can produce better images.

PORTRAITURE BASICS

Portraiture is one of the most challenging genres of photography. The goal is to connect with your subject and capture a bit of their personality or mood. This can be a tall order, especially if you have only met the person a few minutes before the shoot. If a subject says, "you really captured me," then you have achieved the primary goal of portraiture. Technically, a photographic portrait is a likeness of a person, predominately showing their face. Portraits are usually composed and the subject is either seated or standing, but in either case they are still for the most part. A portrait isn't just an off-the-cuff snapshot. There should be some obvious thought about how the image will be produced and this effort is usually visible in the image. Sometimes the person isn't aware that they are being photographed, but nonetheless, the photographer still makes certain decisions on the background and composition.

First, we must distinguish between portraits caught on the fly and those that are posed in the traditional sense. In the adventure genre, there are many times when you will be shooting portraits, either just before or after the action, like a climber putting on their climbing shoes before getting on a route or a mountain biker taking a few minutes to collect themselves before a big cliff drop. These are great times to move around and shoot portraits or lifestyle images. For this type of image, the line between portraiture and lifestyle can get a little blurred. In this section, I will cover a more formal type of portraiture where the portrait itself is the reason for the photo shoot, because this style is often more difficult for most adventure photographers.

For this portrait of Ryon Reed, which was shot during a mountain biking assignment near Moab, Utah, I asked him to look towards the sunset while I shot from a low angle to get a clean background.

Great lifestyle portraits are usually caught on the fly. I ended up on this Chilean fisherman's boat during the 2009 Wenger Patagonian Expedition Race and photographed him as he dived for sea urchins and king crab in a wet suit with homemade weight belts. This image says more about his life than any studio portrait possibly could.

On most of my portrait shoots, I am working with a few people—the subject directly, an assistant, and sometimes a stylist. It just depends on the shoot, my client, and the situation. There are times when it is just the two of us—photographer and subject—which makes for a quick session. But other times it is a full dog-and-pony show where we scout the location the day before the shoot, arrive early the day of the shoot, get a few setups prepared, and then let it rip when the person we are photographing that day is ready. I tend to get the standard shots—like a close up headshot and an even tighter face shot—out of the way first, and then we move onto more creative approaches if the subject is willing. At that point, I am not just looking for a casual portrait. I am trying to catch something quirky or odd that really draws the viewer in to the subject's face.

ESTABLISH A CONNECTION

As you might have already guessed, you need to break down some barriers before you start shooting a portrait. Take some time to get to know the person you will be photographing. Find out what their passions are, what they do, where they live, and as much about them as possible. The more you know about that person, the better you can make decisions about how to create a meaningful portrait of them. For many people, the first thing they think about when they hear the word portrait is, "how does my hair look?" They become self-conscience. And it is your job to allay those fears and put them at ease so they don't turn into a deer in the headlights when you pull out that gigantic pro model camera.

Part of establishing a connection is to include the person you are photographing in the process. This is their portrait after all—you might be taking it and creating an image, but they are part of the process and can greatly help you get something different and unusual. Take time

This high-contrast black and white portrait of Stephen Hyde was shot in the entranceway to a public restroom, just after he had been free diving at Blue Hole in Santa Rosa, New Mexico. With a small amount of equipment and a little creativity, it's not hard to create studio-style portraiture.

before you pull out the camera to explain what you have in mind. See what they think about your idea and ask if they have any ideas of their own. Really listen to what they have to say. People can tell when you are not genuine—when you are tuned out and focused on the technical aspects of the shoot. My hope going into any portrait is that I can get them excited about the process, which in turn gets them involved, giving me much more to work with.

The reality is that some people are more comfortable and exuberant in front of a camera than others. For those people who don't seem as comfortable in front of the camera, give them something to do, a role to play, or some emotion to act out. If you can give them something to do, like hang upside down on gymnastic rings or just look off into the sunset, it helps them think about something besides having their photo taken.

WORK QUICKLY

There is a ticking clock when you are shooting portraits. The person you are photographing will have only so much patience for your portraiture shenanigans, and that amount of time is different for everyone. So it's always best to work quickly. The following are some tips to help you move through a portrait session quickly and keep your subject involved.

First, you don't want to be working out the camera settings during your session (except for little exposure and lighting tweaks). Use an assistant to help you get set up and to also act as a stand-in for test shots so you know everything is dialed in before you bring in the subject. If your subject sees that you are running a quick, well-planned operation, they'll be much more likely to get involved knowing they won't be spending all day on the shoot.

Plan your portrait session ahead of time with some thought to the condition of the athletes. If you've just returned from a full day of skiing, then your subject is obviously going to be tired. If you can, wait for a rest day when your subject will be more at ease and open to working with you. In the end, most athletes know the extra exposure from a portrait session is a good thing. But everyone has a limit, and you will know when they are ready to be done with the shoot—it will show in their body language. For some people it might be five minutes in, for others, they'll stay all day as long as it seems like you are getting good images.

On a technical note concerning speed, set your camera to a high framing rate so you can rip off a sequence of shots. Your subjects' expressions are fleeting and you'll have to react quickly to capture them.

CONFIDENCE AND EYE CONTACT

A big part of putting your subject at ease is to show some confidence. This doesn't mean you should be cocky, it means you should look in control of the process and the setup. Make it feel smooth and easy so your subject can relax. One way to become more relaxed is to start working with the subject and directing them so you can get an image that works. Don't be shy about asking them politely to move to a better position, turn towards the light, or whatever needs to happen to improve the image.

During the shoot, give your subject some positive feedback. Give them an occasional "Oh yeah, that's nice," or some direction that let's them know they are doing okay. Also, be sure to take the camera away from your eye and talk with them from time to time to keep the atmos-

Mike Fischer looking roughed up in Grand Canyon National Park after seven days without a shower. I thought his bloodshot eyes and scruffy appearance would make a great serious looking portrait. I used a gold reflector on his left to accentuate the red color in his face and shirt.

phere personal. This establishes eye contact between you and your subject. Doing so makes you more personable and helps the subject feel like they are dealing with a human being and not a robot programmed to shoot portraits.

Another way to put your subject at ease and to get them involved in the shoot is to show them a few of the best images on the camera's LCD. This will give them a better idea of the type of images you are going for. If the images are conceptual in nature, meaning there is an underlying concept behind the portrait, then this is also a good way to get some ideas from them. And if you can get to the point that you are collaborating, then you'll get way more out of your subject than you would otherwise.

ON LOCATION

Obviously, a lot of adventure portraits are shot on location. Shooting outdoors presents it's own set of problems because you have to deal with the weather, varying light, and other issues. On the flip side, it can also solve many problems because it gives a context for your image—something you don't get in a studio. When the light, weather, subject, and background come together, your job gets a lot easier. Automatically, you have your lighting setup (in naturally lit situations) and an interesting backdrop without having to lift a finger.

Creating a mood can certainly help your portraits. Here, I wanted to portray the sense of freedom and independence one might feel when setting off alone on a Harley on a summer evening. To create the shot, I asked the rider to look towards the horizon, where a flash was set up at eye level just in front of him. I used a small softbox with a ¼ CTO gel to mimic the last light of the day.

Portraiture is all about the right lighting. If the light outside is good, then you won't need flash, unless you want to alter the light radically. Often, a splash of light from a reflector on the shadow side of your subject will be all that's required. When shooting outdoors, I prefer to shoot portraits in late afternoon or evening light—or even better, in twilight—which obviously requires very quick work.

Normally, when on location, the portrait shoot happens in the same area where I have been shooting action images of the athletes, or at the very least in an area where they practice their sport. This allows me to use the location as a background for the portrait, which gives context to the image. If the actual location isn't that great, I'll get low and use the sky as a backdrop. One of the old standbys is to get the athlete into their gear, which again gives the image context and helps to tell their story. While this works quite well, especially with some interesting lighting, it isn't going to win you any awards. I prefer that my subjects are doing something, almost anything, so the portrait doesn't look so staid. Examples would be having them looking towards the sunset, interacting with the camera, or anything that breaks the "stand there and look into the camera" motif. I'll certainly get some shots of them looking into the camera, as that engages the viewer, but if it seems appropriate I'll have them look away, or even down at the ground. Also, I prefer that the subject doesn't smile, though that is sometimes overridden by the client's demands, and it also depends on the situation.

If you are paying attention while out in the wilds, sooner or later you'll see a moment where you just have to stop and ask your compadres to pose for a portrait. Maybe you won't even ask them to stop; you might just catch them in a moment, and these are just as valid as any dog and pony show portrait shoot, sometimes more so, as they are authentic moments. Part of the beauty of adventure sports photography is that these sports are hard and they take place in wild environments that take their toll on the body. Pay close attention and watch for those moments of

Shooting portraits while on the move can be a challenge. It had been raining for two straight days during the 2008 Patagonia Expedition Race when I snapped this picture of Fernanda Rojas taking a quick rest. What you do get, however, is context and real emotion, something not easily duplicated in a studio.

despair, elation, or solitude, as they make for pivotal images in any story. Since you are most likely involved in the adventure, it is easy to anticipate these moments because you'll probably be feeling the same emotions yourself. Just make sure you concentrate on the photography and don't get distracted by the moment. Being able to capture these experiences is all about anticipation and how quickly you can work with your camera.

On-location portrait shoots don't always have to be wild, adventurous affairs. Some of my best portraits came from a shoot of freedivers where I set up a makeshift portrait studio in the most sensible place I could find on a windy day—the entrance to a men's public bathroom, which was just 50 feet (15.2 m) from the dive location. The 80-foot (24.4 m) deep spring my four friends were diving into that day was in the middle of a city, and I figured the portraits of the divers in their wetsuits and goggles, still dripping with water, would be more interesting than the action since the setting wasn't all that adventurous. I set up a white backdrop and used one light, which was an Elinchrom Ranger battery-powered strobe kit with a large shoot through umbrella. It was a very simple setup placed directly above and behind me. It felt like I was really connecting with the divers during the shoot and getting nice shots, though nothing on the LCD seemed earth shattering. But once I got back to the office and started working them up, I realized how solid these portraits really were and I turned on my scientific reasoning to try and figure out what had happened. After speaking with the divers and a few of my peers I realized there were several factors.

The first factor was that the strange location helped the divers let down their guard and gave them a good chuckle. Laughter is always a good way to break the ice on a shoot. And because I chose to photograph them after they came out of the water (where they had been holding their breath for up to two minutes), they were a bit subdued. Second, it helped that it was a simple lighting setup. That allowed me to concentrate on the subject and not have to worry about anything technical. Third, it was just the subject and myself in very close quarters. Since I was so close, they really let me into their personal space. There were also no distractions (save for the occasional person wanting to get into the bathroom). And lastly, I knew these guys really well, which obviously helped. Talking with the divers afterwards, they each told me I had really captured them that day. This just goes to show that if you can be flexible and creative with your surroundings, you don't have to be in a studio to get successful portraits.

This high-contrast black-and-white image of Thorsten Schwander is part of a group of portraits I shot of freedivers one day in the entranceway to a public restroom at the Blue Hole in Santa Rosa, New Mexico. Using a limited amount of equipment kept the shoot simple and allowed me to focus on the pictures.

IN THE STUDIO

If you've never shot in a studio, it is quite a bit different than shooting outdoors because you have no crutch to lean on. There is no exotic landscape for a background, no terrain to work with, and there may or may not be much natural light, so you are starting from scratch. You will have to build the lighting, choose a background, and then decide how you are going to light the image. Studio portraiture also forces you to concentrate on the subject more because that is all you have, unless you have built a set for them to step into. The obvious benefit over shooting outdoors, however, is that you have complete control over your environment in the studio.

I have done shoots in a studio several times for specific portraits. Each time, setting up the lighting and getting it dialed in was a time-consuming process. Be sure to allow plenty of time in advance for getting set up,

otherwise you'll be wasting your subjects' time and killing their confidence in your abilities. When shooting in the studio, have a game plan; in fact, have several. You want to have at least three setups ready to roll depending on what your subject feels comfortable with. Get creative. Hang them from the ceiling. Go for the straight headshot with some killer dramatic lighting. Have them bring in some of their gear and pose with it, like a kayak or a paraglider. Just be sure to give it some serious thought before you begin or the shoot is going to fall apart pretty quickly and your images will show it. Another tip for the studio is to turn on some music. A little music can help set the mood and create a more relaxed environment. Just make sure your subject likes the music and you aren't blasting it so loudly that you can't communicate with them.

This portrait of ocean explorer Celine Cousteau, granddaughter of Jacques-Yves Cousteau, was shot in a studio. The image was created using a Dyna-Lite Uni400jr monolight with a beauty dish, which accentuated her striking features. The white background was not lit, which is why it appears gray in the image. The subtle lighting around her head is the result of post-production work in Photoshop.

CONCEPTUAL PORTRAITURE

A conceptual portrait is one where the subject is put into a scene where they are acting or playing a part. Thus, the concept of the portrait is larger than just the person. Most of the high-end portraiture you see in magazines like Vanity Fair or the New York Times Magazine would fall into this category. It is more challenging and requires a fair bit more thought and energy, and sometimes money, to execute. The image conveys a concept in addition to acting as a portrait. The image of a gymnast at left is a good example of a conceptual portrait within the outdoor genre. In this image of Jake Lawrence, hanging upside down from the rings, we have several concepts immediately conveyed: strength, power, and upside down, to name just a few. These aren't complex concepts, but the point is the image works as a portrait and as a tool to convey those ideas. If you can come up with a concept for your portrait, it makes it much easier for your subject to get into their role— and it might result in a much more interesting portrait.

This image of Jake Lawrence working out on the rings is a good example of a conceptual portrait; it says more about his phenomenal strength and gymnastic ability than it does his personality.

For this image, I positioned an Elinchrom Ranger RX Speed AS strobe setup so it would amplify the already existing daylight. The result is a soft light that helps convey the relaxed mood of the model.

LIGHTING FOR PORTRAITURE

When setting up a portrait, think of the lighting as a method to reveal your subject, just as a sculptor uses a chisel to expose the form inside a chunk of marble. As a photographer, the light is your chisel. Whether it is natural or artificial light, how you light the subject will determine the mood of the image, how that person is perceived, and their relationship to the location. As an example, the image of a cowboy (at left) is a shot where I used flash to mimic the natural light. The flash's light is soft and almost undetectable because I used a massive softbox, a six-foot Elinchrom Octabank, and lowered the power so it was just a touch above ambient. The light helps to amplify the

sense of peace and relaxation given off by the man leaning back in his chair. In contrast, the image on page 168 of Mike Fischer is a great example of using light to create an intense image. In this image I had a friend hold a gold reflector at camera right, just five or six inches (12.7 to 15.2 cm) from the subject's face. We had been rafting the Grand Canyon for a few weeks at this point and I wanted to portray him as a rugged outdoorsman. We were working in deep shade, which I knew would help bring out the roughness of his face, and he was also able to give me a look that communicated his seriousness. The effect is an intense image, which was exactly what I wanted.

I have already detailed one lighting setup in the example with the freedivers, which worked for that location, but it obviously isn't the only setup. Using artificial light on location requires at the very least a few shoe mount flashes, or better yet, a battery-powered strobe setup. Because most adventure-style portraits are shot on location, you'll have to think about wind conditions and weather. A big softbox or octabank might be difficult to deal with on a windy day. One of my favorite light modifiers for location portraiture is the beauty dish because it can still produce soft light and it deals with windy conditions quite well. In Chapter 4, we talked about shooting with artificial lighting and laid out some basic lighting fundamentals. Those suggestions apply to portrait photography just as much as anything else. The only thing I would add in regards to portraiture is that you want to think about how the light will react with your subject's face. Are you photographing an older gentleman who has a rough face with interesting wrinkles? Maybe a hard-edged light will help accentuate them. Are you photographing a woman who has nice, soft skin? If so, you don't want to nuke her with harsh light—you'll want to use the biggest light modifier you have, normally a large softbox, which will wrap soft, even light over her face and accentuate her soft skin. If the subject happens to have really pronounced cheekbones, the beauty dish is a great tool to help show those off. Learning how to light a face is about studying your tools, i.e. light modifiers, and understanding how they are flattering or unflattering for different faces.

Part of learning how your light modifiers sculpt a subject's face is understanding how to position the lights. This is much more critical when shooting portraits than it is when lighting an action image. Even a few centimeters here or there can make the difference between nailing it and getting some funky shadows. With modern D-SLRs, it is easy enough to see what the image looks like and where the shadows fall, but even if you look at the image, you may not know what to look for. Check to see if you have connecting shadows, like the shadow created by the nose connecting with the shadow on the side of the face, which is usually not a flattering look. If you see this happening, move the light so the shadows don't connect. Also, be aware that if you put the light too high, you'll get shadows in the top part of the eye socket. If this is the look you are going for, and it can be effective, then great. Otherwise, lower your light and check again.

Lastly, portrait lighting can get extremely complex. Do you use just one light or two, or ten? Your approach will be commensurate with your skills. If you really want to learn how to shoot high-end portraits, then realize right now that you most likely won't learn how to do it by just reading a book. Sure, you can pick up a few tricks by reading an assortment of books, or looking at the work of other photographers you admire, but to see it all come together I would really recommend taking an advanced workshop with a portrait photographer.

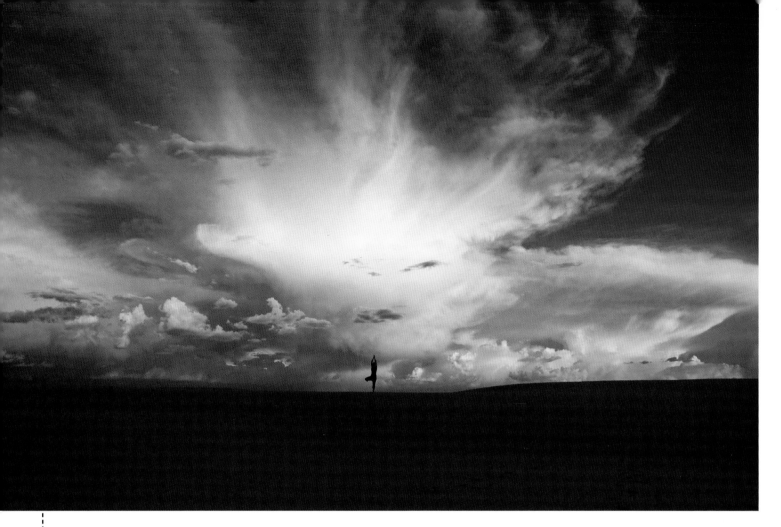

This image of Sadhana Woodman practicing yoga in White Sands National Monument, New Mexico, has been one of my most profitable lifestyle images. While this image was obviously set up, it conveys the yoga lifestyle very well and is thus very appealing to image buyers.

LIFESTYLE BASICS

Adventure sports, at their essence, are a lifestyle and not just something most outdoor athletes happen to do on their weekends. Surfers, skiers, climbers, and mountain bikers often structure their lives around their sports and have a culture all their own. It is a sport's culture and it is often on display in those moments that happen just before or after the action. A few examples would be dropping by the café to pick up coffee before a big day of climbing, checking the map in a foreign country during a trip to find the next killer surf spot, or chilling out in the hot springs after a long day of mountain biking. These are the seemingly mundane, everyday parts of life for an adventure athlete that may not be obvious to shoot.

Shooting lifestyle moments is harder than you might think. Your instincts as a photographer will be tested because you'll have to sense when the key shot is about to happen and be able to catch it. And lifestyle images need to have an authentic feel or they will look just like one of a million cheese ball lifestyle images already rampant in the world. Solid lifestyle images also need to have some style. We'll discuss all of these topics in the next few sections in more detail, but realize that portraiture and lifestyle photography are kissing cousins. A lot of portraits cross over into the lifestyle category and vice versa. Everything we have talked about in regards to portraiture applies to lifestyle images as well.

Nothing says "outdoor lifestyle" like relaxing in natural hot springs after a long day of activity. We visited these springs near Mammoth, California, to take a breather after bouldering all day.

CATCHING THE MOMENT

There are basically two ways to go about capturing lifestyle images. First, you can capture them on the fly as they are happening, which, as you might expect, can be difficult. Second, you can set up a photo shoot where the focus is on lifestyle images. In the first case, if you didn't get the image on the fly, you can ask those you are photographing to do whatever they happened to be doing again, if it's possible. Lifestyle images caught in the moment generally seem much more authentic and real, probably because they are. If you set up photo shoots to create lifestyle-type moments, it will take some hard work to communicate your intent and direct your models so the images look authentic and not contrived.

Capturing images on the fly will depend on your ability to anticipate the moment and get your camera settings dialed in more than anything else. For these moments, I normally set my camera to auto exposure mode, either aperture priority or shutter priority, so I still have control but the overall exposure is at least close to correct when I am shooting quickly. If there is a bit more time, I'll ask the people I am shooting if they can keep doing what they are doing for just a few seconds longer so I can do things like, check the exposure to make sure I am not blowing out important highlights, change lenses, or move to a better perspective. Occasionally, I'll also ask athletes to relocate to a better setting or position if it's not too much trouble. Most athletes are amenable to this, especially if I'm shooting an assignment for their sponsor, and if I'm not constantly bugging them or asking for too much.

Catching those moments before the action starts makes for great lifestyle images—and they can sometimes be exciting in their own right, as seen here in this picture of a balloon being filled with hot air at the Albuquerque Balloon Fiesta.

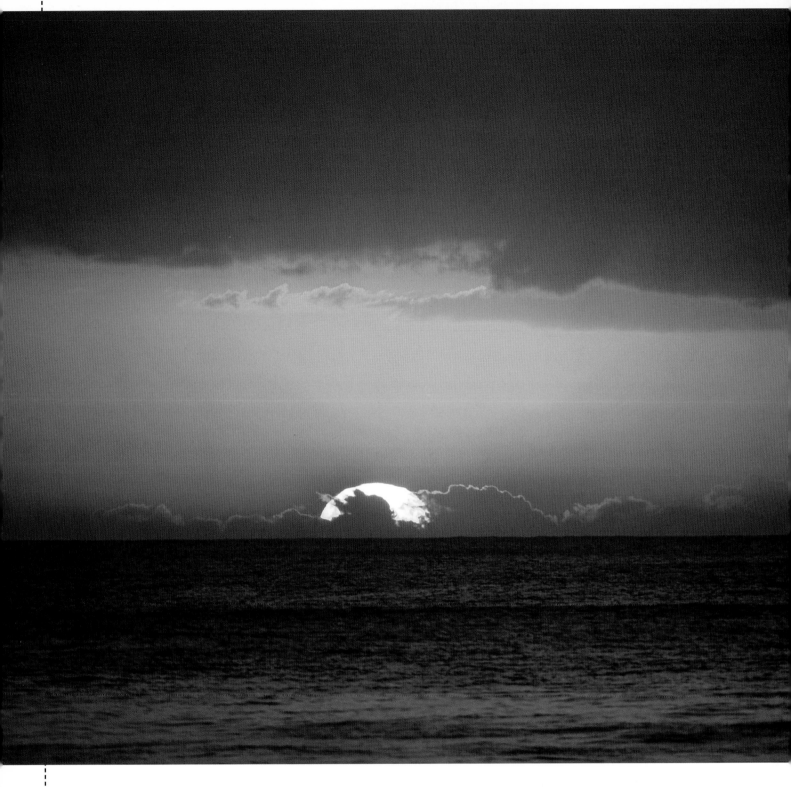

In some cases, a lifestyle moment can also be captured with just a landscape image. A landscape can sum up the experience just as well as anything else because it says, "we were there" and that the scenery was part of the reason for the trip. Normally, most lifestyle images involve people, and for good reason. But because the adventure genre takes place in wild landscapes, pic-

tures of the surroundings are just as valid as the shot of your buddy riding the donkey to base camp. Of course, if I can work a person into a landscape image, that offers the best of both worlds. Whether shooting people, landscapes, or a combination of both, keep your eyes peeled for wild light at sunrise and sunset.

Guess what sport this image relates to? Without even having a person in the image, this shot of the sun setting at the famous surf break, Bonzai Pipeline, in Hawaii, portrays the surfing culture and lifestyle.

AUTHENTICITY

In lifestyle photography, authenticity is everything. If the moment doesn't feel real, or is too contrived, it just doesn't work. It feels like bad acting. As already stated, shooting images on the go usually results in authentic results. One of the first hurdles to pulling it off successfully is choosing your models very carefully. There is no other aspect of your shoot that will affect the outcome more than the people you photograph. If you are setting up a skiing lifestyle shoot, be sure to choose people who are skiers so they know how to carry their skis and they already have the right style and type of clothing. If you pick the right models, they know what is authentic because they do it every day. Seek their input during the photo shoot. Ask if what you have them doing feels normal or abnormal, and change things up if they have a better idea that can improve your shot. Also, be sure to choose the location carefully. The location and your models will define the style and character of your images.

Much like a portrait shoot, you'll have to direct the models. You will have to put your models at ease so they don't look stiff and posed. The techniques we discussed for establishing a connection and building rapport are just as important with lifestyle photography as they are with portraiture. Think of yourself as a director and photographer on a film set. Help your sub-

I shot this image of Gregory Smith floating down a river on a bamboo raft in northern Thailand with the outdoor clothing company Patagonia in mind, since much of the gear he is wearing is from Patagonia. Many clients want to buy lifestyle images that don't look posed, so capturing authentic moments like this is key.

jects understand what you're looking for and pay attention to the moments in the scene that look authentic. Use the experience you gain over time as a "director" to better create these moments again and again. If you don't see those moments at first, keep shooting and shoot a lot. By going over your images quickly on your camera's LCD you will most likely see a few images here and there that have a natural feel to them.

Lifestyle images also express an emotion or feeling, and this is where things get really tricky. Using that ski shoot as an example again, let's say that you are trying to shoot a couple as they are walking through a ski town and you want to convey their excitement as they hoof it over to the ski area, gear in tow. How do you translate "excitement" into an image where the viewer understands that concept immediately? You can have them smile, but that can mean a lot of things. A better solution is to work on body language and have them walk at a

slightly exaggerated fast pace with enthusiastic smiles on their faces; if done well, this will convey their excitement. As you might imagine, this is where working with people that practice the sports you are trying to shoot really comes in handy. This is also the part where your skills as a communicator and director will be challenged.

STYLE

If you are hoping to market your images, either to a magazine, a corporation, or through a stock agency, then the style you shoot with will have a big effect on what type of client will be interested in your images. For example, if I am shooting images specifically for Patagonia, a manufacturer of high-end outdoor clothing, they tend to pick lifestyle images that are extremely authentic and raw, which is the exact opposite of what most stock agencies

This image of Laura Perfetti checking out the waves at Moonlight Beach in Encinitas, California, was shot specifically for my stock agency and has since sold multiple times for a profit of over $5,000. The super clean look of this image fits with the style often requested by stock agencies.

This lifestyle image of my climbing buddies driving back to the campground in Indian Creek, Utah, is a little out of the ordinary. While it may not seem like a lifestyle image to everyone, it speaks to many climbers' familiar determination to stay out until last light and get in one or two more climbs before dark.

are looking for. One of the tenets of lifestyle photography is to keep the images really clean because stock agencies much prefer this look. By clean, I mean uncluttered backgrounds and a simplified graphic look. These images often show a spruced up, glamorized vision of a sport meant to appeal to a wide audience, not just the sport's die hard adherents.

Of course, not every lifestyle image is shot with a clean style, especially in the outdoor category, but shooting like this can definitely improve your images to some degree, and their chance of being sold. Because stock agencies tend to license a lot of lifestyle images, I recommend checking out their websites and doing a search for lifestyle images to get an idea of the different styles and what trends are popular in the market.

If you go to the Getty Images website (www.gettyimages.com), which is the world's largest stock agency, and do a search for lifestyle photography, you'll quickly see that the majority of the 70,000-plus images that come up have a very clean look which is part and parcel of lifestyle imagery. Another agency that currently has the largest collection of top-notch adventure and outdoor images is Aurora Photos (www. auroraphotos.com); specifically, they have the Outdoor Collection that is comprised of images from most of the top adventure photographers in the world.

Every photographer has a certain style whether they know it or not. There is no right or wrong aesthetic when it comes to style; yours will be influenced by the photography that inspires you the most. Shooting lifestyle images is a great place to emphasize your look and practice with varying styles.

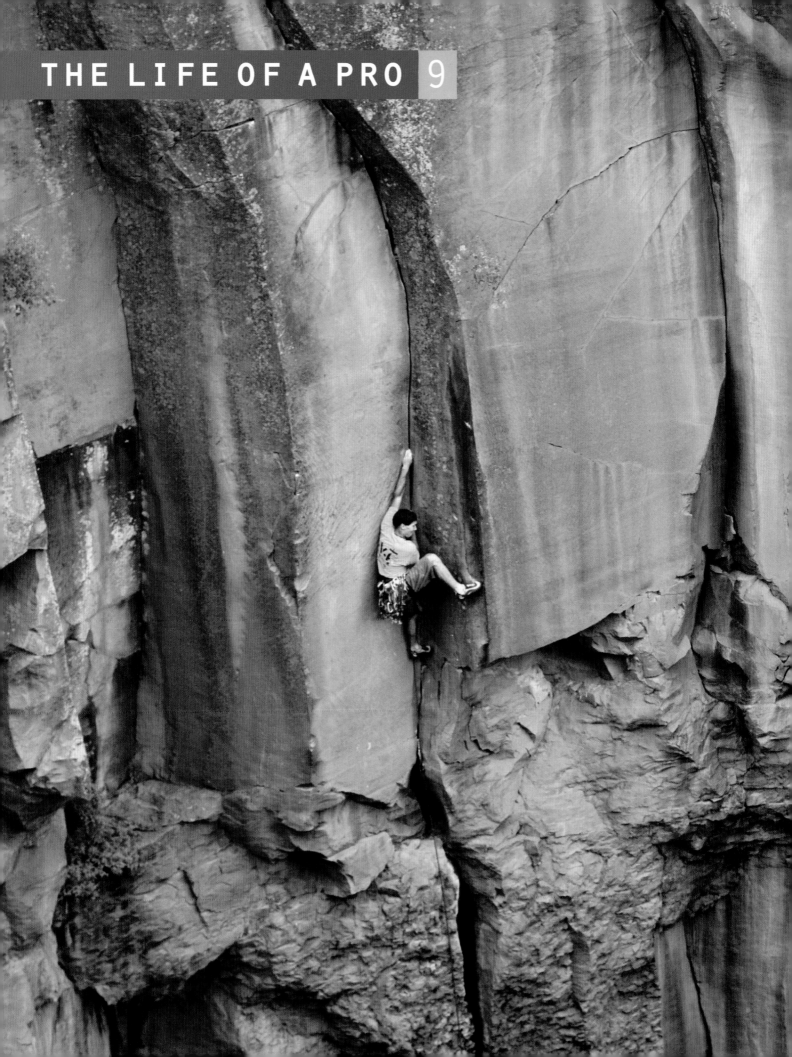

If you've made it this far into this book, the odds are good that you might be thinking about how to become a pro and make money from your adventure images. The life of a professional photographer may seem pretty glamorous from the outside—and every once in a while, it truly is. But the reality of being a professional adventure photographer is quite different than the perception. Don't worry, I'm not here to quash anyone's dreams—after all, I'm living mine. However, I think it's only fair to offer up a realistic view of what it means to make adventure photography a career. While the work is fulfilling and exciting at times, it also requires effort far above and beyond hanging out in wild locations and clicking the shutter button. Hauling 100-plus pound backpacks up the backside of big walls, chasing light that may or may not work with you, traveling non-stop, sleeping in airports, 90-hour work weeks, and being chained to a computer for days on end processing images are just a few of the less exciting aspects of this profession, not to mention the tough realties of owning your own business. But there are, of course, the plus sides—being your own boss, being able to choose (to some degree) where you focus your energy, and being there to witness the accomplishments of elite adventure athletes around the world. Just as with any other art or passion worth pursuing, adventure photography offers a mixed bag of physical and mental hardships along with moments of elation. So for the final two chapters of this book, I thought I'd give some insight into the profession and talk about the realities of working in this day and age as a professional adventure photographer.

Riptide warning signs at the famous surf break, Bonzai Pipeline, on the north shore of Oahu. It's certainly possible to make adventure photography a career, but it's good to be aware of the challenges ahead.

HARD WORK——
AND SERIOUS
DEDICATION

If I were to distill adventure photography down to its basics, there is a correlation between how hard you work and the resulting quality of your images. When I say hard work, I mean going the extra mile to get to that tough-to-reach shooting position, arriving early, staying late, being obsessed, and being driven to learn how you can make your images better. A large part of this is physical. I call it the "sweat factor." If the sweat factor is high, meaning you had to work your rear end off to get into position, then the odds are good you'll have some interesting images.

Being successful in this field requires a lot of dedication, and not just to the craft. Dedication is being able to deal with rejection, setbacks, and roadblocks and still have the ability to keep moving forward. As with many creative professions, photography is one where it helps to have thick skin. Even as a pro, your images will get rejected on a daily basis. If you want to be taken seriously as a pro photographer, you will have to stick around through the ups and downs and prove you are dependable and consistent. I am almost certain that editors look at how long you have been in the business as an indicator of your abilities. Shooting an assignment is hard, stressful work and editors want to know that you will come through for them. On assignments, you have to come back with "the shots" even when things don't go as planned; so having the ability to improvise and solve problems is a requirement beyond having decent photography skills.

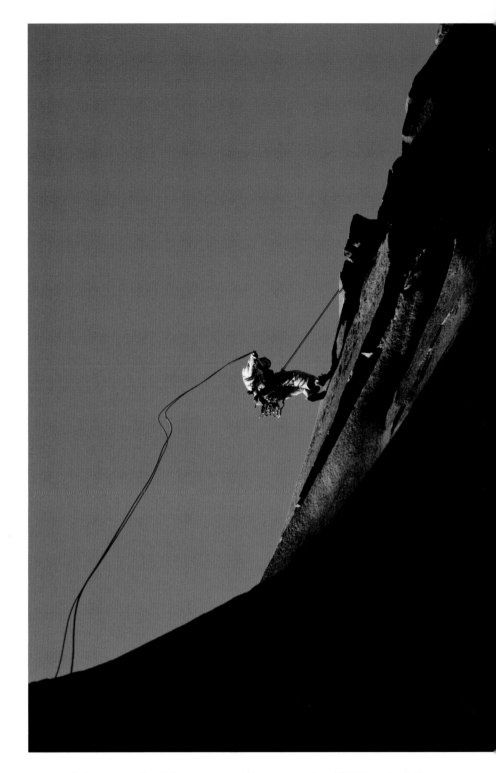

Josh Ewing rappels off the very exposed Learning to Crawl (5.11) on the Bridger Jack Mesa in Indian Creek, Utah. After I shot this image I waited for the climbers to rappel the route and asked if they would sign model releases for me. They were happy to oblige and I sent them a few prints to say thanks.

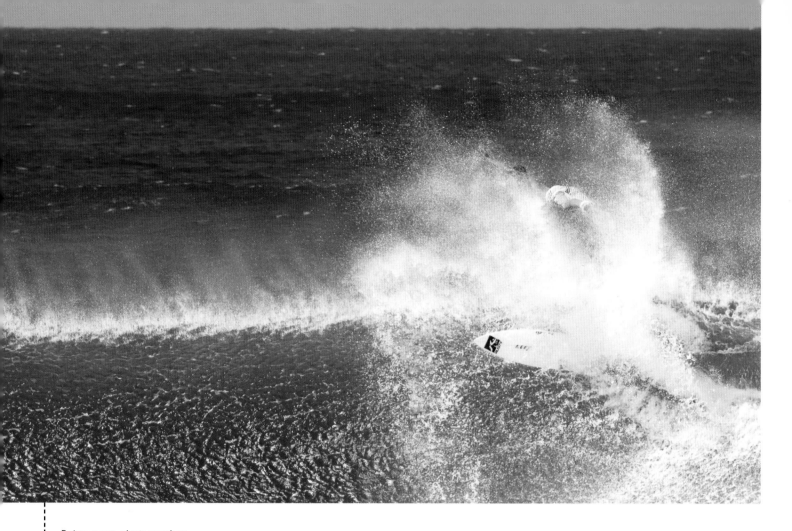

Being a pro photographer means getting rejected fairly often, like this surfer at Bonzai Pipeline, on the north shore of Oahu. Dealing with setbacks and being willing and able to get back on the horse, or in this case the board, is just part of the game.

If you got into photography to get rich, then you've chosen the wrong occupation. Some photographers do make a very good living; however, very few of those are adventure photographers. Just making a living in this profession is a success in many people's minds. But that isn't to say that with hard work, solid social skills, and bit of talent you can't make a decent living. Let's take a look at some key elements that help one make it in this profession.

PASSION, PERSISTENCE, AND MOTIVATION

Being successful as a pro photographer comes down to one question. How bad do you want it? Three keys to success that you'll hear from every pro are passion, persistence, and motivation. I think for any photographer, especially sports photographers, passion about the subject you photograph is key. Being a passionate participant in the sports you photograph gives you an insider's knowledge that sets you apart form the average Joe with a camera. That passion will show in your images. If you look at the work of pro adventure photographers, most specialize in two or three adventure sports. That isn't to say that they don't shoot other adventure sports, but the majority of their images come from those sports they know best and are excited about. Throughout this book it might be obvious that I shoot a lot more climbing, mountain biking, and whitewater kayaking than I do surfing, sea kayaking, or skiing. That isn't to say that I can't shoot those latter sports but, just like the rest of us, I only have so much time in a year to con-

centrate on one sport or another. I started out as a climbing photographer. Climbing was my passion and photographing it was a natural fit. In the larger picture, having passion for photographing a specific sport will help with persistence and motivation, too.

Being passionate about the sport you are shooting will also motivate you to work harder than you might otherwise. In this respect, passion and motivation go hand in hand. Being motivated to work harder, longer, and more efficiently than your peers will also help you make progress as a professional. If you want to make it in this business and be able to stick around as a full-time pro, then you are going to have to want it more than just about anything else. And that means you are going to have to make some tough decisions on lifestyle and your priorities. At some point in just about every adventure photographer's career, especially climbing photographers, we all lived out of our car for at least a little while. Whether choosing between a new lens (chosen because it can pay itself off), the next big trip, or the latest 52-inch plasma screen TV and a fancy apartment, your priorities will have to be focused on making things happen that can move your career and your skills forward.

Persistence, or perseverance, will be the glue that keeps you from throwing in the towel when things get tough. In any freelance profession, there will be times when the work isn't coming in as often as you would like or things just aren't going your way. It isn't anything to get upset about, it's just life. Some of the best advice I got when I was starting out was to keep my overhead as low as possible. Over the years, that has proven to be prudent time and time again, especially when things are slow. That doesn't mean you live on a shoestring necessarily, it just means you need to be smart about how you spend your money, which is true for any business.

Of course, this is not the complete list of the attributes it takes to make it in this profession. Drive, talent, contacts, your social skills, and your ability to deal with risk—both financial and physical—will all play a part. When I went fulltime as a pro many years ago, I remember it feeling like I was running towards the edge of a large cliff and I was about to jump off to see if I could fly. It was pretty scary. Luckily, it worked out well, but it wasn't without its ups and downs over the years.

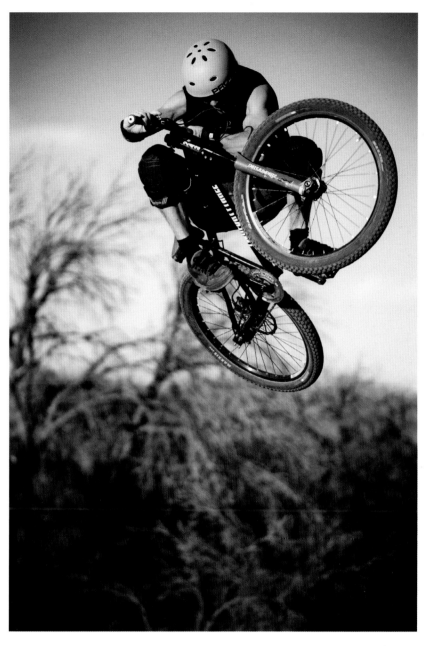

Capturing this image of Ed Strang dirt jumping was the result of waiting until last light and asking Ed to repeat this move a dozen times or more until I felt I got the shot. Sometimes it just takes persistence and a little extra time if you are serious about your images.

GETTING STARTED ————

Every pro photographer knows that the only thing that separates them from an amateur is that pros get paid. If you are thinking about bridging the gap between amateur and pro photography, we'll cover a few ways to go about it here.

First, understand that adventure photography is a genre that is exploding in popularity and practitioners right now, but the demand for images from clients is not growing that much, if at all. So you're going to have to work hard to develop a style that differentiates your work in a crowded marketplace. We have touched on many ways to accomplish that in this book, including subjects such as lighting and portraiture.

When just starting out, you'll first have to generate some quality adventure images on your own dime. And when I say quality images, they should be at least as good, if not better, than those you see in the magazines you want to approach. Once you've got a solid 20 or 30 images (with no more than two or three of those taken from the same shoot), contact magazines that publish the type of images you've shot and submit your work. You can find the photo editor's contact information and submission guidelines in the masthead of the magazine or on their website. Contact the editor via email first, introduce yourself, and ask what would be the best way to submit images. This introduction is key as it shows respect. The last thing a photo editor wants to see is 30 jpegs from someone they have never heard of clogging up their email inbox. The introduction also goes better if you have a decent website they can peruse. Photo editors are always on the lookout for new talent—that's part of their job. If you have something they've never seen before, work that is better than what they are currently publishing, or images that are exceptionally newsworthy, then they will be interested.

The fact that I was able to shoot the 2008 Mountain States Cup mountain bike race in Angel Fire, New Mexico, is a perfect example of maximizing your connections. A good friend of mine, who was the announcer of the event, invited me to shoot during the race and helped me get all of my press credentials.

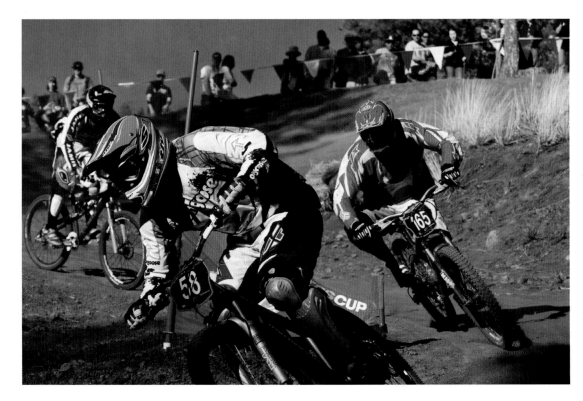

Getting published in *National Geographic Adventure, Outside, Men's Journal, Climbing, Surfer, Bike, Backpacker* or any of the major outdoor magazines lends you credibility, which helps when you approach the next client. When a magazine publishes your images, they aren't just paying you, they are also marketing your work. In the biz, this is called giving you exposure. This exposure hopefully leads to shooting larger editorial assignments or lucrative commercial gigs for outdoor companies directly. Lots of magazines like to act like exposure is some huge commodity, and in some cases it really is, but don't let them talk you out of getting paid for your work. If they want your image it's because it serves a purpose for them, and since they make money from their product, you should get paid as well. When you are starting out I suggest sending your work to smaller circulation magazines that publish your type of images first, like *Urban Climber, Rock & Ice, Mountain Bike or Surfing* for example. Hold off on sending your images to *National Geographic Adventure, Men's Journal* or *Outside*, currently considered the three big guns in the adventure genre, until you have a few published images or even an assignment or two under your belt. In Chapter 10, we'll get into some of the tried and true methods of marketing yourself and getting your work out into the marketplace.

Where you live, what you shoot, and who you know will also be very important in establishing and building your business. Obviously, if you can shoot the top athletes in a sport, you'll have a major advantage. But don't feel like you have to start there; I began by photographing friends and constantly sought out higher caliber athletes. Leverage your relationships and connections to gain access to people, locations, and events. This may sound a little exploitive, but it's really mutually beneficial—your images, when published, have value because they get extra attention for the people and events you shoot. Sometimes you will want to pay athletes if they are really working for you, and other times their work will be paid for by sponsors. Either way, always take care of the people you work with. Usually the athletes are working just as hard as you, or harder. Everyone involved should have a good experience on a photo shoot and in dealing with you. Most of the people I work with are either already good friends or become friends by the end of a shoot.

This image of Gabriela Baumeister rock climbing in Indian Creek, Utah, has been published by Nikon, *Climbing* magazine, and several other editorial clients. It was shot "on spec," meaning on speculation or on my own dime as part of a stock shoot. I later licensed the images directly to my existing clients.

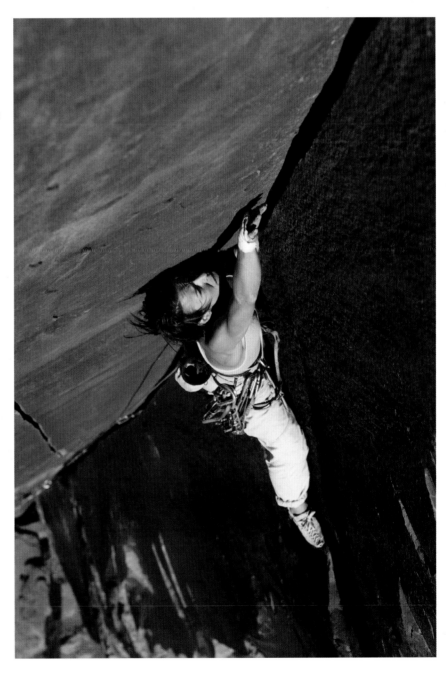

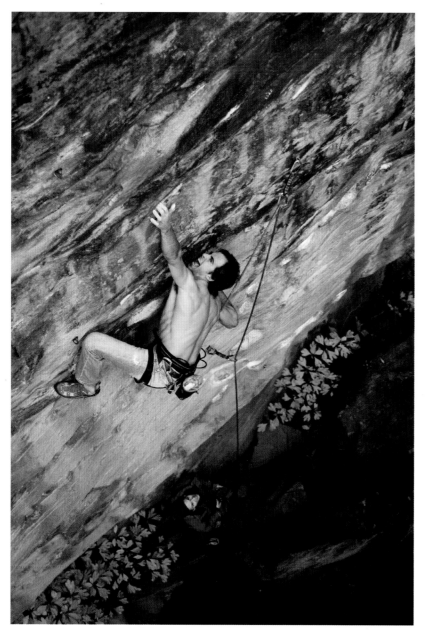

Climber Stephen Meinhold proves my point that sometimes the athletes are working just as hard or harder than the photographer. In this image, Stephen is gunning it on Losers Weepers (5.13c) in the New River Gorge, West Virginia.

PROFESSIONAL BUSINESS PRACTICES

Digital has been a huge boost for photography and has drawn a whole new generation of would-be photographers into the profession. One of the biggest hurdles for most photographers when they are starting out— or even in mid-career—is getting a handle on the business aspects of being a professional photographer. No matter how great your images are, if you can't effectively market yourself and run an organized, strategic business, then your odds of success are low. Not to fear, most photographers don't have business degrees, and while the learning curve is steep, as long as you are motivated to improve your business savvy and learn from your mistakes, the skills you need can be acquired.

In this day and age of information sharing, there are endless resources for the photographer who is just starting out. The Internet is literally buzzing with information and forums where you can ask questions, get answers, and read about other photographers' trials and tribulations in regards to the business of photography. Three of the best online forums I know of are the APA (Advertising Photographers of America), ASMP (American Society of Media Photographers) and EP (Editorial Photographers) forums. There is even a forum aimed directly at the outdoor market, which is run by a group named TOPA (Travel and Outdoor Photographers Alliance). But before you start asking wild questions online, I would suggest reading a few of the excellent books on the business of photography. Two of the very best books that I have

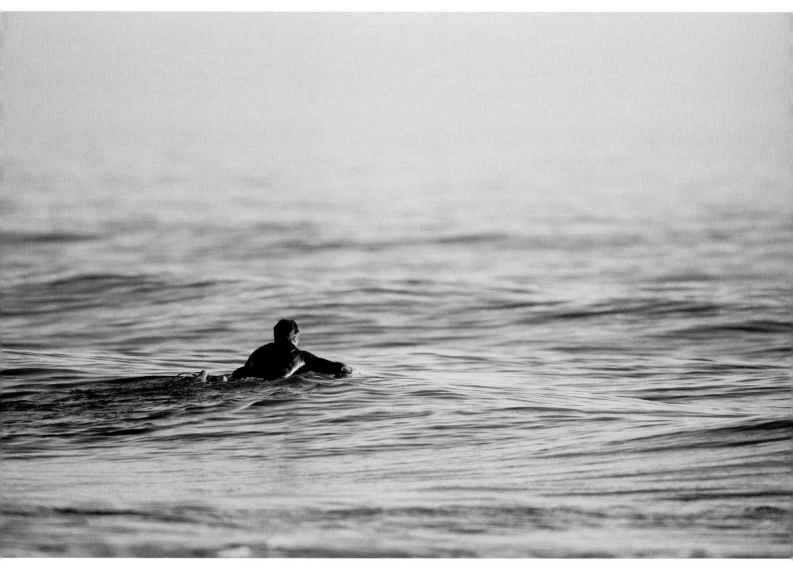

Rich Cezelski paddles out through small waves at Ventura Point, California. This image reminds me of what the life of a pro adventure photographer is like: you are on your own and often paddling into unknown waters.

read on the topic of business as it relates to photography are John Harrington's *Best Business Practices for Photographers* and Richard Weisgrau's *The Real Business of Photography*. ASMP also publishes a book titled *Professional Business Practices in Photography*, which is a great resource and is widely considered the bible on business practices for photographers. In this section, I'll cover a few of the basic topics that any photographer who wants to license their work will have to deal with.

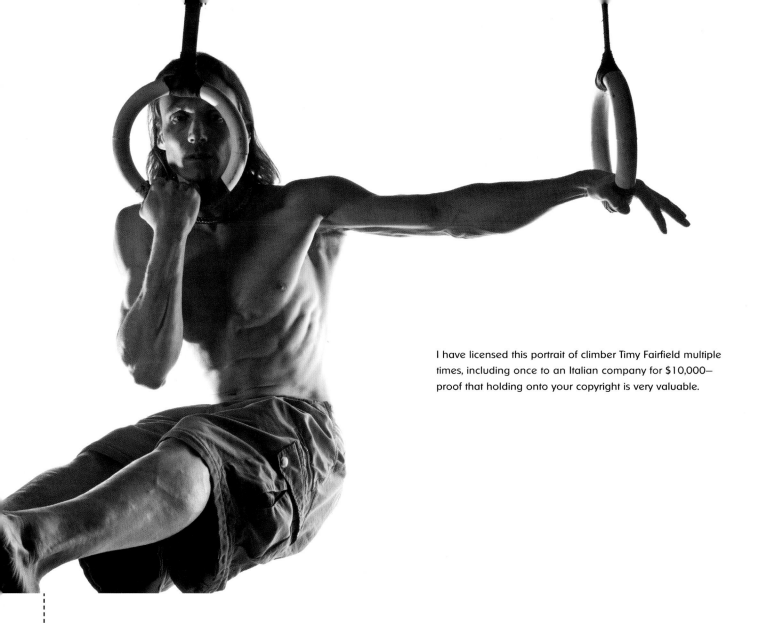

I have licensed this portrait of climber Timy Fairfield multiple times, including once to an Italian company for $10,000—proof that holding onto your copyright is very valuable.

PRICING AND LICENSING IMAGES

Throughout this chapter, I have used the word "license" instead of "sell" when talking about making money from images. In general, professional photographers do not sell their images. Instead, they allow a client to use an image for a specified time and usage. This is called licensing, and specifically we are licensing usage rights. Why is this important? First off, you are the copyright owner of any work you produce, unless you work for a company (like a newspaper) and you have signed a contract that says otherwise. But let's assume you have not signed a contract or given your copyright away, which I would avoid at all costs. If one client finds your image useful, then the odds are good that several others will also. By licensing your images over and over to multiple clients, you can maximize the profits from a photo shoot. Maybe the image was shot on assignment for a magazine, or on your last surfing trip with good friends. Either way, it doesn't matter. It is your image and as such it is yours to license to any client of your choosing.

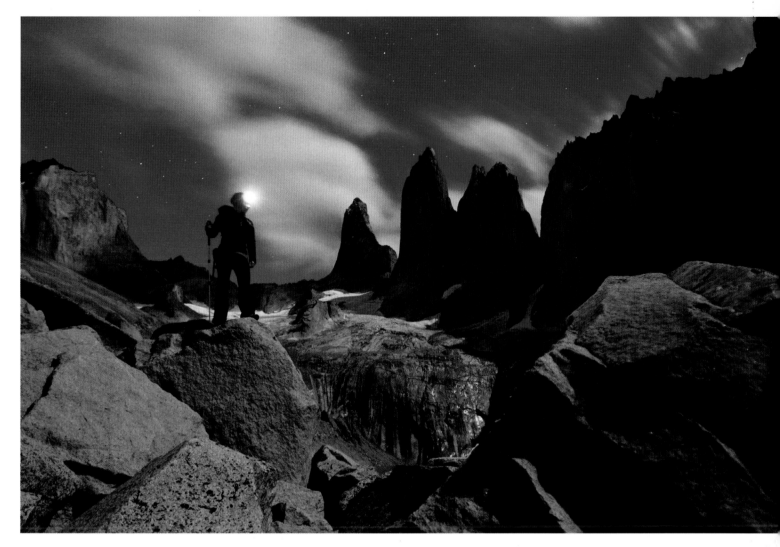

Always think about extra revenue opportunities while traveling. After shooting the 2008 Patagonia Expedition Race, I visited Torres del Paine in southern chile with writer Lydia Mcdonald. We got up at 4 AM and hiked to the base of these spires to shoot images for Black Diamond, the manufacturer of the headlamp and trekking poles Lydia was using.

One of the things I hear way too often from young photographers is, "Oh, I am just starting out so my images aren't worth as much as someone who is more established." I'd like to dispel that myth right here and now. If a client wants to use your image, no matter if you are just starting out or have been shooting for three decades, that image is just as valuable as any other image of similar quality. Yet another trap that many photographers trying to get started make is to give their images away for free for the exposure. Be aware that if you start out giving your images away for free, you won't get a whole lot of respect as a businessperson and you will have a very tough time getting paid in the future. My advice: Don't do it. If the client wants your image that badly, then they will pay for it. In light of that, let's talk about pricing your work.

Pricing your images is a complex calculation. How much is an image worth? Even more to the point, how much is the usage of an image worth? Images are priced according to several factors: the circulation of the publication, the size it will be published on the page (be it a web-site, book, or magazine), the length of time the rights are extended, and the difficulty involved in creating the image.

Let's give a concrete example. In this case, let's say a client sees one of your images on your website and thinks it is perfect for an advertisement they are running in the next issue of *Backpacker* magazine. They call you and ask if the image is available and what it would cost to license that image for their ad. The first thing you need to do is ask some questions. How big is the ad going to be in the magazine? Is it full-page, half-page, or smaller? And how large will your image be used in that ad? Is it the entire ad? For this example, we are going to say it is a full-page ad and your image will be printed full-page as well. The next question is: How many times will the ad be run? For multiple insertions, the calculations get a bit complex as you charge a percentage of the first ad price. (I won't get into this here because I want to keep this example as simple as possible. Check out the business books already mentioned and the pricing guides referenced in the next paragraph to find all of the info you ever wanted on pricing.) For our example, let's say the ad will be run one time. Once you have the information from the client, tell them that you will calculate the price and get back to them

Before you can quote a price, first figure out what Backpacker magazine's circulation is. You can ask the client (who may or may not know), or look online where there are many resources that list magazine circulation. The Editorial Photographers website (www.editorialphoto.com) has an excellent tool that allows you to see the circulation and standard rates for just about every magazine out there. Knowing this information, you can look up the standard pricing for this usage using either FotoQuote (www.cradocfotosoftware.com), or a book like Jim Pickerell's *Negotiating Stock Photo Prices*. I highly recommend both of these, as they will pay for themselves on your first sale. I have used both but prefer the book, as it is easier to use and also includes one of the best discussions on negotiating prices to be found anywhere for the pro photographer.

Doing research reveals that Backpacker has a circulation of approximately 303,000. In this case, the pricing guide—which is just that, a guide or starting point for pricing—says the standard pricing for this usage is $1,310 for a full-page ad. Depending on the client and the uniqueness of the image, you might adjust this price up or down. Once you quote a price, you won't be able to get more than you ask for, unless the client wants more usage rights. For a lot of clients in the outdoor industry, they will start negotiating with you to lower this price. In my experience, most magazines and outdoor clients do not pay FotoQuote rates but many will pay rates that aren't much lower. Be aware that in most cases the client knows what the image is worth. They know all about pricing images and how it is done. So stick to your guns. Also, this is where the online forums really come in handy because you can ask how much money others have received when they licensed images to certain clients.

Some clients, mainly magazines, but also many companies in the outdoor industry, have fixed image pricing that they ask photographers to agree to before submitting images. In many cases, it is a take-it-or-leave-it offer. But remember, you are the owner of your images and you set the pricing. Stand up for yourself and price your images so you can stay in business. If a client comes to you and asks for unlimited usage and wants to pay peanuts for it, do yourself and everyone else a favor and say no. If they really want the image, they will come to their senses and bring their price up. More often than not, they are likely testing you to see if they can get it for cheap. Of course, there is a lot more that I could say about pricing your work. Check out the references mentioned above to get more in-depth information.

MODEL AND PROPERTY RELEASES

If you intend to license your photography then you will need to obtain model releases for everyone in your images. If shooting on private or corporate property, you would also be well advised to obtain a property release. These releases give you permission to license your images for advertising or any other usage that may come up. Technically, according to United States law, you do not need a release to publish an image in a magazine, newspaper, or any other editorial publication. However, I would highly recommend getting the people you are photographing to sign model releases as this greatly increases the value of your images. If Patagonia calls and wants to use one of your images in their catalog or on their website, you will have to submit to them a signed model release. If you don't have it and can't get one, then Patagonia will not license your image. Many magazines are now requiring photographers to get model releases as well when they shoot assignments, just to cover themselves legally. You can find sample model and property releases on the ASMP website (www.asmp.org).

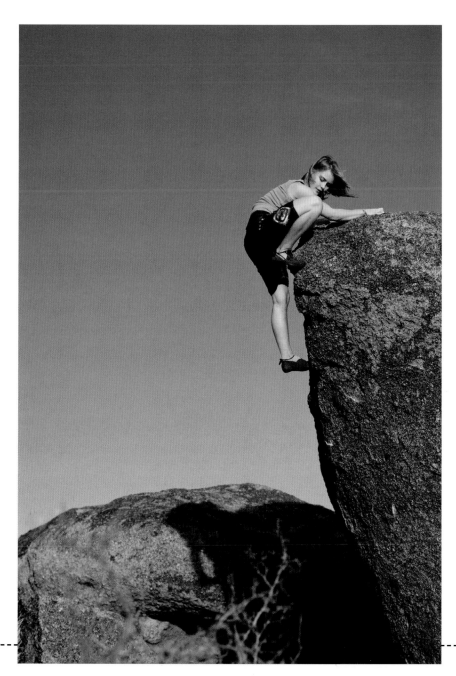

I shot this image of Jena Lupia while on assignment for *Backpacker* magazine. Since Jena was a minor, I had her parents sign a Minor Model Release so I could license the image to commercial clients after *Backpacker* had used the image.

CONTRACTS AND NEGOTIATING

One of the less exciting parts of running any business is reading over contracts sent by your client, or drafting contracts for your client. It is tedious work, but you have to read them carefully as some clients include some very distasteful rights grabbing clauses in their contracts. The language usually is a result of the legal department, not the photo editor you are dealing with, so be firm in rejecting these clauses but also go easy when discussing them with your photo editor, who will be your main contact to discuss alterations in the contract.

Working out contract details can be tricky at times. This is one of many images of the Henry 1 Helicopter Search and Rescue Unit I shot for an editorial assignment. The contract I received from the magazine's parent corporation included some pretty serious rights grabbing language. Luckily, I did not have to negotiate the contract with the Photo Editor, but directly with the legal department. It took a week of back and forth negotiation to work out the details, but it was fine in the end. Always be firm when protecting your rights and interests, but be careful not to upset the client.

One of the biggest issues you want to look out for is any clause saying, "You grant us unlimited, royalty-free rights to use your images in perpetuity throughout the universe." Of course, it won't be that dramatic, but the end result is the same—that they can use the images for the rest of time in any fashion they want. That might sound pretty crazy, but I have seen it in more than one contract. Contracts are a place where some clients will try to trip you up and get more than they paid for, so be aware.

I would suggest having a contract with each and every client for which you shoot an assignment. This is just good business because it clearly outlines your duties, the amount you will be paid, the date those images are due, and all of the other little details so there is no confusion between yourself and the client. I will not walk out the door to shoot an assignment without a signed contract unless I have worked with that client many times and know a contract is on the way. If the client is going to fly you to the other side of the planet and you will be fronting the expenses, you definitely want a signed contract before you leave to guarantee you will be reimbursed and paid for your work. Many of the business books I referenced earlier go into great detail about contracts and understanding them.

One of the basic skills needed in any business is the skill to negotiate. In the business of photography, you will be negotiating all the time. Just about every time you license an image there will be a negotiation involved. Sharpening your negotiating skills is a must if you want to make it in this business. Again, the books I referenced above are great resources and are required reading for anyone looking to make a living from their photography.

Your most powerful negotiating tool is saying no. No to low pricing, no to accepting rights grabbing contracts, and no to bad deals. As we talked about in our pricing example, you want to call the client back after you have carefully put together a quote. If you hear twenty seconds of silence on the other end of the phone then your price may be a bit high, or at least more than the client was willing to pay, or you might just be dealing with someone that doesn't fully understand how images are priced. In either case, you will have to negotiate or educate your client on image pricing. If you hear the client say, "Sure, that's great," then you've either just shot yourself in the foot by quoting too low, or the client realizes the price is fair. Don't get too hung up when the client wants to negotiate. It is their job to get the best images for the least money and it's no different than when you look for the lowest possible price for a lens or a new camera.

In the last chapter we talked about what it takes to work as a professional photographer and how to get started. Even if you have no ambitions of becoming a full-time professional, perhaps you are still interested in licensing your images for some additional income. In this chapter, I will expand upon the marketing techniques used by professional adventure photographers and the tools we use to market our images. In addition, this chapter also includes interviews with well-known adventure photographer Corey Rich and *National Geographic Adventure* magazine photo editor, Sabine Meyer.

Marketing is like yoga. It takes time and effort to reach your goals. Here, Sadhana Woodman practices yoga in White Sands National Monument near Alamogordo, New Mexico.

MARKETING BASICS

Marketing is one of those endeavors that can be uncomfortable for many of us. Tooting your own horn is not a natural undertaking for most people. At least, it wasn't for me when I started out. These days I just take it for what it is: part of my job that I have to do if I want to continue making a living from my photography. Of course, marketing is such a vast topic that I will only be able to scratch the surface here and cover the most basic elements that every pro photographer uses to promote themselves. Because licensing images and shooting assignments is how we make a living, you can imagine that the average pro photographer spends a lot of time on office work and self-promotion. In fact, I'd estimate that 80% of my time is spent on marketing, paperwork, image processing, and all of the office work involved with my business, while only 20% of my time is spent shooting.

When business professionals talk about marketing, it is usually in regards to a marketing strategy. In the photography industry, it is no different. Every one of the marketing tools we will be discussing here are simply different segments of a solid marketing campaign. Of course, there are many other methods of marketing, above and beyond what I have space to cover here, that are also very effective. An effective marketing campaign takes time and consistency on the part of the marketer. If you really want to jump in and give it a go as a professional photographer, I would highly suggest sitting down and writing up a marketing strategy, as well as a plan to create images for your marketing materials.

POSITIONING
YOURSELF AND YOUR WORK

Part of any marketing campaign is to first figure out your audience and what your message is. Basically, you are marketing yourself and your photography services, but prospective clients need to know who you are and, specifically, what you do well. You will need a group of images to convey that message. The ultimate goal is to build a brand around yourself and your work. By brand, I mean when a photo editor or art buyer thinks about adventure images, your name is the first one that pops into their head (right after mine, of course!). Building a brand takes years of work and consistent marketing efforts. It won't happen overnight.

Part of building a brand is also creating a valuable commodity. Hopefully you and your work are that commodity. By assigning you to shoot their next ad campaign, a client is trusting you to come through with the images they need, when they need them, and within the agreed upon budget. Your value is your ability to pull it off time and time again. And as you do so, your reputation and your "brand" will gain traction.

In the adventure genre, there are already a few hundred excellent photographers out there working professionally in the United States alone. Do you have a style that is different from what is already out there? Or can you create better images than are currently in the marketplace? To define your work, I would suggest you take some time and write out what is called a positioning statement. This basically puts into words the type of images you produce and the audience for those images. As an example, here is my latest positioning statement:

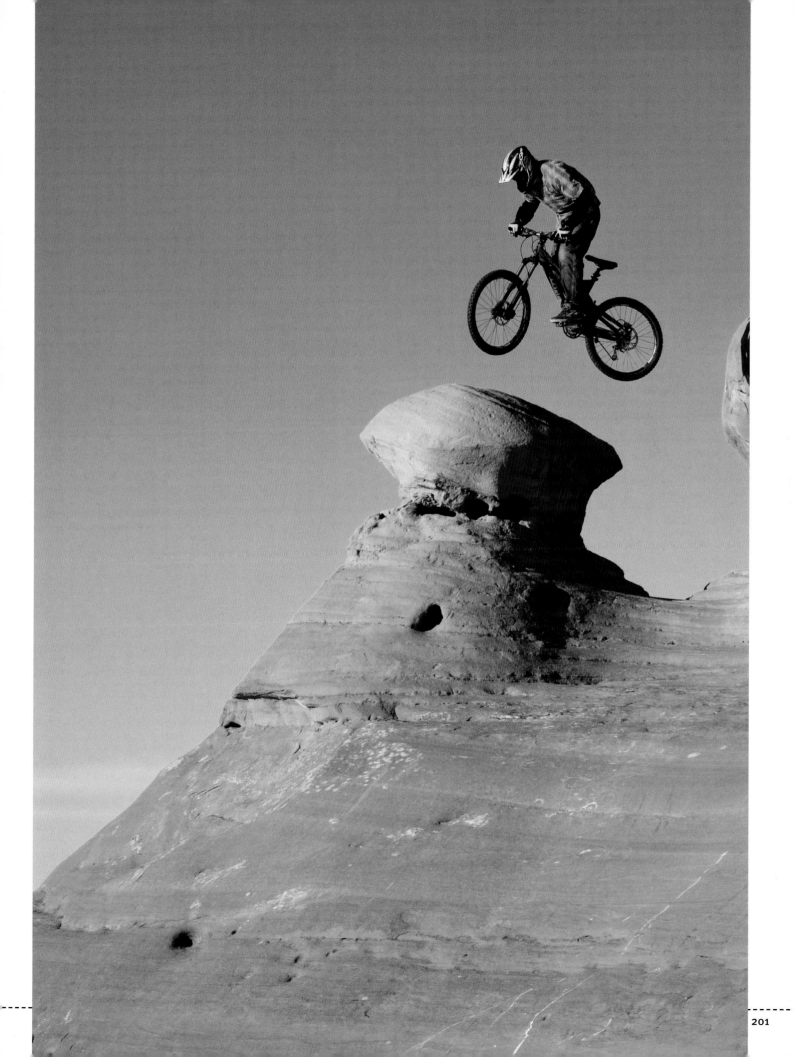

Michael Clark produces intense, raw images of athletes pushing their sports to the limit in remote locations around the world. He uses unique angles, bold colors, strong graphics, and dramatic lighting to capture fleeting moments of passion, gusto, flair, and bravado in the outdoors. Balancing extreme action with subtle details, striking portraits and wild landscapes, he creates images for the editorial, advertising, and stock markets worldwide.

This statement talks about the type and style of images I produce, the subjects I focus on, and where I market my work. While this may seem rudimentary, the positioning statement will help you choose images that are in line with your style when you begin building the specific tools of your marketing campaign (like a portfolio and a website). Any images that don't fit within this definition will only confuse potential clients and will hinder your marketing efforts. That isn't to say that you can't pursue other genres of photography with a whole different style or subject matter, but for the best return on your marketing efforts, you would need to market those images separately.

IDENTIFYING YOUR MARKET

Identifying your market is fairly easy in the adventure sports genre. First, any and all outdoor related magazines and companies should be on your list of prospects. The type of images you have available to license and your specialties will dictate which areas of the outdoor market you'll target first. Of course, as anyone who looks at mass media these days knows, there are many outlets for adventure photography beyond just the outdoor industry. Marketing your work to those clients is a bit more challenging, but if you want to maximize your profits, it is well worth your time to research these extended markets.

This image of Charles Fryberger climbing in Hueco Tanks State Park near El Paso, Texas, was chosen by *Climbing* magazine for a cover. Since I shoot loads of climbing images, it was a no-brainer to send images to climbing magazines in the U.S. and Europe.

One of the best ways to extend your marketing prospects beyond the outdoor industry is to use a list service like Adbase (www.adbase.com) or Agency Access (www.agencyaccess.com). These companies track down and find all of the photo buyers at magazines, corporations, and graphic design firms that use photography and anyone can gain access to that information by paying a subscription rate. While the lists are not cheap to subscribe to, they are a much more convenient method of gaining access to a larger market. One of the other bonuses of using a list service is that they also tell you who the clients are at each advertising agency. This is incredibly valuable information that would take forever to compile on your own, and it will greatly aid you in building your list of prospects. I would advise that you get all of your marketing ducks in a row before you sign onto Adbase or Agency Access, because if an ad agency sees your e-promo, loves your work, and calls for your printed portfolio, they aren't going to wait two weeks for you to build it. Be prepared.

Not all of your marketing prospects will be listed on Adbase or a similar list service, especially some of the niche outdoor industry magazines and gear manufacturers, who most likely have in-house marketing groups. You will have to track down these clients with careful research. Another consideration for identifying possible clients is to realize that you are in a global market. There are clients around the world that are looking for adventure images and you might have just what they need. When you are just starting out, you'll go for the obvious low hanging fruit like the outdoor magazines and gear manufacturers, and as the ball gets rolling your horizons and clientele will expand globally.

I was fortunate to be profiled in the Summer 2006 issue of *Nikon World* magazine. While the magazine only goes out to around 15,000 subscribers, most of whom are amateur photographers, it was a perfect chance to leverage Nikon's name recognition for promoting my work to new clients. Try to maximize the opportunities offered by every reward and recognition to gain exposure in new markets.

Once you have identified your prospective clients, the next step is to start building your marketing materials to promote yourself to those clients. When I started out (and I'd say the same is true for most adventure photographers working as professionals today), we had no real clue about how to go about building a business and creating marketing strategies. We simply thought we had a few cool photos and sent them off to magazines like *Climbing, Bike, or Surfing,* depending on what sports we shot. It wasn't until a few years into my career that I really started thinking about marketing aside from shooting amazing images and showing them to clients. I have listed several books in the last chapter and on the resources page (see page 222)

that will give you more in-depth information on marketing and working as a freelance photographer. Now, let's jump in and discuss some of the individual marketing tools you'll want to use. I'll present these in the order of their importance, starting first with websites.

WEBSITE

The most important marketing tool for any photographer is a website. Whether you are a professional or an amateur, creating a website to display your images is a great way to show your work. For the pro, a website is home base for every other form of marketing because all promotional materials will reference the website. A website is a requirement for any professional photographer seeking assignment work. I cannot stress enough how important a high quality, well designed, easy to navigate, professional website is in this digital age.

From my conversations with photo editors, I know that a photographer's website needs to show the images as large as possible, load quickly, and be straightforward. You don't need a thirty-second snazzy flash introduction—that will only annoy a busy photo editor. In fact, statistics show that you have roughly seven seconds to get their attention. Another recent statistic I have heard is that if your first five images don't impress the viewer, they won't stick around to see any others. Very few photo editors will comb through your entire site; they simply don't have time. Because of this, I would suggest naming the links to your individual portfolio galleries according to the type of images in that gallery, e.g., adventure or action for the sports images, people or portraits for your portraiture, and so on. That way, when a photo buyer comes to your website they can go directly to the type of images they are looking for.

The appearance of your website is also critical. While photo editors are looking mostly at your images, if the design of the website is poor, it will affect the perception of your images. I would recommend a clean and uncluttered look that puts the focus on the images. Make sure you have links for a bio, contact information, and your portfolios at a minimum, and that these links are easily visible and in the same location on every page on the website. For your portfolio galleries, remember that you want to look professional. You don't want your portfolio links to send the viewer to a Flickr page with a grid of images, nor do you want them to be cookie cutter web galleries generated by Adobe Lightroom, Photoshop, or Aperture. The web galleries should fit in stylistically with the rest of the website. On a technical note, since the web is an sRGB color space, you'll want to make sure to convert your images to sRGB. And you'll also want to make sure your images appear sharp on your web page.

In order to keep my website's home page interesting, the images rotate randomly every few seconds through a set of my seven best. You'll notice that I also designed my website with a very understated look that puts the focus on my images.

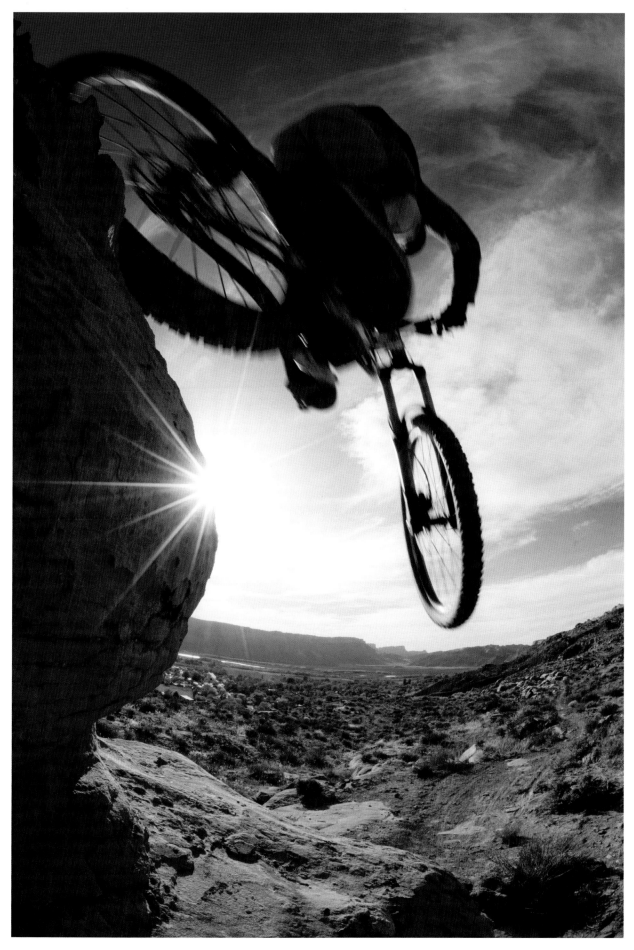

Ryon Reed logs some air time above Moab, Utah, during an assignment for the software maker Adobe. Because Adobe is such a prestigious client in the photo industry, I created an entire portfolio section on my website with images I shot for them.

A website is a great place to show a range of images so clients who might have different needs can see your specialties. Aside from pure action-adventure images, I also love to shoot landscapes like this one of White Sands National Monument, New Mexico.

So how do you go about building a solid, professional website? If you have the skills, you can design and build it yourself. Another option is to hire a web designer to build a custom website for you. The advantage of this approach is that your website will be completely unique. The downside is, in most cases, this is a very expensive option. An easier option is to work with a website company like Livebooks (www.livebooks.com) or A Photo Folio (www.aphotofolio.com). Both of these companies, and many more like them, offer excellent template websites that are customizable to some degree. I would highly recommend both of these options for photographers that aren't knowledgeable about website design. These sites make it very easy to swap out images, they deal with the search engine optimization process for you, and they are very inexpensive compared to having a web designer build your site from scratch. Last but not least, most photo buyers seem to like the basic design of these templates.

Once you have decided on a website template or design, you will have to put together your portfolio web galleries. Just as with a print portfolio, you'll want to include only your best work and nothing more. Again, this is where you want to take a long look at your positioning statement and choose images that reinforce that type of imagery. Be aware that you may have sentimental feelings about some images, which will cloud your judgment as to what is your best work. If possible, I would highly recommend that you have a photo editor look at a select group of your images and help narrow it down to the best of the best.

Once your website is a reality, you'll want to work on Search Engine Optimization (or SEO for short). Why is this important? If you want someone to be able to find you via Google, Yahoo, or any other search engine, then your site will have to be built with an eye towards SEO. We can't get into all of the specifics here, but SEO is based on many factors, including searchable keywords that describe the content of your website. For my website, I didn't choose

keywords that focus on my name or the name of my website. I instead choose keywords that describe the types of images I produce so that when a photo buyer is looking for that type of photography, my website comes up in the first few listings on Google. This is a huge consideration because there are thousands of photo buyers out there that don't know your name, but they know they need images from an "adventure sports photographer." And if you happen to come up in the first four or five search results, the odds are much better that they will look at your work. Since it isn't possible to have your website dialed in for every possible search word someone might think up, you'll have to consider your positioning statement and determine which keywords best represent your work.

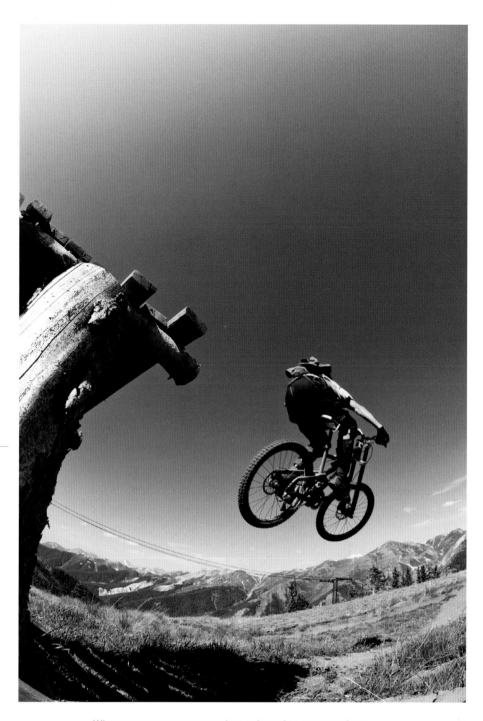

When you capture a great shot or have big news to share, get the word out. A blog is a great way to show your latest work and talk about what you have been doing. Here, a rider goes big on the Silverton Mountain Ski Resort's downhill trail.

BLOGS: THE MODERN DAY PRESS RELEASE

Not every photographer wants or needs a blog, but it is a great way to communicate what you have been up to recently and show new work, especially if you have no other avenue for communicating online. Of course, if you choose to start a blog, you will have to provide content fairly often—at a very minimum of at least once a month. Creating a blog is as easy as signing up with Blogger (www.blogger.com) or WordPress (www.wordpress.org), both of which are free. Or if you want a little more control over the appearance of your blog, which I highly recommend to keep up your professional appearance, you can have a blog site custom built for you, or at the very least customize your Blogger or WordPress blog to match your website.

E-MAIL AND
PRINT PROMOTIONAL MATERIALS

The most basic and effective methods for advertising your work are printed promo pieces and sending out HTML emails. These emails are formatted with HTML coding that makes them appear as you designed them when they show up in the recipient's inbox, and they are called e-promos. Both e-promos and print pieces should be designed with images that will impress the client and drive traffic to your website. Of course, your hope is that a client will see your e-promo or postcard, be floored by your images, and either license them on the spot or hire you for an assignment. Sometimes that happens, but more likely you are building up name recognition and allowing a range of clients to see your work so that when they need those types of images in the future, you get the call.

Printed promo pieces include everything from custom promotional cards printed in-house to small or large printed portfolio books, fine art prints, postcards of all sizes and shapes, mouse pads with your logo and an image, and any other clever method of getting your work in front of clients. The only limitations are your budget and imagination. I once sent out a mouse pad to all of my key clients. The mouse pad was printed by Black Diamond, and was an exact copy of their winter catalog cover. Even though the mouse pad had Black Diamond's logo on the front, the image was credited to me and the photo buyers loved it. It became one of my signature images and every time these photo buyers looked at their desks, they saw my image and thought about my work. In fact, I was in a photo editor's office a few years ago who was still using a really beat up version of my mouse pad. They loved it and couldn't bring themselves to replace it. The very next day I mailed them a new one.

This is an example of an HTML e-promo I sent out via Adbase. You'll notice that there is only one image, which helps the e-promo to load quickly. Because most clients don't have much time, I included only three links below the image for new work, recent news, and interesting blog posts. Any good e-promo should be brief and to the point.

MICHAEL CLARK ◆ PHOTOGRAPHY

www.**michaelclarkphoto**.com | 505.438.0828 | represented by www.wonderfulmachine.com

Postcards are a great way to promote your work. My promos always reference my website, and include a telephone number. I mail the postcards in clear plastic envelopes, which protect them from being stamped and inked up and allow the photo buyer to see the images without having to open the envelope.

If well designed and printed, a simple postcard is an effective and inexpensive printed promo piece. However, if you are sending postcards out to a few thousand clients, the printing and mailing expenses will skyrocket quickly. I suggest that you target your mailing list for print promos to a select audience and rely on email e-promos to cover an extended list of potential clients.

The beauty of an e-promo is that it doesn't really cost you anything and you can send it out to as many people as you want. If you use a list service like Adbase, it has a built-in email tool to send out HTML e-promos. It also tracks your emails, tells you who opened them, and who clicked through to your website. This information provides great feedback and lets you know who is interested in your work. If after sending out three or four emails, you see that certain photo buyers are consistently clicking through and checking out your latest work, you can then follow up with them via email. However, photo buyers are aware that you can track your e-promos, so be very careful how and when you follow up.

This image of shadows and tall aspens in Big Tesuque Basin above Santa Fe, New Mexico, was used on the cover of Black Diamond's winter catalog and was subsequently made into mouse pads, which I sent out to over 200 of my best clients.

You don't want to be a pest. Give it a week or two before you contact them or they will know that clicking through to your website has consequences. Never follow up on an e-promo or print promo piece by calling a photo buyer, unless you have a specific proposal in mind that will be of interest to them. Calling and leaving messages like, "Just wanted to see if you got my latest postcard?" will get you blacklisted immediately.

In terms of frequency, I would advise against sending e-promos more than once a month; every six weeks might even be better because you need to have something new to show and talk about. For printed promos, sending one out every quarter seems to be the norm these days. Of course, as I said earlier, this all depends on your budget. If you can only afford to send out e-promos, make sure you make the most of it and are consistent in their look and feel. Ideally, your e-promos should look like your website so the style is consistent.

PRINT PORTFOLIO

These days, many people ask, "Why do I need a print portfolio?" I have asked myself that same question. Over the fourteen or so years I have been working as a professional photographer, I have only sent a portfolio to a client on three occasions—all to secure an assignment, and all successful. Most photographers rightly rely on their website to act as their main portfolio. I would say that in general it is extremely rare that a magazine or corporate client (in the outdoor industry) will call in your print portfolio before granting an assignment. In a few cases, where I was going to be shooting a major editorial assignment and there were a lot of expenses involved, my portfolio was called in before I was offered the assignment. In those cases, the client wanted to verify that my images were of excellent quality and up to snuff for the magazine.

My print portfolio, which slips into a Patagonia padded courier bag, is kept updated and ready to ship out at a moment's notice.

In recent years, a print portfolio has been a requirement mostly for advertising photographers. If you are going to market yourself to ad agencies or larger corporations, then you'll want to have at least a few top-end portfolios ready to go out the door at a moment's notice. Before you start thinking about how to build your portfolio, consider a few key facts about printed portfolios and how they reflect on you. Just as with your website, the quality of your images and how they look will be a direct reflection on your skills. With a website, you don't know exactly how your images will look on the client's computer. With a print portfolio, the image is right there in front of the art director so there is no fudge factor. You have to have killer prints. You will be judged not only on your photography, but also on how well you produced the book.

I recently created an entirely new custom print portfolio that would satisfy even the most demanding ad agency art director or photo buyer. Several photo editors and art buyers have told me that a nice, high-quality black book for a portfolio is totally fine. It is simple and clean

Details make a difference to art buyers and photo editors. I had my custom logo foil stamped onto the slipcase and book to help reinforce my marketing identity.

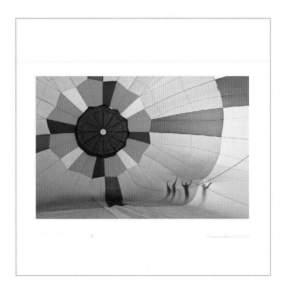

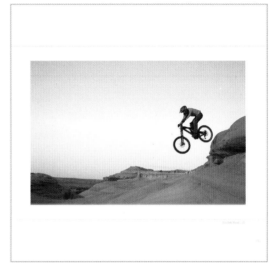

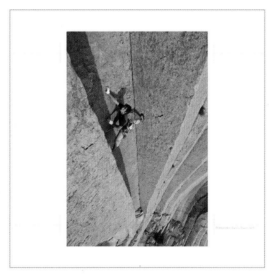

These images are sample pages from my print portfolio. I went with one image per page and a single-sided layout, which makes it easy to replace images in the portfolio and customize it for a specific client.

and directs all the attention to the images. A fancy book is nice, but if the work isn't up to par then it doesn't matter what the exterior of the book looks like. As for size, the portfolio should be big enough to show your work off effectively, but not so huge that it is hard to deal with. For my portfolio, I chose a midrange size and book made by Moab called the Chinle portfolio, and it measures 13 x 14 inches (33 x 35.6 cm). There are many other great portfolio options for photographers to consider, including those designed by Lost Luggage, Pina Zangaro, and Brewer-Cantelmo.

Choosing images for the portfolio was a grueling process because I wanted to make sure the images were on target with my positioning statement. I also wanted to show the breadth of my abilities so photo buyers wouldn't peg me as just an adventure photographer, but they would also see that I could capture outdoor lifestyle images and high-end portraits. And because I have three portfolios, each with a slightly different selection of images, it is easy to customize a book for a certain client before it goes out the door or before a face-to-face meeting.

Another important factor when building a portfolio is to take into account how it will be shipped and transported. I have a few bright yellow padded Patagonia courier bags

that the portfolios fit in perfectly, and they are very outdoorsy looking, which fits with my images. Shipping a portfolio to a client is as easy as dropping it into the Patagonia bag and then into a large Fed Ex box.

FACE-TO-FACE

I have found that one of the best sales techniques is to meet face-to-face with clients. Having a top-notch print portfolio is a useful tool for these occasions. Meeting an art director or photo editor in person can be intimidating, especially as they look at your work. But marketing is all about introducing yourself, proposing ideas, and forging relationships, so meeting the people you work with (or would like to) is the best possible marketing you can do. I will say that it isn't always easy to get a meeting with a photo buyer. They are extremely busy and their time is valuable—just as yours is. If you

have worked with them in the past, or have been recommended to them by another photo buyer, then it is usually possible to get a meeting. That doesn't mean you shouldn't try to get a meeting with clients you want to work with, just understand that it's easier if you have an "in" with them.

When you show up, make sure you look presentable and have your portfolio in hand. Don't feel the need to tell the story of every image in your portfolio—your photos have to speak for themselves. Let the photo editor or art buyer look at your book without any input unless they ask you questions. You'll get immediate feedback if they like an image. In fact, I'd say that you can learn more about your work and where it fits into the marketplace in just a few meetings with photo buyers than you can just about anywhere else. They have seen it all and if you ask for honest feedback, they will give it to you.

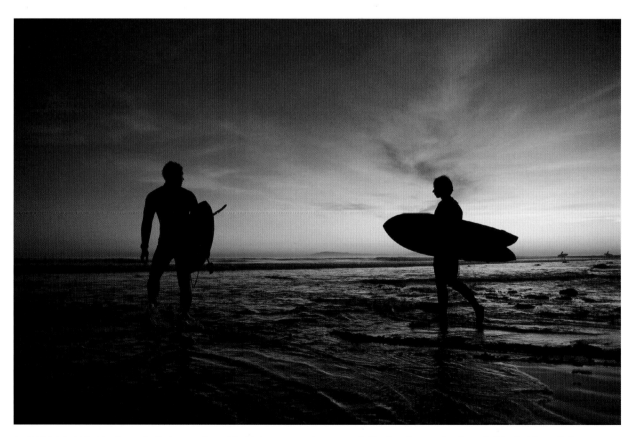

In-person meetings allow photo buyers to get to know you and your work. Postcards may be forgettable, but hopefully a face-to-face meeting with you is not. Editors tend to work with people they know and like, so if you have met a client in-person, it can be the ticket to getting the assignment over other photographers who haven't made the effort.

FOLLOW
THROUGH

While all of this sounds fine and dandy, where the rubber meets the road is in executing your marketing plan. My marketing plan, as an example, consists of e-promos sent to a very targeted list of clients every six weeks and quarterly print promos. I also send out a quarterly e-newsletter, which is basically an electronic magazine, which has been the heart and soul of my marketing campaign for years. All of these tools direct clients to new work and the latest news on my website and blog. Of course, there are other aspects of my marketing campaign, like my agent (who markets on my behalf), online portals, photo contests, stock agencies, and of course, word of mouth.

Honestly, not everything happens like clockwork. The point is that you should make a plan and stick to it as much as possible. And last but not least, a lot of the work for any freelance photographer is self-generated— you have to propose certain stories or projects to get the assignments. In this world, you have to be proactive. You can't just sit back and wait for the phone to ring.

Don't get tossed about by fate just waiting for something to happen, or you might be facing a hard landing like this surfer at Rocky Point, just north of the Bonzai Pipeline in Oahu. Get proactive about creating marketing materials, stick to your marketing plan, and create opportunities for yourself.

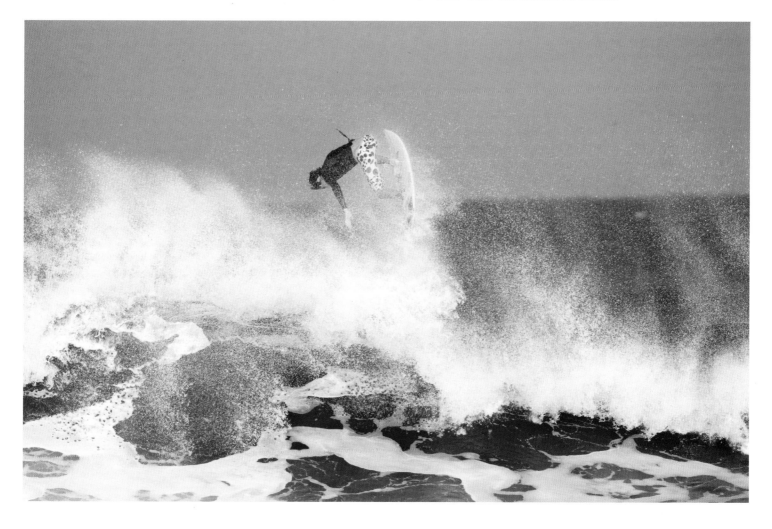

COREY RICH: THE ART OF MARKETING

In the last decade, Corey Rich has become one of the most prolific and well-known adventure photographers in the world. He has worked with numerous magazines, including *National Geographic Adventure, Sports Illustrated and the New York Times Magazine* as well as corporate giants like Apple, Nike, and Anheuser-Busch. He shoots a variety of sports, including rock climbing, skiing, kayaking, surfing, and adventure racing.

Because of Corey's quick rise to prominence and his success in the industry, he is a great resource for advice on marketing and getting started. If you'd like to check out more of his work, his website is www.coreyrich.com.

© Blaine Deutsch / Aurora Photos

Michael Clark (MC): How many years have you been a working pro photographer?

Corey Rich (CR): I fell in love with climbing when I was thirteen years old and it was such a natural progression to start taking pictures of weekend climbing adventures. It's hard to say when I actually became a professional photographer because within a year or two, I was doing everything a young aspiring photographer would do, including taking courses at the community college, working on the high school newspaper and yearbook, and reading every photography book I could get my hands on. By the time I was a junior in high school I was shooting for the real estate section of the community newspaper. That was it. There I was in high school, 16 years old, and I was getting paid.

MC: How long did it take for you to go from that point at the newspaper to the point where you were making a full-time living as an adventure photographer?

CR: One of my breakthrough moments was when I took a semester off from university, where I was studying mass communications and journalism. I had a Honda Civic and I took out all the seats except the driver's seat, and I cut a piece of plywood so it was like a platform that I could sleep on and cook on. I had a hundred rolls of Fuji Velvia (this was the early 1990s) and all my photo and outdoor gear. Then I drove around the United States photographing rock climbing and every aspect of the sport—it was in my blood, it was what I was passionate about.

So I spent six months driving around the western United States trying to document the culture and the sport and make fantastic climbing images. I didn't know if a career was even possible. I didn't understand the mechanics of how you make money with photography, and I wasn't really concerned with that part of it. At the end of that trip, I came back and edited my film down to the best forty pictures and I shipped those to Patagonia and the next 20 went to *Climbing* magazine. I didn't know anything about the business. There was no book on adventure photography. I didn't expect to hear anything, but the day after I sent the pictures, I was sitting in my dorm room and the phone rings. I pick it up like an idiot: "Whazzz Uppp," expecting it to be the guy down the hall. Instead, it was this professional woman and she sasked, "Is Corey Rich in?" I said, "Oh, hold on just a second." After a second or two I answered, "Hello, this is Corey." She introduced herself saying, "This is Jennifer Ridgeway from Patagonia. I run the photo department." After a long silence she says, "These pictures are really great. Who are you?" I think right there, in that moment,

a light bulb went off in my head. It was that credibility, that acknowledgement that my work was okay. I didn't expect to hear anything. I expected an envelope to come back six months later with a note saying, "Thanks, but no thanks." Jennifer made it clear in that phone call that my work was pretty good.

Within a few months there was not only the acknowledgement that my pictures were good enough, but then a check showed up. I don't remember the dates and timing exactly, but I got a check from *Climbing* magazine for the cover, and then another one from Patagonia. When the check showed up from Patagonia, that was it, everything changed. That was absolutely it. I realized in that moment that I was done. The newspaper was behind me. I bought a fax machine and magazines would fax over their lists of images they needed. I would get the list and it became my assignment for the month. I started traveling non-stop and I shot continuously. I became a major contributor to the climbing magazines. There was a period where I think I owned half the magazine every issue. It was simply because I would be pumping so much content in because I was shooting the needs list.

One day I got a phone call, which turned out to be the next pivotal moment in my career. This time it was a secretary from a San Francisco company who basically said, "I work for the vice-president of Quokka Sports, and he was flying home from France last night. He was reading Outside magazine and saw your image in a full-page ad for Patagonia." It was a picture of a guy getting a shot in his butt with his surf trunks pulled down. The secretary went on to say, "He really loves the picture. We think from a creative perspective this is the look and feel, the real documentary type of image we want. Are you available to come in for a meeting?" Of course I said, "Yes,

that sounds great." At this point in my career I had never done a day rate. I didn't understand the business. I had no idea. So I called a mentor friend of mine, Brad Mangin, who runs the Sportshooter.com website, on the drive in to the meeting because I assumed this could turn into an assignment. I asked Brad, "So what happens if they ask me to do an assignment?" He said, "Dude, a thousand bucks, a thousand dollars." I thought to myself, great, I don't even know what they are going to ask me, but that sounds good.

So, I walked into Quokka and I could tell there was money just pumping out of that building. The company brass reviewed my work and my portfolio. Finally they said, "We have this assignment that we think you are perfect for. Are you available next month?" I looked at a school binder and pretended it was actually a calendar and said, "Yeah, I think I can adjust my schedule—what are you thinking?" They said, "We have this assignment. It is in Morocco. You'd be going to the Sahara to photograph this adventure race across the desert, but it's for the web and this will be cutting edge"—this was 1995. They went on, "We need you to shoot with digital cameras (which was a big deal back then—these were $25,000 cameras). We'll be transmitting images via satellite and putting your images on the web in real time, and you'll be working with a writer and a video team." I replied, "That sounds great!"

And then they say, "Okay, what do you cost?" I replied, "A thousand dollars." And honestly, it was really hard to say that because I was thinking, "Man, I'd pay you guys a thousand bucks to go and do this. This sounds insane!"

Then there was this silence. Finally, Brian, the CEO of Quokka Sports says, "That's pretty steep. How about $800?" And

of course I was just so nervous that I didn't really know what to say. I'm thinking in my head, "Dude, this is great! $800 and I am going to Morocco." I was so excited I couldn't respond. Then Brian finally says, "Okay, $900. But you do realize this is 30 days?" And right there I realized he didn't mean $900 bucks for the project. He meant $900 per day!

And that was it. Everything changed. I realized right there on the spot that I was done with college. I realized this was really going to work as a career. This was going to be a $30,000 job!

MC: Now I am going to shift to some marketing questions. You were talking about how your editorial work was your marketing early in your career. Is that still the case?

CR: Certainly, early on it was. I'm not sure it started out as a strategy, but it became my strategy when I realized it worked really well. My strategy was essentially to work as hard as possible and to get published as much as possible. In my genre, which was rock climbing, I shot a lot. I think there were years early in my career where I was on the road shooting 300-plus days per year. Early on, I was still in college and I was hiring office assistants. I had another college student working for me to keep up with the demand for pictures. What happened was that getting published editorially turned into amazing marketing. Most of my great commercial work came as a result of my images appearing in editorial publications.

MC: Is that still the case now?

CR: We still get work from editorial publications. Now I focus my energy much more into the stories I am telling and where those stories land in terms of the publications, and packaging projects that are much more complex than just a single article. We are selling a good story idea in multiple channels to maximize the profit and the exposure. It

starts with a good idea and then we find the right venues for that idea.

MC: How do you market yourself?

CR: We dabble in marketing. We are certainly using HTML emails, we do print pieces, but were getting away from sourcebooks—in other words; we aren't paying for blackbook.com or workbook.com. The sourcebooks in my opinion are dead and I think the sourcebook websites will die soon. That's just not where people go to find photography anymore.

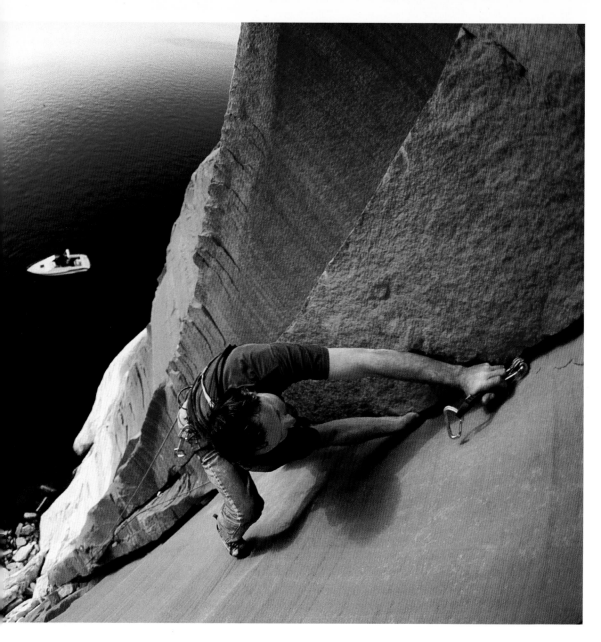

Craig Lubben tries to sink a cam in a sandstone cliff high above Lake Powell, Utah. To capture this unique perspective, Corey shot the image while hanging from a rope above the climber with a fisheye lens. Photo © Corey Rich

MC: Do you use Adbase or any of the list services specifically for photographers?

CR: Yes, we certainly use Adbase. We have a very sophisticated network in our office and we are really diligent about managing our photographic and contact assets. We have a database that we spend a lot of time maintaining. In terms of our contacts, we can divide those lists in a fairly sophisticated way so that we know who we are targeting when we send out an HTML email promo or a print piece. Our goal is to send out a quarterly print piece and a monthly HTML email promo. The beauty of e-promos is that they are cheap, but you need a good message. Certainly the web is the future. That's the bottom line.

What we want is web traffic. We want people to come to the website and see my pictures. The belief has to be that once you get viewers to your website, and you have great pictures, they are going to be excited. The question is: How do you build brand around, in my case, Corey Rich? What is it about my pictures and me that sets me apart?

MC: Do you have a print portfolio that you take with you when you meet with clients?

CR: Yes, we have ten print portfolios. They are all pretty similar. I have an agent in New York, who has some of my portfolios and we ship a lot of books out of my office. We are constantly changing the book. Not just the physical look or exterior, but the images, the pacing, and the layout. We just changed the look of the books six months ago to have full-page images, one per page. I think there is an impression that is made with a print book. It is very refined. There are no excuses.

MC: Do you have any business philosophies that have helped you?

CR: I am a believer in the philosophy that I need to do what I know how to do best. I don't necessarily want to know how to do everything. I actually want people that know how to do things really well to do it for me and I'll focus on what I know how to do really well. I am really good at taking pictures. I love taking pictures. I'm not really good at pounding on doors and negotiating assignments. I don't really enjoy building lightboxes to submit images to clients and sell my stock photography. My philosophy is to hire people to do those things for me.

I know if you are just starting out in the business, you might be thinking, "Oh, that's nice, but if you don't have money then you can't do that." It's at any level. If you are a one-man show and you have $10,000 to allocate towards operations, equipment, and marketing, it is still how you choose to spend that $10,000 relative to your time. From the very beginning, if I didn't know how to do something, I'd rather pay and have it done efficiently versus wasting time to figure it out. This is true in life in general. Do you want to learn how to put a toilet in or do you just want to pay someone to put the toilet in correctly?

MC: Would you say that is the key to your phenomenal success?

CR: Phenomenal success? I'm not sure that is the case. I always say there are three ingredients for being successful in adventure photography. Obviously you need to have some raw talent. You need to be able to make a good picture. That's number one. Number two is you really need to be willing to work damn hard. That's the passionate part. You have to work harder, longer, and more efficiently than anyone else out there. And it really helps if you are a good person. You've gotta be a good guy. So it's some raw talent, a lot of passion and drive, and being a good person. If you have only two of those, your opportunity to succeed is greatly reduced, and if you only have one, then it isn't gonna happen.

This is not a job for me. It's everything. This is my life, my friends, my family, and it all kind of blends together in some kind of seamless way. I love it that way. I can't imagine it any other way.

Sabine Meyer,
Photo Editor
of *National
Geographic
Adventure.*
© Kezi Barry

SABINE MEYER:
THE PHOTO
EDITOR'S
PERSPECTIVE

Sabine Meyer is the Senior Photo Editor at *National Geographic Adventure* magazine, one of the top adventure magazines on the planet. I was honored to have her talk with me for this interview and share some of her insights on the adventure photography industry. She has been a photo editor since 1992, and has been with *Adventure* since 1999.

MC: What qualities should a photographer have if they want to shoot for National Geographic Adventure?

SB: An adventure magazine caters to a lot of different readers and publishes stories every month that each have a different definition of adventure. So I tend to look into three different pools of photographers: outdoor sports photographers, photojournalists, and adventure travel photographers.

I am looking for people with a very strong visual identity, but who have a lot of [outdoor] skills and can also shoot action,

lifestyle, portraits, landscapes, great moments, and details. I am also looking for people who are very enthusiastic, easy to work with, independent, problem solvers, good communicators, people who are going to be team players and who are able to deal with the set of cards they are dealt. We are looking for people who are in touch with the type of stories we write. And in some cases, it's a story that requires very specific athletic skills—like dealing with high altitude or being able to do an Eskimo roll and kayak while shooting. The photographer needs to be geared up for that.

MC: Is it a bonus if a photographer can shoot action and high-end portraiture?

SB: Yes, I don't just hire adventure photographers. I think in the ten years that I have been here, the definition of "adventure" photography has changed. I think that everybody out there knows that to be an adventure photographer you need to be able to shoot action, you need to be able to set up lights and do a great portrait, you need to have a little bit of a stylist's eye, and you also need to be a little bit of a tech head and play with rigging. You also need to be a journalist so you can create a narrative and understand what the story is about. It's not just about taking pretty pictures.

MC: Are you and your staff constantly looking for new photographers? Or is the market already saturated with plenty of talent? Where do you look for new photographers?

SB: The market is obviously saturated with photographers, period. But there are a lot of geographical pockets where there is not a lot of really good talent. There are parts of the country (the U.S.A.) where, should you want to assign a local photographer; it is really hard to find the right talent for the kind of photography we are looking for. Those regions are mostly the southeast and the center of the country. There are a plethora of great photographers on the west coast, in the Rockies, and in the northeast and northwest. We are always looking for new talent

because the way the budgets are going these days, we have to hire locally. We are not in the position to say, "Who is the best for this job" no matter where the assignment is. That has always been the way we have operated.

Where do we look for photography? We get e-promos. It is up to the photographers to reach out to us. Also, we constantly look at all the different magazines that make up our world and our competition. We really look at everything and filter what works for Adventure.

MC: What is the best way for photographers to market themselves to you? Postcards? E-promos? A link to their website?

SB: These days, I definitely tend to favor e-promos because I can see a photo and then click on it and go to a website. Basically, it is immediate portfolio viewing. That is more efficient than just a postcard that shows me one or two photos. I'd much rather see a website because I think that a postcard is very misleading. You might think a photographer shoots a certain way because you see one or two photos, and then you go on their website and you realize that the rest of their work is not at all what you thought it would be. So the photographer who you thought could be right for your magazine is actually not.

I think I get a much more complete sense of who a photographer is and what they shoot when I look at an e-promo and link into a website. It is immediate. And since I am staring at a computer 8 to 10 hours a day, it becomes second nature, when I am multi-tasking, to check e-promos. When I see something I like, I definitely put that photographer on my "hot" radar, or I contact the photographer if I want to see more images of a certain project.

Now, that said, I do still get a lot of postcards and once in a while if I really like one, I put it on my wall. I have this sort of 'wall of fame' in my office. The first thing I look for is a URL on the postcard. The postcard leads to the website.

MC: How many e-promos do you receive a week on average? Print promos?

SB: We get about 25 e-promos a day, if not more. Up to, say, 200 or more per week. I probably get thirty printed promos each week.

MC: Do you have any advice on how to make promos (email and print) better and more interesting for you? Or on the flip side, are there some definite things not to do?

SB: The main important thing, especially for photographers who use Agency Access or Adbase, is to make sure that they target their clients. I do get emails from photographers that do high-end beauty or cosmetics or car advertising and they are a waste of my time. Even if I have to spend five seconds, that is too much time. I want to see things that catch my attention and are also really good photos. I think it is pointless to just send average photos to keep on someone's radar, because I will look at it and think, "It's not so great." Why would I bother clicking through to this person's website? Do your homework. Send fresh material that is relevant and build your e-promos so they load really fast.

MC: Do you ever call in a photographer's print portfolio when considering them for an assignment? How important is a photographer's website when it comes to assigning work?

SB: No, we don't. I think that is something of the past. Why spend the money with Fed Ex and the liability of potentially losing that portfolio somewhere in transit? I think that may be a system that is still valid for commercial advertising work. I never call books in anymore. On a website, a photographer can have a projects link where I can look at individual projects and see 20 to 25 images, and it really gives me an idea on how this photographer would potentially cover or execute an assignment if I were to hire them. That is not something that you tend to get in a book because there are too few images.

MC: When it comes to photographer's website, what are some of your pet peeves?

SB: Websites should be very simple, easy to navigate, and clean. The website should be pleasant to look at. I am very suspicious if there are too many gizmos and embellishments because often that distracts from the quality of the photos. I care very little about the technology. I just want to get to the photos as fast as possible. And I want to be able to navigate back and forth between the home page, the portfolios, and different projects very easily.

I personally hate it when there is an email box set up on the website. Why can't I just use my own email client? Just give me your email address. It just seems silly to me. And also, sometimes there isn't a phone number, which is really annoying. Some photographers don't specify where they are located, which I can understand, but for me it is highly critical to know where a person is located. I don't want to have to play a guessing game with their area code.

Obviously, fast loading images are critical. I also like a bit of caption information somewhere near the photos because it is the type of information I look for when I look at someone's portfolio, especially for people who shoot projects and stories.

MC: Do you ever read photographers' blogs?

SB: I have to say I wish I could spend more time reading photographers' blogs, but I just do not have the time. But I do think it's a good window into peoples' personalities because I don't often meet the photographers I work with.

MC: How important is it for photographers to make the effort to meet with you in person?

SB: It is pretty important. I like to meet someone face-to-face when we've seen a lot of their photos and bought some of their stock on a consistent basis, or when we've done a very small project with them. If we know this person has the right eye for us we always make efforts to meet face-to-face because it is a little personality check. Is this person going to be okay if we send them on a two-week assignment with a bunch of people they have never met? Also, because they will be representing *National Geographic*, we want to make sure that we are on the same wavelength.

MC: Any advice for photographers just starting out?

SB: The most important thing when you start out is to be fully committed to making the best possible photos you can. Right now, photographers should strongly think about diversifying by doing multimedia, HD video, recording sound, and taking notes for lengthy caption information. It all depends on your goals and what you aspire to do as a photographer.

MC: Any advice for those that are already well established in adventure photography?

SB: I think they need to assess if their photography is still fresh in terms of style and technical qualities. I think if your career is just not happening, working on a personal project is very important and can reinvigorate the creative juices. Try to find new ways to tell a story, like using still images to create moving content. You can never take any thing for granted. The media world moves and evolves so dramatically, even in just the last few months, that no one can say, "Ok, I've mastered digital photography, I'm set for the next 30-years." That isn't going to cut it. No matter what, you just have to be in love with photography and breathe it non-stop all day long. It's not a job. It's a way of living.

RESOURCE LIST

PROFESSIONAL PHOTOGRAPHERS

Brian Bielmann (www.brianbielmann.com)

Trevor Clark (www.trevorclarkphoto.com)

Corey Rich (www.coreyrich.com)

Brett Seymour (www.brettseymourphotography.com)

Mike Tittel (www.miketittel.com)

PROFESSIONAL PHOTOGRAPHERS ASSOCIATIONS

American Society of Media Photographers (www.asmp.org)

Advertising Photographers of America (www.apanational.com)

Editorial Photographers (www.editorialphoto.com)

Travel and Outdoor Photographers Alliance (www.t-o-p-a.com)

PORTFOLIOS

Lost Luggage (www.lost-luggage.com)

Moab Paper (www.moabpaper.com)

Pina Zangaro (www.pinazangaro.com)

Brewer-Cantelmo (www.brewer-cantelmo.com)

BUSINESS AND PRICING RESOURCES

Fotoquote (www.cradocfotosoftware.com)

Negotiating Stock Photo Prices by Jim Pickerell (www.jimpickerell.com/guide.asp)

Best Business Practices for Photographers by John Harrington

The Real Business of Photography by Richard Weisgrau

WEBSITE TEMPLATES

Livebooks (www.livebooks.com)

APhotoFolio (www.aphotofolio.com)

LIST SERVICES

Adbase (www.adbase.com)

Agency Access (www.agencyaccess.com)

PHOTO EQUIPMENT:

Nikon (www.nikon.com)

Hasselblad (www.hasselbladusa.com)

Apple (www.apple.com)

SanDisk (www.sandisk.com)

Lexar (www.lexar.com)

Elinchrom (www.elinchrom.com)

Profoto (www.profoto.com)

Hensel (www.henselusa.com)

Dyna-Lite (www.dynalite.com)

Kirk Ball Heads (www.kirkphoto.com)

Really Right Stuff (www. reallyrightstuff.com)

Wimberley Tripod Heads (www.tripodhead.com)

Gitzo Tripods (www.gitzo.com)

LowePro Camera Bags (www.lowepro.com)

Pelican Cases (www.pelican.com)

Ewa-Marine Underwater housings (www.ewa-marine.de)

SPL Water Housings (www.splwaterhousings.com)

AquaTech (www.aquatech.net)

Aquatica (www.aquatica.ca)

IkeLite (www.ikelite.com)

LIGHTING

Strobist (strobist.blogspot.com)

ShootSmarter.com (www.shootsmarter.com)

DIGITAL

Rob Galbraith (www.robgalbraith.com)

Digital Photography Review (www.dpreview.com)

Luminous-Landscape (www.luminous-landscape.com)

Digital Journalist (www.digitaljournalist.org)

Photoshop Insider (www.scottkelby.com/blog)

OUTDOOR EDUCATION

Outward Bound (www.outwardbound.com)

National Outdoor Leadership School (www.nols.edu)

PHOTOGRAPHY WORKSHOPS

Santa Fe Workshops (www.santafeworkshops.com)

Maine Media Workshops (www.theworkshops.com)

D-65 (www.d-65.com)

Photography at the Summit (www.photographyatthesummit.com)

INDEX